The End
of the
American
Avant Garde

THE AMERICAN SOCIAL EXPERIENCE SERIES

James Kirby Martin
GENERAL EDITOR

Paula S. Fass, Steven H. Mintz,
Carl Prince, James W. Reed & Peter N. Stearns
EDITORS

The End
of the
American
Avant Garde

.
.
.
.
.
.

Stuart D. Hobbs

NEW YORK UNIVERSITY PRESS
New York and London

N E W Y O R K U N I V E R S I T Y P R E S S
New York and London

© 1997 by New York University

Library of Congress Cataloging-in-Publication Data
Hobbs, Stuart D. (Stuart Dale), 1961–
The end of the American avant garde / Stuart D. Hobbs.
p. cm. — (The American social experience series ; 37)
Includes bibliographical references and index.
Contents: Toward the last American vanguard,
1930–1955. Introduction : the avant garde and the culture of the
future — The communist party, modernism, and the avant garde — The
American avant garde, 1945–1960. Alienation — Innovation — The
future — The end of the avant garde, 1950–1965. The cold war,
cultural radicalism, and the defense of captalism — Institutional
enthrallment — Consumer culture commodification — The end of the
avant garde, 1965–1995. The convention of innovation and the end of
the future
ISBN 0-8147-3538-X (alk. paper)
1. United States — Intellectual life — 20th century. 2. Avant-garde
(Aesthetics)—United States — History — 20th century. I. Title.
II. Series.
E169.12.H59 1997
973 — dc20 96-35604
 CIP

New York University Press books are printed on acid-free paper,
and their binding materials are chosen for strength and durability.

Manufactured in the United States of America

10 9 8 7 6 5 4 3 2 1

To Jamie

Contents

.

.

.

Acknowledgments

.

.

.

I would like to thank John C. Burnham at The Ohio State University for first suggesting to me that the end of the avant garde was a question worth answering. This book benefited greatly from his reading, as well as the comments of William R. Childs, Edward Lense, K. Austin Kerr, and Susan M. Hartmann. The members of the Cultural and Intellectual Historians Circle, Kevin F. White, Lawrence F. Greenfield, and David J. Staley, supported the project with their insight and good humor. My editor at New York University Press, Niko Pfund, skillfully guided the manuscript through the production process.

I would like to thank the following for the use of their work:

Letters by Robert Duncan cited with the permission of The Literary Estate of Robert Duncan.

Letter by Irving Howe quoted by permission of Nicholas Howe, Literary Executor of Irving Howe.

Excerpts from "Bomb," by Gregory Corso: *The Happy Birthday of Death*. Copyright © 1958 by New Directions Publishing Corp. Reprinted by permission of New Directions Publishing Corp.

Letters by Gregory Corso copyright © 1996 by Gregory Corso. Reprinted by permission of New Directions Publishing Corp.

Letter by Mark Rothko copyright © 1996 by Kate Rothko Prizel and Christopher Rothko. Reproduced by their kind permission.

Excerpts from "Asphodel That Greeny Flower" by William Carlos Williams: *Collected Poems: 1939–1962*. Vol. II. Copyright © 1962 by William Carlos Williams. Reprinted by permission of New Directions Publishing Corp.

City Lights Books Papers, Robert Duncan letters to Sanders Russell, Daniel Moore Papers, courtesy of the Bancroft Library, University of California, Berkeley.

Allen Ginsberg Papers, Peter Orlovsky Papers, Jack Kerouac Papers, Philip Whalen Papers, Rare Book and Manuscript Library, Columbia University.

Malcolm Cowley Papers, The Newberry Library.

Interview with Robert Motherwell, Columbia University Oral History Research Office Collection.

Dwight Macdonald Papers, Manuscripts and Archives, Yale University Library.

Allen Ginsberg Papers, Department of Special Collections, Stanford University Libraries.

Judson C. Crews Papers, Stuart Z. Perkoff Papers, Kenneth Rexroth Papers, Department of Special Collections, University Research Library, University of California, Los Angeles.

Quotation from Elmer Bischoff, Library, San Francisco Art Institute, and Adelie Landis Bischoff.

Material from the American Abstract Artists Records, William Brown Papers, Betty Parsons Papers and Gallery Records, William and Ethel Baziotes Papers, Archives of American Art, Smithsonian Institution.

I dedicate this book to my wife, Jamie, with thanks not only for her editorial help, but also her patience and support over the years of research and writing. Finally, to my daughter, Sarah, I can only apologize that her father's book has lots of big words and no pictures.

Toward the Last American Vanguard
1930-1955

.

.

.

.

.

.

Introduction:
The Avant Garde and the Culture
of the Future

.

.

.

.

.

.

I n 1935, David Bernstein, editor of the American literary magazine *The New Talent*, characterized the avant garde as a group of writers motivated by the "spirit of revolt . . . against artificial boundaries of so-called good taste, against hypocritical 'sweetness and light,' against formalistic strictures of language." Through this revolt, members of the avant garde heralded and to a great extent created unprecedented changes, not only in art, but also in all areas of intellectual and material life in the West. The powerful impact of the movement was still apparent half a century and more later not only in museums and libraries, but also in advertisements and popular culture.[1]

Yet, by the 1960s, many critics, scholars, and artists began proclaiming the death of the avant garde. "Truth is," wrote composer Virgil Thomson in 1966, "there is no avant-garde today. Dada has won; all is convention; choose your own. What mostly gets chosen . . . is that which can be packed and shipped . . . [for] a conditioned public." In 1967, critic Irving Howe argued that

3

it seems greatly open to doubt whether by now, a few decades after the Second World War, there can still be located in the West a coherent and self-assured *avant-garde*. . . . Bracing enmity has given way to wet embraces, the middle class has discovered that the fiercest attacks upon its values can be transposed into pleasing entertainments, and the *avant-garde* writer or artist must confront the one challenge for which he has not been prepared: the challenge of success.

An important cultural development had taken place, which on the surface, given the cultural impact of the movement, was not to be expected. Destroyed by a combination of external forces and internal weaknesses, the end of the avant garde set the stage for the present period of postmodernist culture and poststructuralist thought. Why the dissolution of the avant garde occurred is the subject of this work.[2]

The term *avant-garde* was originally a military one, referring to troops in the lead, or vanguard. In the eighteenth century, the word began to be applied metaphorically to politics. For example, in 1794 it appeared in the title of a French periodical addressed to intellectuals in the army, urging them to continue defending the principles of the Revolution.[3]

The social and political connotations of the term grew increasingly important in the next century. French socialist Henri de Saint-Simon was one of the first, Donald Egbert argues, to apply the idea of vanguard to art. In his *Opinions littéraires, philosophique et industrielles*, Saint-Simon wrote a dialogue between an artist and a socialist in which the artist declares: "It is we, artists, who will serve you as avant garde: the power of the arts is in fact most immediate and most rapid: when we wish to spread new ideas among men, we inscribe them on marble or on canvas; . . . and in that way above all we exert an electric and victorious influence." Saint-Simon believed that he lived on the eve of the greatest period of intellectual and artistic development in human history and that artists had a "priestly" mission to lead the way into that future.[4]

By the 1840s, French radicals regularly described themselves as *avant-garde*, and the term had become a political cliché. Indeed, after 1848 the term lost the older artistic connotations, a meaning that had always been subordinate to politics, even for Saint-Simon. In the early 1860s, Charles Baudelaire knew *avant-garde* only as a military-political word. Not until the 1870s did cultural and political radicalism come together once more as the avant garde. Literary historian Renato Poggioli argues that the crises of the Franco-Prussian War and the suppression of the Communards gave innovative artists and political radicals a sense of common

purpose that brought them together, if only for a short time. It was during the 1880s that avant garde became a synonym for artistic innovation in the modern sense and lost its political connotations. Exactly why this happened is not clear. Egbert suggests that the dissociation occurred because, at the turn of the century, most members of the avant garde were divided: political radicals tended to be Marxists, whereas cultural radicals tended to be anarchists.[5]

The Vanishing Avant Garde

The avant garde might be described as a vanishing topic in American intellectual history at the end of the twentieth century. The writers of earlier classic works of intellectual history, such as Oscar Cargill and Merle Curti, describe the intellectual rebellion of the first decades of the twentieth century in some detail, typically characterizing the event as something of a coming of age, an "end to American innocence," as Henry May put it. In more recent surveys of American intellectual history, authors give some attention to the early phase of the avant garde in America but ignore evidence that there was an avant garde after the 1920s. Lewis Perry, for example, in his 1984 survey of American intellectual life, discusses the avant-garde rebellion against Victorianism that took place in the 1910s and 1920s and created modernist culture. But in his work, as in others, the subject largely disappears from subsequent chapters. Perry, like other contemporary intellectual historians, makes brief reference to the "beatniks" as precursors to the counterculture of the 1960s, but neither in Perry's work nor in most other intellectual histories of the last decades of the twentieth century can the reader learn that an avant-garde community persisted in America from the 1920s through the late 1950s.[6]

In the seminal 1979 anthology *New Directions in American Intellectual History*, John Higham implicitly suggested why the avant garde did not figure in the discussion. Contributors to the book showed a marked turn away from literature and psychology, two staples of earlier discussions of the avant garde. Clearly, the focus of intellectual history was changing. Contributors showed an interest in the social and institutional basis of knowledge and in the history of mentalities—important subjects, but ones that took historians away from the issues raised by the avant garde.[7]

Since the 1960s, researchers in modern American intellectual history have tended to focus on two areas. One group has examined the professionalization of the sciences from the late nineteenth century to the

middle of the twentieth century. Another group has explored the ideas and cultural impact of the New York intellectuals. These authors do show that the intellectuals in the New York community sometimes described themselves as avant garde or mourned the passing of that vanguard, but they see that identity as incidental to the history of ideas and relationships in the group. Many historians have been more interested in the New York intellectuals as anti-Communists than as modernists.

The postwar American avant garde has not been completely ignored in historical scholarship. Anthony Linick, Harry Russell Huebel, and Michael Davidson, for example, wrote important works on the interrelated literary avant-garde movements of the Beats and the San Francisco Renaissance. These scholars describe a community of intellectuals alienated from their society who understood both their work and their community to be, in Davidson's phrase, an "oppositional sign" expressing the avant-garde hope for a new culture.

Art historians have described another vanguard community, the abstract expressionist painters. The work of Irving Sandler, Ann Gibson, Stephen Polcari, and Alwynne Mackie combines a close study of the iconography and stated purposes of these artists with an examination of the intellectual milieu in which they worked. These scholars describe how the avant garde created an art that expressed life-affirming mythological and religious themes, which members of the van hoped would contribute to the regeneration of Western culture.

As the above examples suggest, most recent work on the avant garde has focused on particular genres, such as literature or painting. Walter B. Kalaidjian, Richard Candida Smith, and Sally Banes have attempted to bring the various strands of the American avant garde together, at least for limited places or times. Kalaidjian examines the literary and artistic American vanguard of the 1920s and 1930s as part of an international vanguard movement and argues that an oppositional vanguard continues to exist in the last decades of the twentieth century. Smith looks at the literary and artistic avant garde in California in the mid-twentieth century, while Banes chronicles the diverse avant-garde activities in New York City in the early 1960s.

History after the Linguistic Turn

By the 1990s, poststructuralist thought—what has been called the "linguistic turn"—began to have a significant impact on intellectual history.

Historians have argued that the discourse of intellectuals is not about universalist principles, but is merely the self-referential conversation of elites. According to this postmodern view, language does not describe an objective reality "out there," but rather is a self-contained system in which meaning results from the relations among words, not between words and the world.[8]

This book fits into the new world of discourse in two ways: as a study of discourse and as an examination of the origins of the postmodern linguistic turn. As a study of intellectual discourse, this work addresses the ideas of a specific, self-defined, and self-conscious community—the American advance guard—about the relationship between art and society. I describe the music, poetry, novels, and visual art of avant gardists, and in particular the notion of art as process that is the chief innovation of the postwar van. But the primary focus is on the meaning that members of the advance guard believed their work had for American society. In the primary sources upon which this work is based—that is, the manifestoes, little magazine essays, exhibition catalogs, and letters and diaries written by the members of the avant garde—they discussed their belief that the integration of art and life could create a new consciousness and transform American culture.[9]

The fundamental problem of human discourse—that language, and indeed any form of communication, is open to interpretation—also appears in this account. In postwar America, journalists, critics, gallery owners, museum curators, educators, and others interpreted avant-garde work in ways counter to the vanguard's self-understanding. Far from transforming American culture, cultural Cold Warriors appropriated the radical van as a weapon in the Cold War; curators, gallery owners, and publishers absorbed the advance guard into traditional institutions of culture; and advertisers and businesspeople commodified the movement in consumer culture. The meanings that avant gardists gave to their work, which they believed was expressed in a form that tapped into a universal human subconscious, proved susceptible to diverse interpretations. Ironically, these alternative readings overwhelmed vanguard intentions.

The second relation between this book and the linguistic turn is as a contribution to the history of the transition from modernism to postmodernism. The avant garde is the source of postmodern, poststructuralist notions of language that concern many present-day historians and literary theorists. The genealogy of the linguistic turn can be traced to Friedrich Nietzsche and his contention that the artist, through the innovative use

of language, could destroy the banal bourgeois world and create a new consciousness and thus a new world.[10] The Nietzschean vision of the power of word (and image) in the hands of the artist formed the basis for the faith American vanguardists had in the future. Ironically, however, by the middle of the twentieth century, the legacy of these vanguard ideas would not be cosmopolitanism and universalism but exactly the opposite. From human communication having the power to create a new world and a new culture, intellectuals came to emphasize the limits of communication.

Language can create a new world, postmodern intellectuals argued, but the world created is purely subjective. The artist's vision passes through a myriad of interpretive prisms, creating a plethora of new visions. Cultural radicals abandoned the idea of a unified culture with themselves in the vanguard. Avant gardists looked less to the future and instead emphasized the infinite possibilities of meaning their work could have in the subjective present. Cultural radicals thus led the way to the present state of pluralism in which, as David Hollinger notes, universalist, "species-centered discourse" has been replaced by particularist, "ethnos-centered discourse." At the same time, the idea of the future had been discredited; intellectuals increasingly focused on present injustices against particular communities and looked for elements of the past that could be used in present political struggles.[11]

The Avant Garde and Culture: Alienation, Innovation, and the Future

Culture is that complex combination of values, ideas, myths, and institutions that enables members of a social group to interpret their environment and organize their society. Culture functions to establish order and stability. Historian Warren I. Susman has shown that, in the United States, culture and cultural change have historically been the focus of the "liberal-radical" tradition. In particular, Susman contends, liberal and radical critics have been concerned with cultural restrictions on individual self-expression and self-fulfillment. Self-fulfillment through the synthesis of art and life was the goal of members of the avant garde. Thus, while avant gardism was at least partially rooted in Europe, it also had significant intellectual connections with American traditions of social criticism.[12]

To define the avant gardists in relation to their culture goes beyond

many definitions of their movement, which focus merely on its aesthetic innovations. The resistance of cultures to change explains the extremely innovative quality of avant-garde creativity. With their innovations, members of the avant garde expressed both their alienation from their culture and their desire to transform that culture to create a new future. Thus, a distinct set of ideas defined the van. Some avant gardists illustrated particular points better than others; and there was certainly much room for variation on particular themes. However, the family resemblance, to use a phrase from Ludwig Wittgenstein, between avant gardists was strong, regardless of specific differences among members of the movement.[13]

Three themes explain the relationship of avant gardists to their culture: alienation, innovation, and the future.

The modern understanding of alienation comes from Karl Marx. Marx took this term from Hegel and from legal terminology to describe a sense of uselessness and isolation felt by people estranged from their work and, ultimately, society. Others subsequently used the term to describe modern people in general and intellectuals in particular.[14]

The alienation of the avant garde was rooted in social and economic changes that took place in Europe in the nineteenth century, which transformed the status of the artist. With the rise of the modern middle class and industrial capitalism, the old system of patronage disappeared. Artists were no longer artisans but laborers, selling their products on the open market and subject to the same economic risks as other laborers. And they had to compete against the new mass-produced culture. In this context, artists could either join the culture or define themselves by their opposition to it. Alienation was the beginning, therefore, of self-definition.

The result of this economic change was the creation of a new model for the artist—the bohemian. No longer the artisan, artists became intellectual vagabonds, living in poverty on the edge of society and defying the conventions of the middle class. The idea of bohemia was idealized from the beginning, but the model remained both the stereotype and the reality for artists well into the twentieth century.

The avant garde constituted an opposition culture. It emerged to counter the values of the new Victorian middle class that rose to cultural dominance with the industrial revolution. The Victorian world view of the English and American middle classes emphasized innocence. The Victorians desired to separate themselves from corruption and create a harmonious world. In the United States, this Victorian culture has also

been referred to as the "genteel tradition." Promoted by a group of literary publicists centered in cities of the Northeast, the genteel tradition was an attempt to civilize the emerging industrial order by encouraging graceful manners, strict morality, and respect for cultural tradition, especially that of England.[15]

Avant-garde critics of the dominant culture, who themselves came largely from the middle classes, experienced their society as over-civilized, inauthentic, formalist, and artificial. They believed that the genteel tradition smothered creativity and individuality. They rejected Victorian culture in the name of "real humanity." Thus, in 1930, the editors of the American little magazine *Blues*, the poets Charles Henri Ford and Parker Tyler, declared in an editorial that "the hideous genteel, the sham culture of the admirers of William Lyon Phelps ... comprise the elements in American life which are ... hostile to the experimental enterprise of *Blues*'s artists; and by experimental enterprise we mean simply: freedom of the spirit and the imagination." Vanguardists sought to combine that which the Victorians had tried to separate: the human and the animal, the civilized and the savage. Drawing on the new biology, physics, and social sciences, cultural radicals created a new culture based on ideas of relativity, contingency, and process without a final closure.[16]

Alienation—and the problem of self-definition—fueled avant-garde creativity. The emergence of avant-garde art from this negative ground explains the dark and often destructive quality of many avant-garde works. One should not, however, characterize avant gardism as mere negativism. Alienation also provided the creative energy for the constructive characteristics of avant gardism: innovationism and futurism.

Innovation is the characteristic most closely identified with the avant garde. Poggioli points out that the very phrase *avant garde* focuses attention on this theme. He reminds us that the image suggested by the term is one of soldiers on reconnaissance preparing the way for the advance of the main body of troops.[17]

Avant-garde innovation derived from the goal of creating a new art integrated with life. Members of the advance guard believed that cultural renewal came through the fresh union of art and life, a concern derived from the alienation of the artist in capitalist society. Peter Bürger notes that art in the Middle Ages, for example, was linked with the church, the most important social institution of that time. In the capitalist order of the nineteenth century, art and the aesthetic existed in a sphere separate from the everyday reality of economic competition. Art was thought to

provide an escape from harsh reality into a realm of joy, truth, and humanity. The avant garde emerged to challenge this separation of art and life. Avant gardists accomplished this goal in a variety of ways: by questioning the whole idea of art, most extremely in the work of Dadaists; by responding to technological innovation; and by searching for a new mythological system in which to frame human experience.[18]

While most cultural historians have tended to make innovation the defining characteristic of avant gardism, Poggioli maintains that the endless quest for the new is actually the least distinctive quality of avant gardism. What sets avant-garde innovations apart from others is the fact that avant gardists connected their innovations to cultural transformation and to the future.[19]

Members of the avant garde believed that human creativity could be an avenue to a better tomorrow. As cultural radicals, they believed that by conceiving new expressions in art, literature, music, and other creative areas they could transform the perceptions of their audiences. Vanguard artists constantly asked, "What is painting?" or "What is music?" In answering these questions, avant-garde artists both broke down and extended the formal boundaries of art.

Often the results shocked people, but the point of innovation was not just to *épater le bourgeois*. By ridiculing the rules of genteel society, vanguardists hoped to liberate others from its confines. Radical innovators believed that people perceived art and the world around them in much the same manner. Therefore, they believed that by changing perception in one area they could change perception in another and thus create a new order.

This theme is especially important in the American context, for the American avant garde, for a variety of reasons, was more optimistic than its European counterpart. Vanguard belief in the future was the counter to alienation. American cultural radicals believed in a future in which art and life were integrated and human beings experienced self-fulfillment.

Cosmopolitanism was also an important related theme for American vanguardists. The cosmopolitan ideal was of a future in which people transcended the particularisms of class, ethnicity, political ideology, and religion in favor of a universal, secular, rational vision that united people and enabled them to experience their individual lives more fully, as well as to appreciate the experience of others with greater sympathy.[20]

The avant garde, then, was a movement of creative intellectuals alienated from the emerging industrial order of Western Europe and America.

In the last quarter of the nineteenth century, these intellectuals rebelled against the cultural values of their society and pursued innovations in a variety of areas in order to create a future in which art and life would be merged.

In practice, the avant garde functioned as the leading edge of modernist culture. Yet the extremism of the avant-garde rejection of the immediate past and pursuit of the new can obscure their continuities with the past. The avant garde can thus be described as an unstable combination of the Enlightenment notion of progress and the romantic emphasis on human creativity.

The Last American Vanguard

From 1945 to 1965, the last generation of the American avant garde emerged. This group of advance guardists was born in the 1910s and especially the 1920s. They were mostly of middle-class origin, the traditional breeding ground of the avant garde. The members of this van formed a self-conscious community linked by professional cooperation and personal friendships. This community should be pictured not as one large circle, but as several interconnected circles representing a variety of communities—some geographical, but most defined by specific artistic or intellectual interests. Among those that figure prominently in this work are the abstract expressionist, Beat, San Francisco Renaissance, and Black Mountain College communities.

The abstract expressionist painters illustrate the qualities of geographic proximity and artistic interest that define many avant-garde communities. Among this group of innovating painters were Willem de Kooning (b. 1904), who became famous for his series of abstract figure studies of women that combine the human form with an energetic brush stroke that can only be called violent; Robert Motherwell (1915–1991), perhaps the most articulate theorist of the group; Barnett Newman (1905–1970), an artist large of personality and a skilled polemicist who created severely abstract works; and Jackson Pollock (1912–1956), whose shocking technique of pouring paint on the canvas earned him (from derisive critics) the nickname "Jack the Dripper."[21]

Most of these and other artists of the movement lived within a few blocks of one another in New York's Greenwich Village. They formed a geographic community, but also an intentional community. Aside from visiting each other's galleries or discussing the day's work at the Cedar

Tavern, these artists met formally, first at the Subjects of the Artist School organized by Motherwell and others in the late 1940s, and, most famously, at the Eighth Street Club organized by de Kooning and others in 1949. Throughout the 1950s, the club sponsored a weekly discussion on Friday nights that formed the intellectual and social heart of the community.

A similar community is illustrated by the literary van known as the Beats, who coalesced in New York and San Francisco in the late 1940s and early 1950s. The novelist and poet Jack Kerouac (1922–1969) experimented with a style of spontaneous writing inspired in part by jazz improvisation. Poet Allen Ginsberg (b. 1926) explored the alienation of social outcasts in a poetry inspired by Walt Whitman, the Hebrew prophets, and Eastern religious thought. Novelist William S. Burroughs (b. 1914) drew on his experiences as a heroin addict to present a stream of consciousness critique of the technological society.

The Beat circle intersected with the San Francisco Renaissance particularly through the person of Kenneth Rexroth. Rexroth (1906–1982), poet, translator, polemicist, and patriarch of the Bay Area van, introduced Beat and local vanguardists to each other at salons held in his home. At readings and in his writing, Rexroth encouraged and promoted both the Beat and San Francisco Renaissance movements (though he would later turn on the Beats). The San Francisco Renaissance community included Gary Snyder (b. 1930), a lyric poet of nature who spent twelve years in Japan studying Zen Buddhism, and Robert Duncan (1919–1988), a poet and early advocate of what would come to be called gay liberation.

The interconnectedness of the advance-guard community can be illustrated no better than in the example of Black Mountain College. Poet Charles Olson (1910–1970) served as rector of the innovative North Carolina college in the mid-1950s. Poet Robert Creeley (b. 1926) taught there and edited the *Black Mountain Review* with the help of fellow faculty member Robert Duncan and support from Kenneth Rexroth. After his time at Black Mountain, Creeley lived in New York, where he met abstract expressionist Franz Kline for long talks at the Cedar Tavern, as did Allen Ginsberg and Jack Kerouac.[22]

Several Black Mountain students and faculty would become prominent in the avant garde. For example, artist Robert Rauschenberg (b. 1925) created highly original "assemblages," objects somewhere between painting, sculpture, and the rubbish bin. Rauschenberg made many of these pieces as sets for dances created by choreographer Merce Cunningham

(b. 1919), who, with Cunningham troupe composer John Cage (1912–1992), spent some time at Black Mountain. Cage became a central figure in the postwar vanguard; his experiments with chance techniques in musical composition influenced a whole generation of poets and painters as well as composers.

The trio of Cunningham, Cage, and Rauschenberg was well known back in the Village and the abstract expressionist circle through de Kooning, who had taught at Black Mountain in the summer of 1948. Elaine de Kooning, Willem's wife and also a painter, wrote to a friend in the early 1950s that "Merce Cunningham has finished his ballet to Igor's [Stravinsky] score for Les Noces and everyone is driving up to Boston this Saturday . . . to hear or see Merce's ideas on the sacrament of marriage." Included in the de Kooning circle were Motherwell, Pollock, Newman, and the poet Frank O'Hara (1926–1966).[23]

Little magazines formed another kind of community. The "little" in little magazine refers, of course, to the small circulation of the usually short-lived, low-budget publications that cultural radicals produced as forums for their ideas and creative work. Editor Judson Crews may serve as a typical example of the little magazine editor in the postwar years. From his home in Taos, New Mexico, Crews edited a string of magazines, including *Suck-Egg Mule: A Recalcitrant Beast* (1950–1952), *The Deer and Dachshund* (1952–1954), and *The Naked Ear* (1956–1959). Crews brought together in his magazines a variety of poets, including representatives from the Beat, Black Mountain, and San Francisco Renaissance circles.

Crews's magazines focused on poetry, but a variety of small press periodicals existed in the 1940s and 1950s. In *Possibilities* (1947–1948), editors Robert Motherwell, John Cage, and Harold Rosenberg explored music, poetry, painting, and the interconnections between the three genres. In *The Grundtvig Review* (1950–1957), published in Eagle Creek, Oregon, at the Grundtvig Folk School, editor Glen Coffield produced a magazine containing verse and anarchist social criticism.

While New York City was the center of much avant-garde activity, including publication, during the period covered by this study, a number of other editors across the country put together little magazines that helped link the avant-garde community. For example, the *White Dove Review*, published in Oklahoma by students at the University of Tulsa, was part of the national vanguard movement as well as the focal point of

a local community of cultural radicals. The editors published work by Ginsberg, Kerouac, Creeley, and Crews. In addition, they drew the attention of their readers to other little magazines, including *Hearse, The Fifties, Naked Ear,* and *Trace.* The magazine was also part of a local community. The editors put the magazine together in a local vanguard gallery, and one of their patrons and advertisers was a bookshop proprietor who sold many of the little magazines and avant-garde publications recommended by the editors.[24]

The postwar avant-garde community was intentional, national (and to some extent international), and crossed genres. The members of this community were united by their experience of alienation, their belief in new perception through innovation, and their expectation of a future in which art and life were integrated.

The End of the Avant Garde

The postwar American avant garde struggled heroically for several decades and then ended as a movement in the 1960s. In general, several interrelated developments within American culture and within the avant garde caused the death of the movement: the appropriation of the avant garde by Cold Warriors, the movement of intellectuals into the university and other institutions, the rise of the consumer culture and the transformation of art and ideas into commodities, and the avant gardists' loss of faith in the future. These are the themes I follow to show how and why the avant garde expired.

The avant garde became a weapon in the Cold War. Members of the van felt alienated from Cold War politics and sharply criticized these policies. But many Cold Warriors believed that avant-garde creativity and individualism made members of the movement the perfect demonstration of the superiority of American society over Soviet society. Much vanguard rhetoric supported this interpretation, with the result that cultural radicals became tools of the cultural Cold War. In the process, the movement gained respect and prestige that furthered the process of cultural enthrallment and internal dissolution.

The academization of intellectuals from the 1950s on further, and fatally, transformed the movement. The postwar expansion of higher education in America gave colleges and universities an all-but-insatiable appetite for young intellectuals. The new opportunities provided by these

institutions led most postwar intellectuals to reject bohemianism. Cultural outsiders became cultural insiders. The specialist who spoke to other specialists replaced the freelance intellectual who addressed an educated public and led the public into the future.

Moreover, in the 1950s, as a consumer culture based on the sale of lifestyle images reached maturity, avant gardism became a commodity. Gallery operators, critics, and museum curators all promoted vanguard art to a prosperous middle and upper middle class. Journalists and critics in the popular press converted avant-garde rebellion into fads and fashion, encouraging innovation for the sake of innovation. The result was a pluralist culture in which no coherent vanguard movement could be discerned.

In addition to these external causes, changes in the avant gardists' self-understanding contributed to the end of the movement. In particular, changes in the avant gardists' idea of the future offer the key to understanding how the advance guard came to end. Vanguardists turned away from their historic understanding of themselves as those who led the way into the future. Instead, they began to focus on the present, producing moments of epiphany whose meanings did not transcend the subjectivity of their participants. This change had several results. Avant gardists lost an understanding of culture as a coherent entity. This sense of incoherence further encouraged the pluralism without direction already noted. Furthermore, innovators could no longer look to an end to alienation in a future community in which art and life were integrated. Instead, avant gardists assuaged alienation with the security of affiliation with institutions of commerce or culture. The belief in the future gone, the spirit of the avant garde was lost. Moreover, a central concept that defined modernist culture, and indeed Western culture since the Renaissance, no longer had meaning for many American intellectuals. An important intellectual change had occurred when the idea of the future disintegrated.

The coming together in the 1950s of these several social, political, economic, and intellectual currents caused the dissolution of a movement that for seventy or eighty years had decisively shaped thought and culture in the West. Artistic innovation continued in the 1960s, along with a surfeit of radical activism. But these movements quickly gained, if not universal acceptance, at least a place in middle-class culture. Radical chic was not avant garde. Moreover, intellectual developments after the 1960s were characterized by an inward turn. Not only did intellectuals speak exclusively to a select group of specialist colleagues, but what had been

for an older generation artistic and intellectual self-consciousness became so extreme in postmodern thinkers that they focused on mere surfaces and images. For a new generation of intellectuals, ideas about civilization, culture, and the future became meaningless. In these events lies the significance of the end of the avant garde.

for an older generation artistic and intellectual self-consciousness became so extreme in postmodern thinkers that they focused on mere surfaces and images. For a new generation of intellectuals, ideas about civilization, culture, and the future became meaningless. In these events lies the significance of the end of the avant garde.

The Communist Party, Modernism, and the Avant Garde

.

.

.

.

.

.

As the 1930s generation of American avant gardists sought a specific direction for cultural advance, many increasingly came to believe that the answer was to be found with the Communist Party. Cultural and political radicalism have often been linked. It was no accident that the term *avant garde* had political connotations before artistic ones, and Lenin himself referred to the Communist Party as being the political vanguard. The Communist movement appealed to members of the avant garde for several reasons: Marxist philosophy explained the alienation cultural radicals felt in bourgeois society; the class struggle provided a direction for innovation; and the party promised to lead the way to a future without alienation. The relationship between the Communist Party and the avant garde proved unstable, however. A different conception of the dynamics of social and cultural change led many avant gardists to leave Marxism and the party behind. These intellectuals redefined their role as vanguard in terms of

cultural preservation, a goal they achieved by canonizing the work of the avant gardists of the first decades of the twentieth century as "modernism."

The process of political radicalization and deradicalization set the stage for the emergence of the last American vanguard. This advance-guard movement appeared in the late 1940s, and its members rejected both Communist ideology and modernism. These vanguardists created a variety of innovative artistic works, all with the goal of transforming postwar American culture. But by the 1960s they were assimilated into institutions of commerce and culture and the avant garde was over.

The Red Vanguard

Before the 1929 stock market crash, the American Communist Party was one of many small, sectarian, political parties on the left. Only after the onset of the Great Depression did the Communists emerge from obscurity to become, during the 1930s, the most prominent radical political movement in the United States. Even so, the organization remained small, never attracting more than a hundred thousand members at one time, although during the course of the decade more than twice that number may have joined the party, if only for a short time.

The Communist movement appealed to many of the intellectuals who defined themselves as avant garde. The members of America's prewar rebellion against the Victorian producer culture desired the social, political, economic, and intellectual transformation of American culture. These avant gardists linked what critic Waldo Frank called "the political and cultural currents of advance." Randolph Bourne, in particular, exemplified the integration of political and artistic radicalism and for this reason was greatly admired by the young American avant garde. But Bourne's untimely death in 1919 serves almost as a metaphor for the separation between advanced art and politics that would occur in the 1920s. The destructiveness of World War I and the failure of Wilson's peace plan caused many young intellectuals to become disillusioned with politics. They turned from integrating art with life to an emphasis on art for art's sake.[1]

The Depression radicalized many intellectuals, who moved once more to an avant-garde position and assumed responsibility for the state of American culture. Many intellectuals believed that they had acted irresponsibly in the 1920s because they had retreated from "reality" to Pari-

sian aestheticism. Fanya Foss, a poet, short-story writer, and member of the New York John Reed Club, wrote in 1934 that "the spirit of exile here or abroad is the spirit of an escapist, which consciously or unconsciously is dangerously near Fascism." Leftist theater critic John Gassner remembered that "a great fear of social acedia, of evading or having evaded one's social responsibility, pervaded the world of the artist and the intellectual as the Depression grew deeper and the fortunes of fascism in Italy, Spain, and Germany rose higher. The one thing the artist and the intellectual feared most from an embattled leftist critic was the charge of 'escapism.'" As painter Peter Blume succinctly concluded in 1936, "The artists didn't really descend from . . . their ivory towers—*they were thrown out!*"[2]

If the bohemians of the 1920s were not concerned about their society and culture, most members of the twenties Communist Party cared little for the bohemians. One activist from the 1930s remembered that he and his colleagues "*despised* the intellectuals." Michael Gold, the editor of the party's unofficial literary magazine, the *New Masses*, fought a lonely battle during the 1920s, trying to persuade party leaders that intellectuals were important to the Communist cause, and trying to persuade intellectuals that the Communist Party was relevant to them. This background of indifference and hostility explains the surprise of many Communists at the radicalization of bohemia. As one Marxist editor exclaimed in 1934, "Even Greenwich Village has succumbed!"[3]

During the 1930s, the party leadership began to take an interest in artists and intellectuals. Communist Party leaders exploited the intellectuals' new radicalism to the party's institutional benefit by establishing a variety of loosely affiliated cultural organizations. The John Reed clubs are probably the best known of these organizations. The John Reed clubs, like the other organizations, were (according to the club statement of purpose) "dedicated to advancing the interests of the working class . . . to the defense of the achievements of the Union of Soviet Socialist Republics [and] the development of new working class writers and artists, as well as alignment of all artists, writers and intellectuals to the side of the revolutionary working class, stimulating their participation in revolutionary activity." Most of this activity was centered in New York City, but John Reed clubs in several cities, from Hartford to Hollywood, managed to publish at least a few issues of local literary magazines and sponsor art exhibits. The Worker's Music League established, at least on paper, local Pierre DeGeyter clubs around the country, and the party-associated New Dance Group also had branches outside of New York City. After 1935,

the party disbanded many of these decentralized and local groups and replaced them with national organizations such as the League of American Writers and the Artists' Congress. In all of these institutions, art was closely linked to, if not subordinate to, politics.[4]

Communism and the Avant Garde: Alienation, Innovation, and the Future

The ideology of the Communist Party addressed, in a variety of ways, the themes that defined avant gardism, namely, alienation, innovation, and futurism. The feeling of alienation from bourgeois culture was, of course, basic to the avant gardists' self-understanding. Cultural radicals interpreted the Great Depression as a sign of the failure of bourgeois capitalism and a confirmation of their rejection of the bourgeoisie. Samuel Putnam, for example, writing in *New Hope* in 1934, declared that "society today is *a poisoned well.* . . . Painting, literature, every form of art . . . reeks with the stench of bourgeois decay." Editor William Phillips wrote in the *Partisan Review* in 1934 that alienation was forced on creative intellectuals as a result of the depression:

> The gravity of the economic crisis has levelled most of us (and our families) to a meager, near-starvation existence. Opportunities for cashing-in are gone, and we have no illusions about their return. The kind of reputation which used to bring jobs as editors, lecturers, and readers in publishing houses, holds no lure for us, because those jobs have been whittled down to a few sinecures for stand-patters and tight-rope walkers. The bourgeoisie does not want us, and we could not accept the double-dealing which these jobs require.

In response to the economic crisis, composer Wallingford Riegger said, "As an artist, I feel impelled to continue my creative work, but I also feel, as an artist, that I must help oppose those forces which would deny humanity its heritage of culture and freedom." The Communist Party, possessed of both a counter-bourgeois ideology and an organization dedicated to carrying out ideological goals, seemed to many cultural radicals to be an answer to their alienation and their uncertainty about the work they should be doing.[5]

In the 1930s many avant gardists believed that Marxism and the Communist Party provided both an intellectual framework for innovation and a community that modeled the integrated society of the future. But by

the mid-1930s, divisions among radical intellectuals appeared, especially over the use of Marxism for cultural or social revolution. Some intellectuals maintained that art should serve the revolution of the political economy. Others believed that the new perceptions of the European and American avant garde of the 1910s and 1920s, when combined with the social and economic insights of Marxism, provided the surest way to cultural renewal. This division would ultimately lead most members of the avant garde to reject the Communist Party and orthodox Marxist interpretations of the relations between art and society.

Since the 1920s, Communist Party literary theorists, such as Joseph Freeman and Michael Gold, had argued that innovation needed to be guided by specific ideological goals and social content. In a 1930 essay, Gold, editor of the *New Masses*, described the purpose of proletarian art in functional terms: "Every poem, every novel and drama, must have a social theme, or it is merely confectionery." He rejected innovations in literary technique as "another form for bourgeois idleness," declaring that in proletarian writing there should be "no straining or melodrama or other effects; life itself is the supreme melodrama. Feel this intensely, and everything becomes poetry—the new poetry of materials, of the so-called 'common man,' the Worker moulding his real world." Writers who adhered to this creed tended to use conventional literary forms to describe the life of workers. Thus, the technique of one contributor to the *New Masses* was described as "to make words rhyme and syllables come in exact order, to poetically exalt the proletariat out of its misery."[6]

The proletarian aesthetic, partisans argued, made it possible for the artist to avoid the false conscience of commercial popular culture and the irrelevance of aestheticism. In 1936, painter Louis Lozowick declared that the capitalist system "degrades the human personality, science and art to cash payments." Composer Hans Eisler argued that same year that musical innovations of the first decades of the twentieth century had succeeded in "isolating modern music from life." Rather than communicating to his society, Eisler argued, "the modern composer has become a parasite, he is supported by private connoisseurs and the benevolence of a few wealthy people, and he produces no sensible, social work." The solution Eisler advocated was for musicians to recognize the crisis facing modern society and contribute their talents to the struggle for change. "In a period of great struggle for a new world, why should the musician be a skulker?" He urged composers to "ally with those others who suffer under the

present system of society and fight against it. Here is the tie between the progressive intellectual, scholar, doctor, engineer, artist and the workers."[7]

Vanguard intellectuals, in contrast to the advocates of proletarian art, interpreted Marxist philosophy as a universal theory around which a unified culture characterized by social and economic equality and avant-garde aesthetics could be created. Cubist painter Stuart Davis, for example, argued that abstract art, not realist art, addressed the social reality of the modern world. Davis believed the stylistic innovations of abstract art reflected the dynamism of modern technology and the relativism of modern thought. Davis wrote, "Abstract art is a contemporary expression of the new lights, spaces, and speeds of our time. . . . It is the only art that concerns itself with the material world in motion and not as a world of absolutes and static entities." Davis also believed that Marxism was "the only scientific social viewpoint." In particular, he argued that the dialectical emphasis in Marxist thought paralleled the dynamism of the modern world. The influence of jazz in Davis's work perhaps best illustrates what he was trying to do. In his 1940 painting, *Hot Still-scape for 6 Colors — 7th Ave. Style*, Davis conveyed the rhythms of jazz, the modern American urban milieu that produced the music, and the dialectic of history through the use of bold colors, overlapping geometric shapes, and swirling forms. In this and other paintings of the time, Davis wanted to express, as he wrote in his notebook, "[The] progressive spirit of democracy; individual freedom; wonders of science; new light, space, speed."[8]

The editors and contributors to the little magazine *Experimental Cinema* declared, in terms very much like those of Davis, that motion pictures presented a new way of seeing. For example, in 1931, writer Seymor Stern, with the montage technique of Soviet director Serge Eisenstein in mind, described film as "a new instrument of human consciousness. As the form of consciousness itself." He maintained that film required a new kind of creator, "the scientist-artist laborer" who was a "dialectic-minded thinker" and could join "radical-revolutionary science" to attain "an ultimate exposition of radical revolutionary world-meaning." Indeed, Stern concluded that the cinema would transform Western civilization more profoundly than the Bolshevik revolution because as cinema advanced, "all bourgeois conceptions of esthetics and creativity [were] being forever swept away."[9]

In 1934, William Phillips and Philip Rahv launched the *Partisan Review* with the explicit purpose of combining the precepts of proletarian art

with innovative techniques of previous generations of vanguards. In a 1934 essay entitled "Three Generations," Phillips presented a literary genealogy for proletarian literature, proceeding from the first generation of naturalists, such as Theodore Dreiser and Sherwood Anderson, to the "lost generation" of the 1920s. The work of this expatriate generation, Phillips argued, needed to be integrated with that of the previous generation. Phillips assigned this task of integration to the "third generation," the proletarian writers of the 1930s. "The spirit of the twenties is part of our heritage," Phillips wrote, "and many of the younger revolutionary generations are acutely conscious of this." Phillips noted that most of the important figures in revolutionary literature, men such as Freeman, Gold, and Joshua Kunitz, were of the same generation as Ernest Hemingway and e. e. cummings. These older radical writers were not expatriates and had kept alive the sociological tradition of Dreiser while "side-stepping" the innovations of their peers. Writers like Gold and Freeman had thus "carr[ied] the line of revolution forward," according to Phillips. But they left a task for the third generation, the "proletarian generation": to tie the threads of the past together, "to use whatever heritage there is at our disposal for our revolutionary tasks." Phillips did not say outright that Gold and the others were wrong to ignore contemporary literary developments, but he clearly rejected the leftism of those who would argue that proletarian writers had nothing to learn from avant gardism. On the contrary, Phillips evaluated the quality of past writing on aesthetic, not social or political, grounds. "T. S. Eliot," he wrote, "is one of the strongest literary influences on us. This is so[,] probably, because he is the only really important poet of the immediate past." Rahv and Phillips had set for themselves a clear program: to meld innovative aesthetics with Marxian revolution.[10]

Despite differing interpretations of the relation between art and social change, a common vision of the future united the Communist Party and avant-garde intellectuals. Communists seemed to share the vanguard vision of a future in which art and life were integrated and human creativity liberated. Karl Marx and Friedrich Engels envisioned a communist community in which specialization was eliminated and all people were laborers and artists: "In a communist society," Marx wrote, "there are no painters, but at most men who, among other things, also paint." Leon Trotsky described the new human of the future as "immeasurably stronger, wiser, subtler" than people of the present. "The average human type," Trotsky declared, "will rise to the heights of an Aristotle, a Goethe,

a Marx. And above this ridge, new peaks will arise." Davis described the new, postrevolution human beings as a new breed of perceptually sophisticated "Color-Space People." This belief in the new person, the liberated, authentic human being who was the true destiny of all people, linked the Communists and the avant garde.[11]

Furthermore, members of the Communist Party did not just talk about the future; they described the Soviet Union as the place where the community of the future was already being built. American avant gardists used the Soviet Union as a model for their vision of the future. For example, Kay Rankin, a member of one of the Communist Party-associated dance groups in New York City, declared, "Dance must be used to teach workers' children that they belong to the working class . . . [and] use themes of nature to teach children to dance together in harmony, just as workers on a Soviet collective work together." According to the idealized picture of the Soviet Union that many American vanguardists held, the great cause of building the socialist state had inspired unity among diverse people and a willingness to sacrifice and suffer for the good of the whole. As this community was built, art and life would become integrated. Soviet music critic Grigorst Schneerson described in *Modern Music* in 1936 how "Soviet music is sharply distinguished by a purposeful ideology, a truthful realism in the aspirations of Soviet composers who are stirred by the life surrounding them."[12]

The Communist Party represented to American vanguardists the fulfillment of the cosmopolitan ideal. The revolutionary new society would be rational and progressive. Ethnic and class hostilities would be replaced by cooperation. Human creativity would be liberated to make self-fulfillment possible. Capitalist society, in contrast, produced only poverty, economic crisis, fascism, and war. To the intellectuals of the 1930s, Gassner later recalled, Marxism presented "the other side of despair and the alternative to a passiveness disgraced by the appeasement policies of the government."[13]

Breaking with the Communist Party

In the latter half of the 1930s, avant gardists began to reconsider their relationship to the Communist Party. Political events were generally the ostensible reason for the break. The hypocrisy of the Moscow trials of 1937 caused many intellectuals, including *Partisan Review* editors Phillips and Rahv, to reject the party. Others, like Davis, rationalized the purges

but could not rationalize the 1939 Nazi-Soviet Pact. Confronted with the choice of supporting the policies of the Soviet Union or their own moral and intellectual integrity, most vanguardists broke with the party. But beneath the immediate cause of the break, in most cases, there lay a deeper reason: avant gardists and Communists believed in different dynamics of cultural change.

What was the cause of cultural change? For the Communists, the clash of different interests created by inequalities in the political economy generated conflict and change: the eighteenth-century French bourgeoisie rejected the authority of a feudal aristocracy; the exploited industrial proletariat would revolt against its capitalist exploiters. The result, in time, would be a humane new society. For the avant gardist, power came through ideas, and especially through perception. By presenting people with new ways of looking at reality, cultural radicals expected to change their audience's perception of reality. Vanguardists believed that people confronted with new uses of language, visual media, and sounds would recognize the limitations of the conventions of their culture. Recognizing these limitations, people could then proceed to envision a new, more fulfilling way of life.

These two models of cultural change proved irreconcilable. The Depression focused the attention of radical artists on economic issues. The Communist Party addressed that problem with a theory (the writings of Marx et al.), an organization (the party), and a model (the Soviet Union). Always short on specifics themselves, it is no wonder that cultural radicals gave Marxism and the Communist Party serious attention. The primary interest of the Communists, however, for reasons both pragmatic and theoretical, was politics. Creative activity had to be subordinate to political goals. This policy conflicted with avant-garde insistence on creative freedom.

For cultural radicals in the United States, creative freedom was the essence of authentic vanguardism because freedom was the opposite of the bourgeois conformity that alienated the avant garde. Artistic innovation was predicated on the free imagination of the creator. Avant-garde self-expression was the means to the cosmopolitan, liberated future envisioned by vanguardists.

Communist Party leaders emphasized the artist's social responsibility rather than his or her creative freedom. Responsibility meant socially relevant art, in particular socialist realism, a type of genre art with a message that vanguardists rejected. Furthermore, the political agenda of

the Soviet Union came into conflict with both avant-garde and American values. American individualism, with its emphasis on political liberty, and avant-garde cosmopolitanism, with its hostility to war, could not support the Moscow trials, the Hitler-Stalin Pact, and Soviet militarism.

In the end, the Communist Party's conception of change through the dynamic of politics proved incompatible with the avant-garde vision of change through new ways of self-expression and perception. Artistic radicals wanted to look at the world directly, as Davis always argued, and respond in their art to what they saw without the limitations of political ideology. As poet Kenneth Rexroth wrote to Malcolm Cowley, "I don't believe ART should be solely or even principally concerned with the class struggle. . . . ART is mainly concerned with getting born, growing up, eating and drinking, fucking, getting an 'aim in life,' wishing you hadn't, dying." Thus, by World War II, the cultural radicals of the thirties came to reject the political radicalism of the Communist Party and returned to the historic vanguard theme of integrating art and life. In large part because of the experience of the 1930s avant garde, the next generation's vanguard would be fiercely independent, anarchistic in politics, and focused on transforming the individual, not society directly.[14]

Modernism Canonized

In the late 1930s, the New York intellectuals, disillusioned with the extant Marxist vanguard, reconstituted themselves in the cultural forefront by returning to the basic texts of the European and American avant garde of the 1910s and 1920s. By aligning themselves with a "high culture" tradition that critics such as Dwight Macdonald and Clement Greenberg defined as distinct from both low "mass culture" and the somewhat more refined "middle-brow" culture, the New York group separated themselves from American society and culture even as they identified with America's liberal political institutions as opposed to Soviet totalitarian politics.[15]

In this program, the New York intellectuals had allies in the so-called new critics. John Crowe Ransom, one of the founders of the new criticism, described the method as "more scientific, or precise and systematic" than the impressionistic, ethical, or historical approaches of traditional criticism. The new critics, represented in such journals as the *Kenyon Review* and the *Hudson Review*, and with a very different political and cultural pedigree from that of the New York intellectuals, shared an interest with the New York group in writers such as Henry James, Na-

thaniel Hawthorne, and, most important for our purposes, avant gardists such as T. S. Eliot, Franz Kafka, and Ezra Pound. The New York intellectuals and the new critics formed a cultural movement with a strong ideological "charter," to use historian Grant Webster's term, based on liberal, consensus politics and a "high" modernist aesthetic. This cultural charter received institutional support from periodicals such as the *Partisan Review* and the *Kenyon Review* and from the academic positions of many of the members.[16]

In the process of canonizing the historic avant garde, intellectuals transformed the vanguard from a movement for cultural renewal through the integration of art and life into another style period in European literature, called "modernism." This process was accomplished in several ways.

First, intellectuals canonized modernism by redefining the role of the avant garde in society. From the late 1930s through the 1940s, in the pages of the *Partisan Review*, the meaning of the avant garde changed as writers focused less on themes of innovation and cultural renewal and more on the role of intellectuals in conserving the gains of a narrowly defined high culture. In a 1938 essay, Rahv defined the role of the intellectual to be "the sphere of technical and spiritual culture." Rahv argued that intellectuals had the responsibility to cultivate cultural values, protecting the legacy of the past and seeing that culture continued to grow. The fruits of the past provided the energy for future development, so intellectuals had a somewhat contradictory role: "They watch over the hidden manna even as they consume it." But the *Partisan Review* writers also described the avant gardists as alienated from their society. Creative intellectuals could not count on having influence beyond a small coterie. The avant garde existed in a state of creative tension with society. Advanced artists formed a cosmopolitan community that served as guardian of human values, presenting a vision of the future to which people should aspire, and yet was incapable of actually leading humanity to that future. As Phillips wrote, "Envisioning the most far reaching ideals, the artist is, nevertheless, isolated from those forces which can realize them."[17]

Second, intellectuals canonized modernism by redefining avant-garde innovation in formalist rather than cultural terms. In 1948, for example, composer and critic Kurt List reviewed "The State of American Music" for the *Partisan Review*. List began his essay with a formalist account of musical aesthetics from Bach to the present, an account designed to show that Arnold Schönberg's twelve-tone polyphony presented the solution to

the technical problems faced by twentieth-century composers. "If music is to exist as an artistic expression of modern America," List concluded, "atonal polyphony is really the only valid guide." He mentioned Roger Sessions and Charles Ives as the best examples among American composers of what he had in mind. Of the emerging vanguard, he had little to say beyond dismissing the early work of John Cage as an "escapist . . . [and] regressive . . . reversion to Oriental techniques." List explicitly defined the task of the composer as continuing the evolution of European music within the framework of "problems" that the work of the past had left for the next generation. He expressed no interest in innovations that looked to a completely different music. Here was a model keeper of the canon.[18]

The formalist interpretation of art was advocated by the painters and sculptors associated with American Abstract Artists (AAA). The AAA was founded in 1936 by a group of mostly geometric abstractionists who felt alienated from movements more prominent in the New York art world of the day, specifically surrealism, regionalism, and social protest art. The primary goal of the organization was to sponsor exhibits of members' work, but they also assigned themselves the mission of educating the public about American abstract art through catalog and magazine essays. Perhaps the AAA's most indefatigable polemicist was painter George L. K. Morris, a founding member of the AAA and also a patron of and contributor to the *Partisan Review*.

The artists of the AAA defined themselves as avant garde, or as one catalog essayist explained, "in the forefront of aesthetic development," because their art returned painting and sculpture to their basic roots in color, form, and design. Morris explained this formalist view by arguing that Western artists, especially since the Renaissance, had explored the basic aspects of painting within a realistic framework until the nineteenth century, when the old formulas had been used to the point of banality. At this point, Paul Cézanne, Georges Seurat, and the cubists rescued painting by turning artists back to the basics, clearing the path, as Morris expressed it, for abstract artists "who have finally stripped painting down to its bones and thereby established foundations for a new beginning." Abstractionists, Morris declared, took art into the future by "attack[ing] the established conceptions of art itself."[19]

Morris's stance was similar to another *Partisan Review* editor and art critic, Clement Greenberg. Greenberg, however, did not believe that geometric painting was avant garde. He championed the new vanguard

painters, the abstract expressionists. Greenberg may thus appear to be an exception to the pattern of canonizing the work of the past. On closer inspection, however, he becomes the exception that proves the rule. In Greenberg's formalist aesthetics, the "modernization" process of art consisted in eliminating conventions from other mediums until the art, whether music, poetry, or painting, was pure. Applying this formula to painting, Greenberg wrote that in their paintings the abstract expressionists were "testing the limits of the inherited forms and genres, and of the medium itself, and it is what the Impressionists, the post-Impressionists, the Fauves, the Cubists, and Mondrian did in their time." Greenberg could account for abstract expressionist painting in this formalist fashion because he consciously and consistently dismissed the intellectual concerns of the artists themselves. In so doing, he completely misinterpreted and misrepresented what these artists understood themselves to be doing, but he was able to connect their work to the modernist canon.[20]

Canonical modernism resulted in part from the canonizers' response to their activist pasts. Having believed in the promise of a new world offered by the Communist Party and then felt betrayed by the totalitarian reality of Stalinism, the intellectuals of the Depression generation became suspicious of any program of cultural renewal. They interpreted the texts of the historic avant garde, with which they had come of age intellectually, as, in David Hollinger's phrase, "a set of suspicions" about human beings and human society rather than a world view. Intellectuals used these suspicions to question the verities of liberal society—human goodness, progress, middle-class morality—without having to take a stand on the truth of these suspicions. At the same time, by attacking the totalitarian suppression of the avant garde, intellectuals could affirm the liberal state. As a result of this process, intellectuals transformed the avant garde from a movement closely related to the surrounding culture to a highbrow movement suspended above culture, "*of* the world," as Hollinger notes, "but not *in* it."[21]

Canonical modernism also resulted from the institutional goals of the new critics. The new critics defined their method as intellectually rigorous and therefore most appropriate for the university setting. Ransom described the method as a complex one intended to be practiced by "learned persons," that is, technically trained experts, not gentleman scholars; "its proper seat," Ransom declared, "is in the universities." The practitioners were especially adept at using the method on the complex texts written by the first-generation avant garde. The new critics used the technical preci-

sion of their readings to justify bringing both the new literature and the new criticism into the university curriculum. In this way, the historic avant garde became another academic specialization.[22]

The success of this modernist-liberal synthesis was such that, in 1950, the editors of *Time* featured T. S. Eliot on the magazine's cover. The feeling of acceptance appeared to be mutual: Rahv and Phillips noted in their introduction to the famous *Partisan Review* symposium "Our Country, Our Culture" that American writers (with exceptions) no longer felt alienated from American society. The modernist avant garde had traveled a long way from its beginnings as a rebellion of alienated bohemians to stand at the center of contemporary culture. Literary historian James Breslin noted that "at mid-century, accepted, even celebrated by the Luce corporation, the modernist revolution might well seem to be finished."[23]

Indeed, throughout the immediate postwar years, many cultural commentators for journals such as the *Partisan Review* and the *Kenyon Review* expressed disappointment that the avant garde had been tamed even as they continued to canonize the works of the 1920s modernist vanguard. In 1946, for example, William Barrett, in a review of Frederick J. Hoffman, Charles Allen, and Carolyn F. Ulrich's *The Little Magazine: A History and Bibliography*, published by Princeton University Press, noted that "the very existence of this book shows the avant-garde has become institutionalized to the extent that the little magazine is now accepted as a more or less permanent sideshow in our culture." In 1951, Paul Goodman wrote about the avant garde in the *Kenyon Review* as if cultural radicalism were largely a thing of the past. A few years later, Greenberg seemed nostalgic for the rambunctious past of the avant garde, before its "acceptance by official and commercial culture." In 1958, F. W. Dupee, in a review of several recent poetry anthologies, lamented that none of the work was "conspicuously creative." Dupee characterized the writers as the "job-holding generation" and speculated that "the favorable—if that is the word for it—economic situation of recent years has affected the tone and substance of the poetry written by the young generation" whose subjects tended to be "home, wife, children, parents, pets, gardens," and such. Dupee missed the engagement with larger ideas, if not the experimentation, that had characterized the avant garde.[24]

The picture drawn by these critics of avant-garde institutionalization and predictability bore little relation to the facts, of course, as would become very clear by the end of the 1950s. This attitude indicated the preoccupation of the New York intellectuals and new critics with the

aesthetics of early modernism rather than with innovative artists of their own day.

The Last American Vanguard

From the mid-1940s through the early 1950s, the last American avant-garde movement came together. The Communist Party and Stalinist politics formed the context for this van's rebellion. Not all of these vanguardists had been party members, but most were aware of the debates that had divided cultural radicals in the 1930s. This advance guard differed from the previous generation in that the younger radicals refused to compromise the vision of a renewed culture. The new generation thus also defined itself as alienated from the canonizers of the older avant garde.

Some members of the new vanguard movement had been members of, or associated with, the Communist Party. Painters Mark Rothko and Adolph Gottlieb were members of the Communist Party-dominated Artists' Congress until the Soviet Union invaded Finland. Disillusioned, the painters broke with the movement. Beat writer John Clellon Holmes, in the years immediately after World War II, identified briefly with Communism. Holmes wrote that for him and others of his generation, "our youth, our passion, our betrayed idealism: the sum total of lives without real hope was poured into this belief in a better life." For Holmes, Marxism was inextricably linked to the Soviet Union. The 1948 coup in Czechoslovakia "severed" Holmes from the Communist movement, much as the show trials and Nazi-Soviet pact alienated the earlier generation. Now, Holmes saw Communism as pernicious, a kind of "intellectual disease." The "lucky ones" left "before they died spiritually." The flaw in Communist morality, Holmes decided, not with a great deal of originality, was the idea that the end justified the means. He also saw this immoral principle equally at work in the West and its anti-communist Cold War. As a result, Holmes lost all faith in politics. "I don't believe," Holmes wrote in the late 1940s, "that real justice can be legislated, that goodness and equity can be established merely by putting them on the statute books, and that human laws will always operate for the majority merely because you write them down Can we really live without hope based on reason? I only know that somehow we must."[25]

Critic Lawrence Barth agreed with Holmes, declaring that "human society cannot much longer stand the ravages of politics." Marxist parties,

he argued, were little more than cliques characterized by "trickery" and "hypocrisy" as they jockeyed for power among themselves. Barth compared radical parties to religious movements that oversimplified the world around them, becoming "non-realistic, anti-sexual, [and] anti-rational at [their] core." Critic James Courzen wrote that Marxist ideology, "in place of a needful righting of religious values," suppressed human personality and put in its place a "deified State" that took on the "guise of a punitive rather than loving god." Members of the avant garde rejected Marxist materialism as an insufficient answer to the problems facing human beings. Cultural radicals believed that Marxism, much like American liberalism and conservatism, did not go far enough in articulating a new anthropology and a new spirituality by which individuals and culture could be redeemed.[26]

Avant gardists also dismissed the social realist art that went, as they saw it, with Communist politics. In their view, the Marxist aesthetic was as spiritually bankrupt as its politics. To require of an artist political or social content was to block the creativity of the spirit and thus the possibility for real social renewal. Such an aesthetic created one more conformity in an age of conformism. Kenneth Rexroth dismissed proletarian literature as "the product of a sociology course and a subscription to a butcher-paper weekly." Poet Stuart Z. Perkoff joined the Communist Party while in high school in the forties. He also wrote love poetry in the style of Kenneth Patchen. Party officials told Perkoff that his subject matter was too personal and that he should stop writing such poetry. Perkoff quit the party. Painter Barnett Newman lumped social realist painting with American regionalist art and dismissed both as "commercial official art." Newman's friend, painter William Baziotes, agreed, declaring that "when the demagogues of art call on you to make the social art—the intelligible art—the good art—spit down on them—and go back to your dreams—the world—and your mirror."[27]

While vanguardists shared with the canonizers of modernism an antipathy to Communism, the two groups had little else in common. To most vanguardists, the canonizers were the enemy to be defeated. Writer and little magazine editor Oscar Collier carefully noted to editor Judson C. Crews that Collier's journal was "certainly not a partisan review [sic]." Kenneth Rexroth dismissively referred to the "Ku Klux Klenyon" and "the Bronx edition of the PMLA, otherwise known as the *Vaticide Review*." Painter Clyfford Still instructed his exhibitor, Betty Parsons, not to show his work to just anyone, explicitly stating that critics John T. Soby and

Greenberg and Museum of Modern Art curator Alfred H. Barr were not to see the paintings. Members of the avant garde repudiated any connection with the canonizers of modernism.[28]

What issues specifically alienated the postwar vanguard from the New York intellectual circle? Cultural radicals linked the latter to the academic culture of postwar America. Perkoff described literature published in journals such as the *Kenyon Review* and the *Partisan Review* as the "arch-rigid, over conscious, so carefully constructed verse of the English majors." Such writing was of the past, Perkoff wrote, it was not "living poetry" of the present or the future. Members of the avant garde recognized, without using these terms, that the project of the New York intellectual and new critical groups was to canonize the modernism of the teens and twenties. George Leite, a pioneering editor of the San Francisco Renaissance, wrote in 1948 that "the Red Beast articles in *Partisan* are almost word for word like those that appeared in *Hound and Horn* during the period when Phillips and Rahv were whining at the door of the John Reed Club and barking at the intellectual reactionaries." Leite, like other vanguard editors, believed the decade of the 1940s was a "new world" and that art had to develop in new directions.[29]

To call the modernist canonizers academic was, for the members of the avant garde, another way of saying that the canonizers were an integral part of the techno-bureaucratic conformist culture that avant gardists opposed. Vanguardists believed that modernist intellectuals possessed a false value system. In 1954, editor and writer Leslie Woolf Hedley voiced these concerns in a review of a book by Russell Hope Robbins called *The T. S. Eliot Myth.* Hedley maintained that the volume deserved attention because Robbins exposed the dangerous, reactionary influence of Eliot and the "intellectual . . . clerico-fascism" he represented, especially on "our younger, conscripted generation." The popularity of Eliot, and the modernist canonizers who promoted him, signaled to Hedley "the breakdown of both moral and philosophical values among writers today." The outcome of this collapse of values was clearly stated by Robbins: "the suppression of all creative activities, . . . and the abandonment of the mainstream tradition of culture and enlightenment." Here Hedley voiced almost all the themes that defined the alienation of American avant gardists in the years after World War II: the belief that the social and political system tended toward totalitarianism; that avant-garde innovation was becoming ossified in the academy; and that many, if not most, intellectuals acquiesced in this process. Declared the editor of *Neurotica,*

"As we see it, the little literary magazine is dead. The 'little mags that died to make verse free' have been replaced by subsidized vehicles for clique poetry, critical back-scratching, and professional piddle."[30]

The ideas about aesthetics and the relation between art and society that defined the avant-garde canonizers and the true cultural radicals were so different that the two movements could hardly communicate with each other. Literary historian Grant Webster uses the concept of paradigms as formulated by historian of science Thomas Kuhn to explain the conflict between rival vanguards. A paradigm is a framework of values and inter- pretation. When paradigms come into conflict, adherents of one para- digm will be unable to communicate with adherents of another. Avant gardists believed that their opponents did not understood what the inno- vators were doing. The academic "creeps," Allen Ginsberg wrote, "wouldn't know poetry if it came up and buggered them in broad day- light." The estrangement between the two groups is sharply demonstrated by Norman Podhoretz's denunciation of the Beats as "Know-Nothing Bohemians," published in the *Partisan Review* in 1959. "The plain truth is," Podhoretz declared, "that the primitivism of the Beat Generation serves . . . as a cover for an anti-intellectualism so bitter that it makes the ordinary American's hatred of eggheads seem positively benign." Furthermore, he continued, "This is the revolt of the spiritually under- privileged and the crippled of soul." After reading Podhoretz's essay, Ginsberg wrote to his friend Peter Orlovsky, "Saw Partisan review [sic] attack on us, goofed up, long as enemies bullshit like that we're awright." Even when critics sympathized with new work, they did not seem to understand what the vanguard artists were doing. Poet Robert Duncan described a conversation with Greenberg in which Greenberg was "en- thusiastic" about a Duncan essay published in Macdonald's *Politics*, but Duncan concluded that "what I actually wrote was nothing that he read." This inability to communicate may explain why, as Rexroth observed, the New York intellectuals could talk about the end of the avant garde and then "visit . . . the Gotham Book Mart and pick up a copy of the *Hudson* or *Kenyon Reviews* and literally not see all about them the dozens of little magazines . . . full of free verse and anarchism, but so it was."[31]

Conclusion

The members of the avant garde desired to enliven the arts with a vital aesthetic, and by so doing to enliven society. From the avant-garde

perspective, the moral sense of the American people was dead and needed quickening to prevent a physical death in nuclear war. The differences between the older generation and the new vanguard are apparent in an exchange of letters between Macdonald and Ginsberg in 1964. The context of these letters was a discussion of the merits of the avant-garde films of Jonas Mekas and Jack Smith, especially the latter's *Flaming Creatures*, which was involved in an obscenity case. Ginsberg wrote to Macdonald that "there's no political revolution possible in USA[.] There *is* possibility of an artistic revolution and consequent revolution of mental consciousness and bodily feelings[, and therefore,] political change." This remark prompted Macdonald to note a distinction between their two views:

> You [Ginsberg and Mekas] are moralists, reformers, rather than artists. What you're after is a better way of life, and so you accept a movie like *[Flaming Creatures]* . . . because it exemplifies your morality of free personal expression. But you can have f.p.e. without art. . . . Living free is one thing, creating a work of art is another. . . . Art has to be controlled, ordered, arranged in patterns, rhythms, all very artificial and unfree.

Ginsberg responded, "I have written some poetry of 'controled [sic] arranged order' so unique it was unrecognizable for several years as poetry by the guardians of order of an ancien regime." Reiterating the by-now standard avant-garde critique of academic culture, Ginsberg described this "ancien regime" as "imitative of earlier poetry" and attached to methods of versification "already decayed when Ezra Pound went to London." Ginsberg reaffirmed his commitment to an aesthetic of spontaneity and individuality ("intuition and character") and concluded, "As for your idea of me as a moralist, . . . it[']s charming, but don't get carried away. I just don't want to see the planet go up in a cloud of sexless hydrogen."[32]

Committed to the integration of art and life, avant gardists like Ginsberg sought a vital and expressive aesthetic and a new relation between art and society. These goals did not appear to the members of the last American vanguard to be the goals of the New York intellectuals. The latter group appeared, to cultural radicals, to be the aesthetic expression of the values of a society from which the advance guard was highly alienated. Alienation was the negative ground from which the vanguard sprang, but these radical artists also developed a positive definition for themselves. These positive values they expressed in their ideology of innovation and their vision of the future.

The American Avant Garde
1945-1960

.

.

.

.

.

.

Alienation

.

.

.

.

.

.

I
n a 1956 poem entitled "The Suicide," Stuart Z. Perkoff noted that in the aftermath of such a tragedy, the question asked out loud was always "Why did he do it?" But Perkoff argued that the most important question remained unasked, festering inside and "rotting the soul." That question was: "How? Could I?" Suicide is one expression of an individual's alienation from self and from society. Perkoff suggested that everyone in contemporary society repressed a great deal of alienation from the modern world. Perkoff was not alone in this belief: other members of the postwar avant garde were deeply alienated from the society in which they lived.[1]

Renato Poggioli described avant-garde alienation as a "sociopsychological condition" related to the artist's economic and social status as well as the intellectual's attitude toward her or his culture. Members of the postwar American van were aware of their alienation and of the historical meaning of their condition. Kenneth Rexroth, for example, discussed the

estrangement of the artist as a product of industrial capitalist society: "[From] Baudelaire, Blake, Holderlein, down to T. S. Eliot, Voznesensky, or Allen Ginsberg, every important poet since the rise of acquisitive, competitive modern society has been alienated to a greater or lesser degree." Alienation was not, however, Rexroth contended, the typical experience of American poets throughout most of the nineteenth century. Only when the nation was heavily industrialized, Rexroth said, could there emerge a strong community of alienated avant gardists.[2]

Indeed, in 1948, critic Clement Greenberg declared that "the alienation of Bohemia was only an anticipation in nineteenth century Paris; it is in New York that it has been completely fulfilled." In 1959, painter Jack Tworkov, a member of the avant-garde Eighth Street Club in Greenwich Village, wrote in It Is that Paul Cézanne was "the very image" of contemporary artists. In particular, Tworkov wrote, the French painter was an "alienated intellectual" who was profoundly interested in the question of meaning and was uncomfortable in the presence of those who "got along" easily in life, and in particular of those people whose "religion" was to "get on in the world." In contrast to this worldly attitude, the alienated artist was one "who in his innermost center has a fierce pride and sure conviction about the values of the artist in the world."[3]

Members of the avant garde believed that this "worldly" attitude of which Tworkov wrote was an indication of how divorced modern Americans were from the real world. Cultural radicals believed that in contemporary American society people were separated from the worlds of nature, human community, and the spiritual self. Rexroth wrote that "as human beings grow more remote from one another, they become more like things than persons to each other. As this happens, the individual becomes remote from, loses, himself. First alienation from comradeship in the struggle with nature, then alienation from each other. Finally self alienation." Vanguardists believed that values in Western culture had become so attenuated that societies faced "material and spiritual disintegration."[4]

American cultural innovators experienced this alienation in various ways, but the bomb serves as a key theme around which they expressed their alienation. The bomb, a product, according to members of the advance guard, of bureaucratic technology in the service of a bankrupt political ideology, seemed to be the ultimate folly of rationalistic, industrialized capitalist society. The bomb threatened not only the cultural, aesthetic, and ethical ideas of the avant garde, but also the existence of humanity itself.

The vanguard also criticized the United States as a conformist society. Cultural radicals described a "spirit of the age" that molded individuals to a materialist success ethic and a narrow Cold War political ideology. Such concerns reflected a historic avant-garde interest in individualism. For these reasons, then, members of the vanguard felt deeply alienated from American society. But estrangement produced a constructive result for cultural radicals: the state of alienation strengthened their resolve to create a new cultural landscape in which art and life would be integrated and from which no one would be estranged.

The Bomb, Technology, and Progress

Writing in the mid-1950s, William Carlos Williams pondered the meaning of the atomic bomb. In his long love poem, "Asphodel, That Greeny Flower," he wrote,

> I am reminded
> > that the bomb
> > > also
> is a flower
> > dedicated
> > > howbeit
> to our destruction

Williams noted the fascination, almost religious awe, that the exploding bomb had for people, and he transformed the bomb into a symbol for humanity's destructive acts from the Salem witchcraft trials to book burnings to environmental desecration. For Williams, the bomb brooded over the world, exercising a malignant influence in history. Williams presented a choice between the creative influence of love and the destructive influence of the bomb. "There is no power" he wrote, "so great as love / which is a sea, / which is a garden." Unfortunately, he concluded, few people really believed this: "they believe rather / in the bomb / and they shall die by the bomb."[5]

Williams was, of course, one of the leading figures in the first-generation American avant garde, but he was also an important influence on many post-World War II vanguardists. The bomb, too, was a pervasive influence on these cultural radicals. Writer Douglas Woolf chose an apt title for his little magazine review of Donald Allen's 1960 anthology, *The New American Poetry:* "Radioactive Generation." In particular, the bomb heightened the sense of social alienation felt by members of the avant

garde. In his participant-observer history of twentieth-century American poetry, Rexroth noted that the bomb had "permanently shattered the crust of custom" and "made all but the most insensitive alienated at least a little." Williams's poem presents themes that weighed on the minds of most advance-guard intellectuals in the years after Hiroshima and Nagasaki. Members of the avant garde came to doubt the idea of progress, especially technical and scientific progress, and they feared for the very future of humanity. Radical intellectuals also expressed a sense of powerlessness before the new technology and its attendant bureaucracy.[6]

The members of the postwar van were not the first cultural radicals or intellectuals to question the idea of progress. As historian Spencer Weart notes, nuclear weapons did not create an entirely new, post-Hiroshima culture. Rather, people responded to the bomb within intellectual categories formed in the past. Thus, intellectuals responded to the bomb within a framework of anxiety and despair that dated from the beginning of the century. These feelings resulted from many causes: the impersonal universe described by Newton, Darwin, Marx, and Freud; the collapse of religious belief in response to these thinkers; the failure of the values of humanism to prevent World War I. W. H. Auden had other reasons besides the bomb to call the years at mid-century the "Age of Anxiety." The bomb was, however, the perfect symbol for this anxiety and most discussion of the topic in the years after 1945 made some reference to the bomb, however brief or stereotypical.[7]

Rexroth described his own increasing feeling of hopelessness from the 1920s forward. For Rexroth, the lights of progress and hope that had burned so brightly in the first quarter of the century began to dim with the executions of Sacco and Vanzetti in 1927. The Moscow Trials, the Spanish Civil War, the Hitler-Stalin Pact, the war and concentration camps—all these dimmed further the light of hope. "Now the darkness is absolute," he concluded. "In the blackness," Rexroth wrote, "well-fed, cultured, carefully shaven gentlemen sit before microphones at mahogany tables and push the planet inch by inch towards extinction." It was this link between an educated and cultivated elite and atomic annihilation that more than anything explains the depth of alienation felt by postwar avant gardists from their society, whether from its institutions, such as the academy, or from its values and mores. To cultural radicals of the 1950s, a vanguardist underground was vitally necessary.[8]

Some commentators tried to use the new physics to construct positive metaphors for innovative art, not unlike the promoters of the peaceful

atom in the U. S. government and nuclear power industry. In 1951, for example, critic Peter Blanc, writing in the mainstream *Magazine of Art*, drew on ideas from modern physics to explain recent avant-garde art. Blanc related the paintings of surrealists Arshile Gorky and Joan Miró to Heisenberg's uncertainty principle, and defended the work of abstract expressionists Jackson Pollock and Willem de Kooning by describing their paintings, not as expressions of (as critics charged) "spiritual confusion" or "lack of humanity," but as pictures of movement that recognize that "energy and void" are the only reality. "It is the paradox of art today," Blanc concluded, "that what is still known as *realism* is actually an escape from reality."[9]

Most members of the avant garde were not disposed to such arguments. From the avant-garde perspective, the influence of science and technology was as likely to destroy life and curtail individual freedom as it was to improve life and expand freedom. Soon after the first use of the bomb, critic Dwight Macdonald wrote in his journal *Politics*, " 'The greatest achievement of organized science in history,' said President Truman after the Hiroshima catastrophe—which it probably was, and so much the worse for organized science." The result of technological progress was a weapon whose power threatened the very existence of civilization. "The bomb," Macdonald declared, "is the natural product of the kind of society we have created." Macdonald argued that in a society that associated the good life with mass-produced consumer goods and technological conveniences, the citizenry willingly abrogated great power to the organizations that produced these goods without questioning the consequences for moral decision making in a democratic society.[10]

Members of the avant garde rejected the notions of progress that they perceived to be prevalent in postwar society. In 1960, Beat poet A. Pankovits wrote in a poem called "Progress": "I am not only going to stand in the way of progress. / I am going to stick out my foot as it runs past." Painter Morris Graves declared that his work was not for those who were comfortable in the new atomic world: "Those who seeing and tasting the fruits and new buds of self-destructive progress [and] still calling it good, to them the ideas in the paintings are still preposterous, hence not worth consideration." The reality of the bomb meant that belief in technological progress was not just fatuous, it was positively dangerous.[11]

In 1959 poets and critics Robert Bly and William Duffy argued that, in both the Soviet Union and the United States, the scientific outlook, "with its passion for experiment[,] . . . its confusion on moral issues, [and

indifference] . . . to human suffering," was becoming much too powerful. "Unless," they concluded, "these men are fought, in their inquisition millions will die." Painter Clyfford Still wrote that he did not want to express the spirit of his age in his paintings because "our age—it is of science—mechanism—of power and death. I see no point in adding to its mammoth arrogance the compliment of homage." Novelist William S. Burroughs, who had been a student at the Los Alamos Ranch School a few years before the government acquired the institution and turned it into a bomb laboratory, felt a special connection with the bomb. He noted how the "idyllic Ranch School, an outpost of the pastoral dream" (and where Burroughs had been miserably unhappy) had been "commandeered by a government agency for a team of foreign-born scientists who gave away their secrets of mass destruction to the generals and politicians." Burroughs forthrightly declared himself "anti-scientist," maintaining that "if anybody ought to go to the extermination chambers . . . [it should be] scientists."[12]

The mushroom cloud also cast a great shadow over the future of humanity. Many avant-garde intellectuals, like others at the time, believed that nuclear war would be the likely end of Western culture. Journal titles from the 1940s and 1950s such as *Death: A Literary Quarterly* and *Hearse* illustrate this fear. The editors made their concerns explicit. In 1948, a writer in *Neurotica* declared that "the new look is the anxious look." In 1950, Leslie Woolf Hedley, the editor of *Inferno*, also expected an apocalypse: "Unfortunately, we're all waiting for the explosion. If you find a tinge of that terror and death on these pages, it's a sign of the times." "Hearse is not a hobby nor an intellectual game," wrote the editor of the magazine, E. V. Griffith, in 1954. "It is a serious attempt on the part of seriously-minded editors to get as much good work into print as possible, as we await The Bomb." Poet Kenneth Patchen characterized himself as a poet "for a generation born in one war and doomed to die in another."[13]

At times members of the avant garde, like other Americans, feared that nuclear war was imminent. In 1958, poet Allen Ginsberg wrote to his lover, Peter Orlovsky, "It looks like war, maybe in the next week or if not the next months. It may be atomic war so be wise to get out of large cities." In 1961 and 1962, San Francisco artist Bruce Connor left the United States because he feared the coming nuclear war.[14]

Rexroth argued in his history of modern American poetry that an "eschatological world-view" was typical of the first-generation avant

garde. Poets from Arthur Rimbaud to T. S. Eliot, Rexroth noted, believed in the imminent end of Western civilization. But the end of civilization did not mean the end of the world, and, as Rexroth pointed out, such anxieties had a certain "neurotic character." They raised the question, Was a decline really happening? The bomb, argued Rexroth, changed everything: "eschatology has ceased to be a world-view, it has become a simple fact with which every living person must reckon." In 1945, painter Barnett Newman wrote, "After more than two thousand years we have finally arrived at the tragic position of the Greeks . . . because we have at last ourselves invented a new sense of all-pervading Fate." Coming to terms with the bomb and the society that created this threat redefined avant-garde alienation.[15]

The Bomb and the Avant-Garde Moral Vision

Members of the avant garde have generally been deeply interested in questions of moral values. Typically, avant gardists rejected the prevailing moral standards, leading critics to accuse them of immorality. But far from being immoral, members of the vanguard strove to shape a life-affirming and life-sustaining morality to replace what they perceived to be a restrictive and stultifying system. The atomic bomb threw into sharp relief a number of important moral questions. The use of the bomb by the U. S. government caused many vanguard intellectuals to doubt the morality of the whole Allied cause in the World War II. Macdonald compared the use of the bomb on the Japanese to the Nazi death camps and concluded that neither side in the conflict could now claim moral superiority.[16]

Members of the avant garde believed that individuals should have the power and freedom to make moral decisions. The development and use of the atomic bomb suggested to them that individuals played only a limited role in modern, bureaucratic, technological society. Macdonald, again, articulated this concern. He noted that the bomb was the product of group effort, that many involved were highly educated scientists, and that all were dedicated to the cause of defending democracy. But, Macdonald pointed out, most of them knew very little about the complete project or how their contribution would fit into the whole. Further, the American public, Macdonald argued, knew nothing of the new weapon that was developed and subsequently used in their name. Where then, Macdonald asked, did moral responsibility lie? He concluded:

> The bomb becomes the most dramatic illustration to date of the fallacy of "The Responsibility of Peoples." . . . The social order is an impersonal mechanism, the war is an impersonal process, and they grind along automatically; if some of the human parts rebel at their function, they will be replaced by more amenable ones; and their rebellion will mean that they are simply thrust aside, without changing anything.

In a technological society, the individual seemed to be impotent before giant organizations with their own imperatives.[17]

The reality of the bomb, cultural radicals argued, changed the entire moral context of modern life. The basic dilemma, from the avant-garde perspective, was well expressed by the editors of *Death* in 1946: "It seems to be much easier today for man to decide how he is going to destroy himself than how he is going to live." Americans seemed, in the opinion of vanguardists, to have been "struck blind, deaf and dumb" by the bomb, and thus they turned to old answers—in particular, military answers—to solve new problems. As the Cold War developed, members of the avant garde believed that morality was becoming militarized. In 1958, Ginsberg wrote in a poem fragment:

> *The army is trying to*
> *Blast fire at god's face*
> *How many cannons*
> *are pointed up into*
> *the sky at night.*

Avant gardists such as Ginsberg attempted to communicate a more peaceful vision.[18]

Advanced artists and intellectuals believed that they could help Americans plot a new moral course, but they also believed that few people wanted to hear their voice: "America, you know, pathologically hates poets," wrote Hedley in *Inferno* in 1950. He concluded: "America loves generals and whores like that." Rexroth, writing to Macdonald, a few months after the first atomic bombs were dropped, was discouraged: "Man's universe of pseudo-values is finally, literally, about to destroy him. Only those who rebuild from the personal, responsible core out, of materials that the bursting of all the atoms in the universe cannot destroy, will be, as the old word has it, saved. I think it highly unlikely that they will . . . have any influence on history."[19] Members of the advance guard believed that the people of the United States, and of the world, needed the vanguard message before it was too late.

Atomic Art

Avant-garde writers and artists tried to respond creatively to the bomb but, like other intellectuals at the time, often could go no further than a superficial symbolism. Some cultural radicals tried to appropriate the bomb as a symbol for their social criticism. For example, in late 1947, in painter Robert Motherwell's and critic Harold Rosenberg's little magazine, *Possibilities,* Paul Goodman published a surrealist allegory called "The Emperor of China" about the dehumanizing nature of modern society. One character was a "hellish wizard" described as having "made his excrement into missiles" and as "destroying those who love him. . . . They are drowned in the searing piss, beaten by his penis, and jumped on up and down." Goodman grafted nuclear fears uneasily to a Dantesque vision.[20]

Other artists tried to express their moral outrage at the bomb. In 1946, a show at the Museum of Modern Art of "14 Americans" featured a painting by Boris Deutsch, "What Atomic War Will Do to You." Parker Tyler, reviewing the show in *View,* noted that the painting had won a competition sponsored by a cola manufacturer and commented sardonically that "evidently, not only Pepsi-Cola 'hits the spot.'" Tyler went on to describe the stylistic similarities between Deutsch and Pablo Picasso and to ask, "Is it not the sibylline implication of the painting that the horrid violence of the atom bomb may succeed in converting us all, quite literally, into 'Picassos' and such?" As these examples suggest, the immediate artistic responses of avant gardists to the bomb were forced and superficial. The bomb was a difficult symbol both because it was beyond the realm of artists' direct experience and because its destructive power seemed to point only to the end, not to the future.[21]

Some writers tried to put the new weapon in perspective by contrasting the innocence of children with the destructive power of the bomb. Little magazine editor Judson Crews's 1955 story "Atomic Bomb Cathedral" presents a dreamlike description of the narrator entering a deserted city. Deep inside the crypt of an abandoned cathedral he finds a playground full of maimed children going about their games in rags. Realizing he can do nothing for them, and sensing that the place will soon blow up, he flees as the city disappears in "dull gray mushroom smoke" and the sky fills with radioactive embers. The story concludes:

The Atom bomb cathedral.
A. B. C.
I am conscious as I awake that these are the initials of my infant daughter
screaming terror in the night."

James Boyer May's 1950 poem "Return to Pelagianism" refers to the
destructive power of the bomb and of science and technology in general.
But May concludes with some hope, referring to a child "snug" in bed,
"prepared to counter nuclear physics," offering the possibility that the
next generation might be able to envision, and perhaps create, a new
world.[22]

Beat poet Gregory Corso was one of the early experimenters in the
satirical approach to nuclear fear in his 1958 poem "Bomb." In his poem,
printed in the shape of a mushroom cloud, Corso described the bomb as
the "Budger of history Brake of time You bomb / Toy of universe."
"O Bomb I love you," Corso declared, and continued, "I sing thee Bomb
Death's extravagance Death's jubilee." Such lines as "BOOM ye skies
and BOOM ye suns / . . . ye days ye BOOM / BOOM BOOM," and his
final vision of the "magisterial bombs wrapped in ermine . . . / fierce with
moustaches of gold" proved too much for some audiences. After reading
the poem at New College, Oxford, Corso was pelted by shoes from the
feet of members of the Campaign for Nuclear Disarmament, who also
called Corso a fascist. Though Corso regarded the poem as his best to
date and "timely," the Oxford experience caused him to doubt the wisdom
of his humorous approach.[23]

The profound anxiety about the future felt by members of the avant
garde in response to the bomb increased their alienation from postwar
American society. But this sense of anxiety and alienation also resulted in
innovative work that proclaimed the hope of cultural radicals in the
possibility of the future.

Conformist or Individualist?

The characterization of the 1950s as a time of conformity is a stereotype
dating from the decade itself. As early as 1950, sociologist David Riesman
described the loss of individualism before institutional pressures in his
influential book *The Lonely Crowd*. In 1954, critic Irving Howe declared
the postwar years an "Age of Conformity." Historians have since noted
that, while conformity may have been a part of the culture of the decade,
it was far from the only characteristic. The burgeoning civil rights move-

ment and the existence of the avant garde both indicate that the culture of the 1950s was more complex than the stereotype suggests. Indeed, the avant garde was one source for the stereotype.[24]

Members of the cultural vanguard experienced the years immediately following World War II as stifling to the individualist spirit. This theme was explored humorously in an essay by S. E. Laurilla on men's clothing of the 1950s. Writing in the little magazine *Miscellaneous Man* in 1956, Laurilla described "the average man [as] dark brown and gray . . . ; without adventure; lifeless," indeed downright "*dull.*" Laurilla went into great detail describing and ridiculing men's clothing styles, especially in comparison with the freer and more colorful clothing worn by women. According to Laurilla, the dreary clothes that men believed they had to wear restricted both movement and spirit. He concluded by looking to a future when people could "breathe freely in the knowledge that men really are men without the necessity of proving it, and concentrate on making our whole lives a work of art in other ways too, besides clothing." Laurilla thus linked anxieties about gender and status to a group behavior (fashion) that he viewed as inimical to individual expression and freedom. The concluding call to integrate art and life is, of course, an historic theme of the avant garde.[25]

Other members of the vanguard expressed their alienation from a conformist culture. In 1954, James Boyer May, editor and champion of little magazines, declared that these publications represented "life-versus-death" and "creative individualism versus patterned group dogmas." In 1953, editor E. E. Walters said that the purpose of his magazine, *Embryo*, was "to serve as a medium of conveyance for the expression of those few who refuse to be thwarted by demands for complacence and conformity." In 1961, writer David Meltzer contended that people feared "self-freedom" and thus could "only move as directed by paranoid monkeyhouse kings." From fear came conformity and a citizenry destined to be "food in power's pigpen." In the opinion of these and other members of the avant garde, the people around them conformed their behavior to a set of prescribed norms that included consensus politics, militarism, traditional bourgeois sexual ideas, and economic materialism. From the vanguard perspective, this conformity stifled the spirit of individuality that was the source of creativity and originality—the very spirit, indeed, of life.[26]

In order for a society to be conformist, there must be something to which people conform. "To what does one conform?" Howe asked in his essay, and he answered: institutions, the needs of daily survival, and,

especially, "the *Zeitgeist*, that vast insidious sum of pressures and fashions." Norman O. Brown declared in 1961 that "the Western consciousness has always asked for freedom: the human mind was born . . . to be free, but everywhere it is in chains. . . . It will take a miracle to free the human mind: because the chains are magical in the first place." The conflict between the independent individual and the conformist pressures of society was the starting point for avant-garde critiques of American materialism, technocracy, Cold War politics, and academic culture.[27]

Avant-gardists criticized what they regarded as their conformist society in part as a response to nuclear weapons. The moral outrage and downright fear that the bomb inspired in radical intellectuals was in sharp contrast to the general agreement among Americans that the use of the bomb was justified and the acceptance by Americans of the postwar arms race. In the face of what many radical critics believed to be the moral challenge of the century, most Americans appeared content to accept things as they were. Such complacency was repugnant to members of the avant garde. Rather than thinking, Americans appeared to be conforming to whatever opinions those in authority presented them.

Other developments in postwar American culture gave support to the vanguardist description of a conformist society. The stifling of political dissent as a result of the second Red Scare was a concrete example, to cultural radicals, of the practice of politics when citizens behaved as pliant conformists. Avant gardists also argued that the economic expansion of the postwar years (not unrelated to the Cold War militarization of American society) encouraged conformity. As far as these critics could see, the only ambitions shared by Americans in the 1940s and 1950s were to find a good job in some corporate bureaucracy and buy a house in a ticky-tacky suburb. Such goals, of undeniable importance and moral value to many Americans, were unworthy of human ambition in the opinion of the radical vanguard.

Furthermore, these cultural critics saw conformity in the technical bureaucracies of big science and the growing universities. As scientists organized to build more bombs, university humanists institutionalized modernism as a new scholasticism. According to cultural radicals, once the initial anxieties that attended the launching of the Cold War had passed, the American public allowed themselves to be soothed by President Eisenhower and members of the Atomic Energy Commission, and they turned to the pursuit of private agendas of career and suburban home ownership. The avant garde's attacks on materialism, technology

and bureaucracy, the politics of the Cold War, and academic culture, were, among other things, specific aspects of a more general attack on conformity. As poet Amiri Baraka recalls, the postwar avant garde "came out of the whole dead Eisenhower period, the whole period of the Mc-Carthy Era, the Eisenhower blandness, the whole reactionary period of the fifties."[28]

For members of the advance guard, the conflict between the individual and the demands of society for conformity was of vital importance. One could only discover one's true self, they argued, through creative non-conformity. This explains, for example, the interest of the Beat writers in the various undergrounds of jazz, madness, and homosexuality. That Ginsberg's poem *Howl*, which dealt with these subjects, should be de-clared obscene by authorities in San Francisco in 1957 only served to demonstrate his point that American society was repressed and tyrannical. The judge's ruling that the book was not obscene was a victory for Ginsberg and his publisher, Lawrence Ferlinghetti (who was the one actually on trial), which might indicate that American society was less oppressive than vanguardists thought. And yet the acquittal was not en-tirely a surprise to avant gardists. Beat poet Corso, for one, had great confidence that the future was theirs, and he wrote to encourage Ferlingh-etti, saying, "What you are going through is marvelous, young, true, great—the philistines can't win out—you will win. . . . Thus, fight on! go forward, for forward is the Light!"[29]

Alienation from Tradition

The same desire to escape the limitations imposed by the past that moved the first avant gardists motivated members of the postwar van to innovation. The past most had in mind was the Victorian world. For example, in 1947, painter Jean Franklin wrote that the Victorians tried to protect themselves from the "unhappy realities of the Industrial Revolu-tion by establishing an ideal of behavior completely unrelated to life" and created in the process a "foolish muddle" of values and ideas that im-peded, among other things, "the growth of a new and vigorous artistic expression." Franklin thanked the intellectuals of the interwar years for their "iconoclastic attitude toward the existing social structure," as a result of which, Franklin said, "the damp Victorian fog has lifted." In 1946, poet Oscar Collier described the nineteenth-century German avant-garde philosopher Friedrich Nietzsche as a model for cultural radicals because

"socially conscious, he had the good sense to examine, and when he found stupidity, to destroy. Is that a terrible thing to do? I think it is good to be terrible then, and long may terrorism live."[30]

The iconoclasm of avant gardists extended to any tradition that they believed placed limits on their creativity. Thus, many radical painters rebelled against the Renaissance heritage. Mark Rothko spoke of "breathing and stretching one's arms again" after he "escaped" the "oppressions of the Renaissance heritage." Choreographer Merce Cunningham linked the linear staging of classical ballet to Renaissance perspective and celebrated the origins of modern American dance in German expressionism and the personal experience of American vanguard dancers in the first half of the twentieth century. Each cultural radical, however, defined "tradition" for him or herself. In each case there was a past to reject, and avant gardists intended their innovations to knock down that past, sweep the rubble away, and begin a new building process. Sculptor David Smith spoke for most avant gardists of the postwar generation, and indeed of all avant-garde generations, when he declared, "This is the greatest time to make art. I enjoy watching the world crumble and the old values go down. Why shouldn't I enjoy it? This is my time!" The members of the avant garde saw the future of humanity in individual self-realization through creativity. This hope was the positive impulse behind their critiques of postwar American society.[31]

Alienation as a Positive Force

Alienation describes the relationship between the avant-garde intellectual and his or her society. But it describes more than simply a negative or destructive attitude. As Poggioli notes, the characterization of the avant garde as a "culture of negation" is accurate in the general sense that members of the vanguard are estranged from the values and traditions of bourgeois culture. The advance guard must not, however, be interpreted as being opposed to culture in general. Rather, he argues, two "parallel cultures" are in conflict, and "as a minority culture, the avant-garde cannot get by without combating and denying the majority culture it opposes." The goal of the vanguard is a new culture, "hence, [the avant gardist's] dreams of reaction and revolution, his retrospective and prophetic utopias, his equally impossible desire to inaugurate new orders or to restore ancient ones." Observers from among the avant garde agreed. Painter William Baziotes declared in 1957 that alienation was "a positive

force" in avant-garde creativity. In 1958, James Boyer May contended that "true poets" need "opposition/s," arguing that "the creative 'motor' of every psyche is powered by resistances, the charged statements which carry the current endlessly negating conformist death." Also in 1958, Philip Whalen made the point in verse:

I can't live in this world
And I refuse to kill myself
Or let you kill me
.

I shall be myself—
Free, a genius, an embarrassment
Like the Indian, the buffalo
Like Yellowstone National Park.

Alienation functioned, therefore, as a kind of negative ground out of which radical innovations grew.[32]

Alienation also freed cultural radicals from conformity to critical expectations and the weight of art and literary history. They were, as Poggioli said, "cursed in [their] alienation" but also "blessed in [their] liberty." In 1949, Clyfford Still told his exhibitor, Betty Parsons, that his paintings were distinguished by their discontinuities with accepted standards of painting. This, Still believed, alienated the pictures from art history and prevented their appropriation as "Culture." Members of the advance guard did not desire to be a part of a tradition or to produce conventionally uplifting work. Free from the past (as expressed in present expectations), members of the avant garde were, in Rosenberg's phrase, "aesthetic Legionnaires." In 1947, he characterized painters such as Motherwell, Baziotes, and Adolph Gottlieb as coming "from the four corners of this vast land" to "plunge themselves into the anonymity of New York" and carry on their own "private revolt against the materialist tradition that . . . surround[ed] them." Alienation separated the cultural vanguard from their community and from the values and traditions that defined that community. In this way, members of the avant garde created something new.[33]

The result of the extreme isolation and loneliness (the "curse" of alienation) that Rosenberg described was not negative, however, but rather "a kind of optimism, an impulse to believe in their ability to dissociate some personal essence of their experience and rescue it as the beginning of a new world." Avant gardists turned inward and transformed

their private struggles into public expressions of universal experience and truth. In 1947, Rothko wrote that "the unfriendliness of society to his [the painter's] activity is difficult for the artist to accept. Yet this very hostility can act as a lever for true liberation. Freed from a false sense of security . . . transcendental experiences become possible." In 1958, painter John Ferren recalled the freedom many of the innovative painters of the Eighth Street Club felt as a result of their isolation. "Well, we don't sell anyway," they said, "so why not?" Ferren explained:

> In short, by accepting our isolation we acquired its rewards. We were alone with ourselves; we painted by ourselves, and in some degree we became better acquainted with ourselves. Our complete divorce from the official art world, from magazines and the museums—in a word, our hopelessness— gave us the possibility of unknown gestures. The "crazy," the "gone," had no terror for us. We were in limbo. It was in this situation that Pollock kicked over his first can of paint . . . picked it up . . . saw the drip, and saw that it had an expressive power he could use.

Alienation freed vanguardists for innovation.[34]

Ferren's Eighth Street colleague, Baziotes described public acceptance as a cause for despair. The "miracle" of being "*loved* by a whole country, or embraced by his enemies" probably indicated, Baziotes said, that an artist had lost passion or become complacent. Estrangement, he argued, made the artist "more aware of himself and the world. It is as natural and necessary for his advancement as the use of his eye and brain." For members of the avant garde, the state of alienation did not make for an easy life, but artists channeled this negative energy to creative purposes. Vanguardists believed that creative self-expression was essential to authentic human existence.[35]

Conclusion

For a previous generation of American avant gardists, to be new meant to reject America for Europe. In accordance with a long tradition of expatriation, cultural radicals like Ezra Pound and Gertrude Stein linked their rebellion with the European avant garde. The expatriate model appealed to subsequent generations of American rebels. In 1944, Motherwell advised just such a course to his friend Baziotes. Arguing that there was no future in the United States for the innovative artist, Motherwell described only two choices: to permanently relocate to France or to remain in the

United States and undergo psychotherapy. Significantly for the history of the American avant garde, Motherwell and other cultural radicals did not expatriate themselves. Instead, they remained in the country of their birth and, building on the innovations of European colleagues, created an authentically American vanguard culture.[36]

Innovation

.

.

.

.

.

.

Cultural radicals are defined by more than their state of alienation from their culture; creative innovation is equally important. Poet and editor Cid Corman said in 1952 that "the subject and object of all avant-garde action ... is the creative." By "creative," Corman and other members of the vanguard meant much more than technical innovations in their artistic medium or change for mere shock value. As Corman noted, "Avant-garde doesn't reach definition in the word 'eccentricity.'" Composer John Cage declared in 1956, that "I have never gratuitously done anything for shock ... My work is almost characterized by being insufficiently exciting."[1]

American cultural radicals in the postwar years, like their predecessors in Europe and America, believed in the regenerative power of creativity. They chose the creative path of radical innovation over more conventional directions because they wanted to express their own independent spirit, to enlarge the creative freedom of artists so that others could

express themselves fully, and, most important, to transform their world through the integration of art and life. Poet John Clellon Holmes brought these themes together in a journal entry in August 1948: "The knell is sounding of the old way and now we must do things, not only because they can help, because something will come out of them, but because it is necessary for us to do them to exist."[2]

Interpretations such as that of Clement Greenberg—who described vanguard painting as a process of purifying the medium of external influences by focusing on two-dimensionality—are narrow and do not adequately explain the goals and ideas of members of the avant garde. Cultural radicals had ideas they wished to communicate to others through their work and, in many cases, their lives. The meaning of avant-garde innovation emerges best from exploring the passionate concern of avant gardists for the relationships among art, ideas, and society.[3]

The primary motivation for avant-garde innovation was the notion of cultural regeneration. The integration of art and life was typically the way vanguardists described their goal of a radical transformation of personality, politics, and economics. Avant gardists tried to accomplish this integration through various means. A central expression of the ideal of integration, and the primary aesthetic innovation of the postwar avant garde, was the definition of art as process. This notion produced an aesthetic based on using materials from everyday life. The integration of art and life was also important to four other interests of the postwar van: jazz, sex, drugs, and the spiritual quest. The unifying thought behind all of these themes was the regeneration of the self and society through the liberation of creative energies. Here I treat each of this themes in turn. To separate them in this manner is somewhat artificial, though necessary to understand avant-garde thought. One should keep in mind, however, that art and life formed an integrated whole in the thought of members of the avant garde.

Cultural Renewal, Not Politics as Usual

Members of the advance guard strove to do more than innovate artistic practice: innovation had a social, political, and broadly cultural intent, as well as an aesthetic one. From the 1950s to the present, however, the prevailing account of the politics of the postwar vanguard has been that its members were apolitical. Leftist critics in the late 1950s castigated the literary vanguard for lacking a coherent (often Marxist) critique of Ameri-

can society. Irving Howe, for example, writing in the *Partisan Review*, argued that the apolitical protest of the Beat writers made them functionally the same as the middle-class suburbanites they criticized.[4]

The politics of the abstract expressionists is another case in point. Scholars such as Serge Guilbaut have argued that the abstract expressionists, in their revulsion toward political extremism, compromised and revised their ideals until they became willing agents in the cultural Cold War. As we shall see, the abstract expressionists (and the avant garde in general) were coopted in the Cold War, and weaknesses in the vanguard made this possible. But this result was ironic and not at all what cultural radicals intended. Other scholars reject interpretations such as Guilbaut's but, as in the case of Stephen Polcari, go too far the other way in denying any political intent on the part of the abstract expressionist vanguard.

The mistake made by critics is to assume that because the members of the avant garde rejected established categories of political thought and action, especially Marxist ones, they therefore abrogated social and political responsibility. In fact, vanguardists looked for the path to the future in very different places from those inhabited by political activists.

Although the concerns of avant gardists did not quite fit the boundaries defined by Marxist political analysis, they can be broadly placed in the tradition of pacifist anarchism. Anarchists tend to be antiprogrammatic and dismissive of standard political processes and procedures. Renato Poggioli describes anarchism as "the least political or the most antipolitical of all . . . political ideolog[ies]." This explains, in part, the appeal of these ideas for avant gardists. The lack of a program may also explain why Marxist and other critics have had trouble recognizing the new generation as having a political ideology. Historian Donald Egbert argues that anarchism attracted cultural radicals in Europe and America from the late nineteenth century forward because the philosophy was antistatist and emphasized the role of the individual. Furthermore, Egbert notes anarchist ideology emphasized irrational and subjective forces, in contrast to the Enlightenment tradition of rationality and natural law to which Marxism and liberalism were heirs. The anarchist focused on the free individual creatively making his or her own life and allowing others to do the same.[5]

The alienation of members of the American vanguard from what they perceived to be the bureaucratic centralization and conformism of postwar America made a return to anarchist ideas a logical move. Many American vanguardists, moreover, learned from and appealed to an Amer-

ican tradition of anarchism in the thought of Henry David Thoreau, Ralph Waldo Emerson, and Walt Whitman. Evidence of this change in political thought appeared in the poems and essays published in the little magazines that emerged from the mid-1940s forward. Writers denounced private property, war, and censorship and advocated a decentralized society with greater freedom for the individual, usually discussed in terms of the right to use drugs and have more open sexual relations, all of which they believed would create a more humane society. The change was also apparent in the actions of some vanguardists: Venice, California, poet Stuart Z. Perkoff described himself as the first postwar draft resister because he turned himself in on the day the grace period expired for registering for the Korean War draft.[6]

Members of the avant garde looked beyond changes in economic and power relations to bring about the end of alienation in American culture. They believed that political solutions were no solutions; renewal needed to come from deeper and broader sources. The English critic Herbert Read, a thinker read by many abstract expressionists and other vanguardists, described the means to cultural reconstruction as the "politics of the unpolitical." Writing in 1943, Read tried to look to the future in the midst of the ravages of war. He could hope for the future because he believed in the moral sense of humanity. And because Read believed that the aesthetic sense was a guide to seeking and recognizing basic needs and values, he also believed that artists would play an important role in the renewal of postwar society.[7]

Read's book represented an early formulation of the stance toward society that members of the American vanguard would take—a stance I describe as a politics of cultural renewal. The word "culture" should be read not as "high culture," but in the broader anthropological sense, which is how most avant gardists, knowledgeable as they were of the works of Franz Boas, Ruth Benedict, and Margaret Mead, used the word. Radical innovators believed that all aspects of society—from mores governing sexual and family relations to the organization of the political economy—needed to be changed and renewed. This was also true of the standards defining what was and was not art. Ultimately, cultural radicals believed that creativity was central to a meaningful life. They based their cultural politics on the idea that the unleashing of creative forces would change the way individuals thought about themselves and their environment and thus produce a transformation in society. For avant gardists, the creative act was the means to a liberated future for humanity.

To achieve the goal of cultural renewal, avant gardists worked to change the relations between artists, their works, and their audiences by integrating the three. Art would no longer consist of distinct objects for aesthetic contemplation, but would be expressive of community values and therefore provide models for new relations between individuals and their world.

An early explication of this viewpoint comes from painter Robert Motherwell and critic Harold Rosenberg's "occasional review," *Possibilities*, which they edited in the late 1940s. In a short statement of principles introducing the magazine, Motherwell and Rosenberg noted the pressure for action exerted by "the deadly political situation." Implicit was the tension of the developing Cold War. The shadow of the bomb lay across the page. Recognizing this political reality, Rosenberg and Motherwell argued that art and political action were mutually exclusive. They state flatly that "political commitment in our times means logically—no art, no literature." Intellectuals faced a choice between "'more serious'... organized social thinking" and art: "whoever genuinely believes he knows how to save humanity from catastrophe has a job before him which is certainly not a part-time one." While sympathetic to the reasons one might choose this course of action, they saw it as a "political trap." The editors expressed skepticism about any program of activism because, like other members of the vanguard of the time, they doubted the relevance of any established modes of thought to the crisis of their times. Instead they affirmed the possibility of renewal in creative activity somewhere "in the space between art and political action." Neither Motherwell nor Rosenberg offered a program or direction, only "the extremist faith in sheer possibility." Creative action would produce the necessary new insight to prevent catastrophe. They made clear, however, that this was not an escape from politics or the world situation. Rather, they said, the political pressures of the times demanded such action.[8]

Throughout the 1940s and 1950s, cultural radicals affirmed their faith that the answer to the cultural and social crises was not political organizing but the reorganization of consciousness through the release of creativity. For example, in the early 1940s, poet Charles Olson resigned from his government position and ended what many regarded as a promising career in politics to dedicate his life to art and education, because he believed that the solution to social problems lay in cultural, not political, action. In the 1950s, Olson was for a few years chancellor of Black Mountain College in North Carolina and an important figure in avant-

garde literary circles. Poet Michael McClure declared, "The prime purpose of my writing is liberation. (Self-liberation first and hopefully that of the reader)." William H. Ryan, editor of the little magazine *Contact*, described his faith in art in an early issue of the periodical:

> Through the means of Art, by which we mean the utterances of the creative imagination, we believe that Insight and Truth are attainable, and if Truth or a truth can be merely sighted, it lights the way toward the understanding of human needs which is the only kind of understanding that can deal with this Age of Adolescence. . . . The essence of *Contact* is, I hope, unpredictability and spontaneity in its search for truth.

Composer Morton Feldman, a friend of John Cage, remembered that when he started composing in the 1950s, his purpose was to "free sounds." "I wanted sounds to be a metaphor, that they could be as free as a human being might be free." Feldman believed that sound is "some kind of life force that to some degree *really changes your life* . . . if you're into it."[9]

In 1955, the editors of the little magazine *Miscellaneous Man* declared their purpose to be "seeking and testing creative approaches to the problems that face individual men and women, that limit their humanity and chain them in a cage of mere existence." Merely to live, alienated from themselves, from others, from anything that gave human life a larger purpose, was not enough, vanguardists maintained. In the postwar years, they argued, technocratic bureaucracies had destroyed human beings as surely as the atomic bombs produced by those bureaucracies. Rejecting the rationalism they believed caused this situation, members of the avant garde argued that people must turn to the subjective, spontaneous, creative forces within themselves to find liberation. In 1958, LeRoi Jones and Hettie Cohen, editors of *Yugen*, described their goal of cultural regeneration in the subtitle of their little magazine, "A New Consciousness in Arts and Letters." Poet Kenneth Rexroth expressed his idea of cultural renewal in his tribute to jazz musician Charlie Parker and poet Dylan Thomas. These men were, he said, "heroes of the post-war generation" because "both of them did communicate one central theme: Against the ruin of the world, there is only one defense—the creative act."[10]

Cultural radicals believed that old ways of thinking and acting, including politics, had created the crisis faced not only in America, but around the world. Vanguardists believed that people needed new ways of thinking and acting and that the aesthetic politics of creative innovation was the way to rebirth. As individuals liberated their minds and spirits, they

would, so avant gardists hoped, turn outward to their fellows and create a new society.

Many cultural radicals intended their work to model the future they hoped to create. For example, the individual was the starting point for much avant-garde social analysis. The editors of *The Needle* declared in 1956 that "individual liberty is a prerequisite for any rational system of relationships between men." Cage tried to fulfill such a commitment in his compositions. He argued against the use of conductors in the performance of music, saying that "from the point of view from which each thing and each being is seen as moving out from its own center, this situation of the sub-servience of several to the directives of one who is himself controlled, not by another but by the work of another, is intolerable." Instead, Cage wrote music that was indeterminate in both composition and performance. In this way, Cage's music modeled the ideal society of free individuals. The cultural politics advocated by vanguardists dissolved the boundaries between art and politics. This blurring of traditional categories is a defining characteristic of avant-garde movements: the advance-guard goal to integrate art and life.[11]

Continuities

Although alienated from the "modernist canon" that critics developed in the 1940s, members of the avant garde did not separate themselves completely from the art of the past. Radical artists acknowledged continuities between their work and the work of earlier advance-guard artists. The poetry of French vanguardists Charles Baudelaire, Arthur Rimbaud, and Guillaume Apollinaire served as examples for American avant-garde painters such as Robert Motherwell and William Baziotes and writers such as Allen Ginsberg and Jack Kerouac.

The more recent vanguardists who influenced the new generation tended to be artists without canonical status. Thus, advance-guard poets looked to William Carlos Williams as an exemplar of poetic practice. Given that Williams's response to *The Waste Land* was that "it had set me back twenty years," he would seem a natural mentor. While T. S. Eliot's work became the subject of essays in critical quarterlies and part of college curriculums, Williams worked in relative obscurity. But Williams's emphasis on speech rhythms and everyday American subject matter appealed to young vanguardists. Poet Joel Oppenheimer declared, "i see william carlos williams [sic] as my poetic grandfather." The analogy is apt.

Williams corresponded with Ginsberg and wrote the introduction to Ginsberg's *Howl and Other Poems*. Ginsberg spoke of the older poet as being the link between the younger generation and the avant garde of the 1920s, and through that movement to Herman Melville and Thoreau. Ezra Pound, especially his language-collage technique of verbal associa- tion in the *Cantos*, influenced many avant gardists. Ginsberg, for example, told Pound that the *Cantos* were "like stepping-stones" that made a "ground for *me* to . . . walk on. . . . [T]he practical effect has been to clarify my perceptions."[12]

The standard description of abstract expressionist art as a synthesis of cubism and surrealism also indicates continuities between the avant gardes. Jackson Pollock admired Pablo Picasso and Joan Miró. Pollock and the other artists associated with abstract expressionism shared an interest in surrealist notions about the subconscious. As painter John Ferren said, "The *idea* of the subconscious, the techniques of chance, and a concern for the depths of the inner life: these took hold of us as a powerful influence."[13]

Cultural concerns linked the abstract expressionist vanguard with movements not usually thought of as avant garde. For example, the ideas of the regionalist painters of the 1930s, especially Thomas Hart Benton, with whom Pollock studied, shaped avant-garde understandings of the links between art and culture. Benton believed that "art is not only art but a regenerative force and because of that, permanently valuable to men." Abstract expressionists rejected the ruralism of Benton and other regionalist artists, as well as the "utopia of material technology" that predominated in the Works Projects Administration (WPA) murals in- spired by the regional school. But members of the vanguard shared Benton's belief in cultural renewal through art.[14]

The aesthetic rebellion of avant-garde composers marked perhaps the most fundamental break with the past. In the postwar years, advanced composers defined themselves, according to Catherine M. Cameron, by their "disavow[al] of history and tradition" and their "complete . . . antipa- thy to the idea that there are any connections between past and present music." Thus, for example, Harry Partch advised students to

> question the corpus of knowledge, traditions, and usages that give us a piano, for example — the very fact of a piano; they must question the tones of its keys, question the music on its rack, and above all, they must question constantly and eternally, what might be called the philosophies behind the device, the philosophies that are really responsible for these things.

Cage liked to quote painter Willem de Kooning's remark that "the past does not influence me; I influence it." The innovations of the new generation of composers, such as Partch, Cage, Feldman, and Christian Wolff, produced a body of work that most commentators agree is highly original, a quality illustrated by the need of these composers to develop their own systems of notation in order to write out their musical scores. The work of these younger musicians marked a radical break with what had come before in Western European music, including the older vanguard of Arnold Schönberg and Igor Stravinsky.[15]

If the younger composers claimed any genealogy, they claimed the avant-garde figures of the past who were not securely a part of the modernist canon, such as Erik Satie, and especially the American composers Edgard Varèse and Henry Cowell. Cage commented that Cowell

> was not attached (as Varèse also was not attached) to what seemed to so many to be the important question: Whether to follow Schoenberg or Stravinsky. His early works for piano, . . . by their tone clusters and use of the piano strings, pointed towards noise and a continuum of timbre. Other works of his are indeterminate in ways analogous to those currently [1959] in use by [Pierre] Boulez and [Karlheinz] Stockhausen.[16]

The claims to complete originality that pepper avant-garde rhetoric should be regarded with suspicion. The work of these American composers marked a break with the past of European music, but not with the past of music or aesthetics in general. Rather, these composers looked in part to other traditions—for example, Cage's interest in Zen Buddhism, or Partch's attempts to revive traditions of music and theater derived from ancient Greece and non-European cultures. This interest of postwar avant-garde composers in non-Western sources linked them to other radical innovators with similar interests in non-Western cultures such as Picasso and Eliot.

Perhaps the most important continuity linking the musical vanguard with movements in painting and literature was the ideas of Dada and especially Marcel Duchamp. De Kooning described Duchamp as a "one-man movement" and as "a truly modern movement because it implies that each artist can do what he thinks he ought to—a movement for each person and open for everybody." Ginsberg met Duchamp and Tristan Tzara in Paris in 1958 and told Peter Orlovsky he was reading Tzara's Dada manifesto's "carefully."[17]

Cage and Motherwell each contributed to putting the ideas of Dada

and Duchamp before the contemporary vanguard. Motherwell edited the anthology *Dada Painters and Poets*, published in 1951, through which a whole new generation of painters and poets learned about this central avant-garde movement. At the New School for Social Research in New York and Black Mountain College in North Carolina, Cage taught a synthesis of Duchampian Dada and Zen Buddhism to the generation of artists who followed the abstract expressionists. Like Duchamp, Cage rejected the surrealist idea of automatism, according to which artists used chance operations to express their subconscious. Cage used chance procedures to get away from psychological meanings altogether, so that sounds and objects could be appreciated for what they were. Cage combined Duchamp's use of "Readymades," everyday mass-produced objects used by the artist without change, with Zen ideas to produce an aesthetic that emphasized the integration of art and life. The breadth of Cage's influence is illustrated by his collaborations with artist Robert Rauschenberg and dancer Merce Cunningham. As Cage explained, "We are not, in these dances and music, saying something. . . . We are rather doing something. . . . I may add there are no stories and no psychological problems. There is simply an activity of movement, sound, and light. . . . The activity of movement, sound, and light, we believe, is expressive, but what it expresses is determined by each one of you." By calling artists' attention to Dada and Duchamp, Motherwell and Cage not only established an important link between the earlier vanguard and avant-garde movements in America, they also threw another set of ideas into the eclectic mix from which American cultural radicals as diverse as Rauschenberg, Cunningham, Jasper Johns, and Allan Kaprow could draw to create a new, highly innovative art.[18]

Making Art Relevant: Innovation and Integration

Though continuities existed between the avant-garde innovations of the past and the new work of the postwar avant garde, most cultural innovators emphasized the quality of newness. Many members of the postwar avant garde, like previous van movements, believed that the present was "their time" and that their art should relate to the new developments in science, technology, politics, and economics that they believed defined their era. To "make it new" was, in their eyes, to make an art that would speak to the world in which the artist found him or herself. Partch argued

that he did not have to justify his search for a new musical idiom. Rather, he maintained, the opponents of change needed to defend their choice of program. Justification of the status quo, Partch wrote, "belongs to those who accept the forms of a past day without scrutinizing them in the light of new and ever-changing technological and sociological situations, in the light of the interests that stand to profit by the status quo, and in the light of their own individualities, this time and this place." In 1950, Pollock declared, in a statement that recalled the technological interests of the turn-of-the-century Italian Futurists, that "modern art to me is nothing more than the expression of contemporary aims of the age we're living in. . . . It seems to me that the modern painter cannot express this age, the airplane, the atom bomb, the radio[,] in the old forms of the Renaissance or any other past culture."[19]

The members of the new advance guard were determined that their art would be more than aesthetically pleasing objects sheltered in museums or books apart from the world. They wanted their creative works to speak to their time and contribute to current social and cultural developments. "We live in a period of transition," declared Miró in the American little magazine *Possibilities* in 1947. "It is necessary to make a transition of everything that has been done."[20]

As noted, the integration of art and life was the primary goal of avant gardists. This concept has many meanings and ramifications. First is the notion that the act of creation is not restricted to special people called artists. Rather, creativity is available to all. Consider, for example, the following dialogue from Cage's 1955 essay, "Experimental Music: Doctrine:"

QUESTION: But, seriously, if this is what music is, I could write it as well as you.
ANSWER: Have I said anything that would lead you to think I thought you were stupid?

As Cage also wrote, "It is better to make a piece of music than to perform one, better to perform one than to listen to one, better to listen to one than to misuse it as a means of distraction, entertainment, or acquisition of 'culture.'"[21]

Cage also makes a second point: members of the advance guard rejected the notion that art consists of objects to be collected in museums, concert halls, and libraries and consumed for cultural uplift or entertain-

ment. They believed art is a vital part of life to be experienced directly. Sculptor and assemblage maker Claes Oldenberg declared:

> I am for an art that is political-erotical-mystical, that does something other than sit on its ass in a museum. . . . I am for an art that imitates the human, that is comic, if necessary, or violent or whatever is necessary. I am for an art that takes its form from the lines of life itself, that twists and extends and accumulates and spits and drips and is heavy and coarse and blunt and sweet and stupid as life itself.[22]

The specific application of this idea to artistic practice is the use of everyday materials in the making of paintings, music, or poetry.

The goal of integrating art and life extended to more than matters of artistic materials, however. The cultural politics of the advance guard called for all of life to be a creative self-expression. Historian Harry Russell Huebel characterizes this concern as a quest for "enlightenment." He notes that many vanguardists pursued this goal through liberated sex, bebop jazz, and illicit drugs. Critics at the time dismissed these actions as mere hedonism. While certainly cultural radicals enjoyed these activities, they did so in part because they placed sex, jazz, and drugs in a larger context of liberating the body and spirit and becoming more aware of the creative potential of everyday life. Ultimately, the quest for enlightenment was a spiritual one. Avant gardists studied myth, ritual, and Eastern religion in order to shape a new system of values that could give richer meaning to life in modern America.[23]

Art as Process

The members of the avant garde rejected the definition of art as an artifact to be institutionalized in a museum or an academic mannerism. In order to safeguard art from such degradation and integrate art and life into a renewed culture, avant gardists defined art not in terms of the object, whether poem or assemblage, but as a process of creation. A work of art, according to cultural radicals, is not an object that fulfills certain conditions that define one thing as art, another as not. Rather, it is a process of imagination and struggle applied to ordinary objects, whether words, paint, or noise, that challenges the person confronted by the artist to feel, or see, or hear differently.

In 1950, for example, Motherwell contrasted European with American painting: "young French painters . . . have a real 'finish' in that the picture

is a real object, a beautifully made object. We are involved in 'process' and what is a 'finished' object is not so certain." Poet Robert Duncan related the creative process to the learning process: "Human learning is not a fulfillment but a process, not a development but an activity. . . . Every moment of life is an attempt to come to life. Poetry is a 'participation,' a oneness" with that process. Composer Earl Brown described his compositions for piano *MM87* and *MM135*, which were inspired by Pollock's drip paintings, as "composed very rapidly and spontaneously and . . . in that sense performances rather than compositions." Kerouac's "spontaneous prose" aesthetic was an attempt, similar to Brown's, to record the creative process directly on the page, without any subsequent revisions. In this way, the reader could have an almost direct experience of the creative process.[24]

The emphasis members of the literary avant garde placed on poetry readings also reflects this conception of art as process. The "poetics of performance," as literary historian Michael Davidson calls it, conceived the poem as a living work of language. San Francisco poet and publisher Lawrence Ferlinghetti described oral poetry as a means of "getting the poet out of the inner esthetic sanctum where he has too long been contemplating his complicated navel. It amounts to getting poetry back into the street where it once was, out of the classroom, out of the speech department, and—in fact—off the printed page." To remain on the page was to be objectified for academic study. To be poetry, the words had to live in the ears of hearers, and to penetrate their subconsciouses. Poetry so conceived was social in the sense that the writer intended the work to, as Davidson says, "engage the reader in a more interactive role."[25]

Such an understanding of social poetry is very different, obviously, from the social realist aesthetic of the Depression era, in which subject matter and adherence to working-class tastes tended to define social art. Vanguardists defined the artist not as a teacher of sociological facts, but as a teacher of religious truths and a performer of religious rituals. The poet was, as Gary Snyder declared, a type of "shaman" who presented, as he read, "a kind of Communion" and "articulated the semi-known for the tribe." By defining art as a process and not a finished object, members of the avant garde hoped both to redefine the nature of poetry, painting, and music and to achieve their goal of integrating art and life.[26]

The Aesthetics of the Everyday

Members of the postwar avant garde also expressed their goal of integrating art and life by using materials from daily experience in their work. Literary historians have characterized the aesthetic of the postwar avant-garde poets variously as a "poetics of presence," of "immanence," and of "immediacy." The idea behind these interpretations is that the poetry of the postwar vanguard is, as James Breslin expresses it, grounded "in a sharply observed physical present, its dense materiality implicitly mocking the transcendent, totalizing imagination of symbolism as well as the more covertly transcendent imagination of the new criticism and the young formalists." These poets sought to communicate directly to their audience by including ordinary experience and emotions, producing, as one vanguardist said, a "collage of the real." This aesthetic concern with "immediacy," as Breslin calls it, characterizes not just the avant garde writers of the period but all aspects of radical creativity.[27]

Radical artists expressed the immediacy of the everyday by making emotion a primary focus of their work. In 1948 painter Barnett Newman described his goal as "reasserting man's natural desire for the exalted, for a concern with our relationship to the absolute emotions." After witnessing the dehumanizing experience of war and facing the fear of nuclear destruction, many cultural radicals expressed a need to feel and to express emotions. In 1946, poet Oscar Collier praised Judson Crews's poetry for "transcending the mass, of going beyond personal neurosis, of portraying your struggle in a way that has universal significance."[28]

For avant gardists, works of art are not objects but, as Newman put it, "specific embodiments of feeling." As Ferren wrote in 1958, "There is no longer a belief in an objective reality out *there* and a pure arrangement of lines and colors right *here*." In place of this false distinction between the painting and the observer, Ferren declared, "the avant-garde artist has substituted 'immediacy.' He permits no barrier between his inspiration and his execution, no intellectual editing, no cleaning up to conform to some preconceived idea."[29]

The immediacy of expression in the work of the abstract expressionists inspired other avant gardists, including poet Michael McClure and composer Earle Brown, who both tried to capture the spontaneity and energy of these painters in their works. Pollock's paintings, for example, moved Brown, who saw in them "life, energy, and immediacy" and decided that "these qualities should also be in my music."[30]

Avant gardists also used everyday materials in their works, whether mass-produced objects, common speech, or the sounds of life, to express the immediacy of lived experience. Visual artists produced such works as Oldenberg's *Store* (1961), which featured plaster replicas of common objects, or Rauschenberg's combines made up of commonplace items the artist found at hand in his studio or in rubbish bins on walks through his neighborhood. For example, the combine *Bed* (1955) consisted of Rauschenberg's quilt and pillow splashed with paint. These works confronted viewers with the world of the quotidian, not an aesthetic realm where paintings were worlds unto themselves. As Rauschenberg commented, "A pair of socks is no less suitable to make a painting with than wood, nails, turpentine, oil and fabric." Poet and art critic Frank O'Hara, writing in the avant-garde magazine *Kulchur,* praised Oldenberg's *Store* because of Oldenberg's ability to transform "the very objects and symbols themselves, with the help of papier-mache, cloth, wood, glue, paint, and whatever other mysterious materials are inside and on them, *into* art."[31]

As a poet, O'Hara also transformed everyday objects and events into art. In 1960, he wrote about his technique, in which the ordinary events and thoughts of lunch-hour walks became the stuff of poetry: "I am mainly preoccupied with the world as I experience it. . . . It may be that poetry makes life's nebulous events tangible to me and restores their detail; or conversely, that poetry brings forth the intangible quality of incidents which are all too concrete and circumstantial." LeRoi Jones also constructed poetry out of the everyday: "*My poetry* is whatever I think I am. . . . I make a poetry with what I feel is useful and can be saved out of all the garbage of our lives[:] . . . wives, gardens, jobs, cement yards where cats pee, all my interminable artifacts . . . *all* are a poetry."[32]

Other vanguardists transformed ordinary language into art. To express the immediate experience of life, these writers used the rhythms of American speech as the proper language for American poetry. In this practice, they followed the ideas of William Carlos Williams and Charles Olson. In his influential essay "Projective Verse," originally published in 1950, Olson expanded upon Williams's notions about American meter. Olson urged that the poem should express both the poet's "ear" for American language and his or her "breath."[33]

Avant-garde composers expressed the idea of immediacy by using the sounds of ordinary life as musical material and by using chance techniques in composition. The result was a radically different kind of music that Cage called "organization of sound" and Wolff described as "sound come

into its own." Cage's interest in the use of ordinary sounds—what most people would consider noise—dated to the 1930s. In 1937, Cage wrote: "Wherever we are, what we hear is mostly noise. When we ignore it, it disturbs us. When we listen to it, we find it fascinating. The sound of a truck at fifty miles per hour. Static between the stations. Rain. We want to capture and control these sounds, to use them not as sound effects but as musical instruments." In the early 1950s, Cage discovered the possibilities of silence, as in his famous silent "composition," *4' 33"* (1952). What he discovered, of course, was that "silence" was not so quiet: the music was the ambient sounds of wind and rain, and, as Cage observed, "the people themselves made all kinds of interesting sounds as they talked or walked out."[34]

In the early 1950s, Cage and others began using chance techniques in composition and performance, which also contributed to the process of "sound coming into its own." Chance techniques remove intentionality from the composition. The composer's purpose and the feelings he or she is or is not expressing become irrelevant considerations. The only important fact is the sound of the piece. As Wolff wrote, "The 'music' is a resultant existing simply in the sounds we hear, given no impulse by expressions of self or personality. It is indifferent in motive, originating in no psychology nor in dramatic intentions. . . . But this does not make their work 'abstract,' for nothing, in the end, is denied." Cage advocated the use of chance procedures to prevent sounds from "being exploited to express sentiments or ideas of order." Cage desired that sounds be sounds and left it up to the audience to make of them what they would. These composers hoped that their auditors would begin to hear differently and discover music in the sounds of everyday life.[35]

Jazz and Life

Jazz music inspired many members of the advance guard, who interpreted the music and the community of jazz musicians as models of the culture vanguardists desired. Cultural radicals believed that jazz musicians had succeeded in integrating art and life. In the bop jazz created in the 1940s by Dizzy Gillespie, Charlie Parker, Lester Young, and others, avant gardists heard emotional self-confessions. In the dedication of these musicians to their music, often at the expense of everything else in their lives, vanguardists saw an example of the artist giving all to creativity. In these ways, the beboppers represented for cultural radicals rebellion from

the perceived pressures of conformity and repressed individuality. Kerouac declared that the jazz artists "kept talking about the same things I liked, long outlines of personal experience and vision, night-long confessions full of hope that had become illicit and repressed by war."[36]

That avant gardists should be interested in jazz was entirely appropriate because both emerged in opposition to Victorian culture. The proponents of the genteel tradition codified Culture as refined, traditional, harmonious, and exclusive. For these Victorians, Culture was to be experienced in a passive, reverent manner. Jazz was the complete opposite: raucous, new, discordant, and accessible. Jazz was played for noisy, dancing, clapping, stomping audiences. Genteel Culture was "highbrow," while jazz was "lowbrow." Jazz was also a black art form, whereas Culture was white. Recognizing its countercultural aspects, most white Americans throughout the first half of the twentieth century viewed jazz as morally suspect and denounced the music. Jazz did, however, find a growing white audience, especially among young people more interested in rhythm than Culture.

The big swing bands of the 1930s and 1940s presented a sanitized kind of jazz that did not interest avant gardists. The new bebop jazz that emerged in the 1940s, however, did attract their attention. As jazz became popular with white audiences, especially in the form of swing, black musicians became acutely aware of the racial hypocrisy of their white contemporaries. While whites gave jazz music increasing attention, black musicians experienced discrimination in pay and accommodations, as well as other indignities. The bop rebellion allowed black musicians to take back their music, devising a new jazz form that did not have the suspect popularity of swing. As it turned out, however, the bop rebellion appealed to alienated white avant gardists also, and they contributed to the acceptance of the new music into the jazz mainstream.

Kerouac and other avant gardists identified with the alienation from mainstream society felt by these black musicians and interpreted the music as a creative force for cultural renewal. Holmes, for example, wrote that he and his friends felt "like blacks caught in a square world that wasn't enough for us." The notion that black, urban culture provided a model for rebellion against contemporary white society and culture was the theme of one cultural observer, novelist Norman Mailer, in his 1957 essay, "The White Negro." For Mailer, jazz played a crucial role in this rebellion: "The Negro . . . in his music . . . gave voice to the character and quality of his existence, to his rage and the infinite variation of joy,

lust, languor, growl, cramp, pinch, scream and despair of his orgasm. For jazz is orgasm, it is the music of orgasm, good orgasm and bad, and so it spoke across a nation."[37]

Kenneth Rexroth declared that "during the years of darkness"—that is, the period of the Cold War and the dominance of academic poetry—the artists who spoke for the young were jazz musicians such as Parker, Young, Monk, and others. Moreover, he argued that "modern jazz is not just music—it is also a social system, a way of life." Like Mailer, Rexroth linked jazz to sexual liberation, but Rexroth also spoke of the regenerative force of "the creative act." Kerouac developed this theme in novels such as *Doctor Sax* and *Visions of Cody*, in which he presented jazz as a procreative force in both a physical and spiritual sense.[38]

The music and culture of bebop jazz was more than rebellion, however. It served members of the advance guard as a model for a new, more creative society. Peter Willmott declared in a 1947 essay in *Jazz Forum* that "the most important artistic medium is life itself, . . . [and] the aim of each of us should be to achieve in our living grace, harmony and integration with all other life." Willmott argued that "wholly improvised hot music" presented a perfect balance between the freedom of improvisation and responsibility to the group, adding that "in social terms these conditions seem to me to constitute the basis of a coherent social philosophy, a philosophy which holds that only through freedom and responsibility can men play a living and creative part in society, and that only through a devolution of power can men act responsibly in small social units."[39] The jazz combo was thus an example for society.

For many avant gardists, the vitality they heard in jazz represented the powerful creative energy inside people, the release of which could, they believed, transform society. An editorialist wrote in *Climax* that jazz "affirmed the ideal of creative vitality." Jazz represented, Eithne Wilkins wrote in *Jazz Forum*, "the form that art must take if it is to work out the nightmare and what lies behind, [and] so gradually liberate the patient, who is both the person-in-society and society itself." This understanding of innovative jazz as a revolutionary force for social change inspired Ginsberg to rhapsodize, in his poem "Footnote to Howl," about the "bop apocalypse." A new world was coming, members of the avant garde believed: a world in which art and life came together as in a bebop combo.[40]

Bebop also served as a model for the technical innovations of many vanguardists. The musical line of bop jazz fit in with the interest of avant-

garde writers in common American speech. Ginsberg believed that the U. S. vanguard differed from the British Angry Young Men, a movement to which the Beats were often compared, because of the American "tradition of speech and prosody experiment and new jazz." While Kerouac's ideas of "spontaneous prose" reflected European influences (especially surrealism and James Joyce), the language Kerouac used to describe his aesthetic clearly derived from listening to musicians like Parker, Young, and Gillespie. The writer should, Kerouac said, "tap from yourself the song of yourself—blow!" Poets such as Ginsberg, Patchen, and McClure explored the use of jazz rhythms and imagery in much of their writing.[41]

Patchen and Rexroth regularly combined poetry readings with jazz music (indeed, Rexroth had participated in such performances as early as the 1920s). These musical readings fulfilled the avant-gardist goal of bringing together art and life by combining the oral experience of poetry with a popular musical form. As Rexroth argued, "It returns poetry to music and to public entertainment as it was in the days of Homer or the troubadours." Poetry and jazz recalled for members of the avant garde an earlier (idealized) time when artists were an integral part of the community. Jazz inspired technical and performance innovations that radical artists hoped would create such a community anew.[42]

Sex and the Regeneration of Art and Life

Sexual liberation was an important concern of members of the first-generation avant garde, and the theme continued to be important for the postwar vanguard. Sex meant many things for cultural radicals in the 1940s and 1950s. As it did for the first American vanguard, uninhibited sexual relations served social, psychological, and spiritual purposes for the last American vanguard. Sex served a social function as a rebellion against middle-class morality. Psychologically, avant gardists viewed sexual expression as important to emotional health, reflecting a vulgarized version of Freud and especially the radical Freudian Wilhelm Reich. More generally, sexuality represented for members of the vanguard a creative force for spiritual and broadly cultural regeneration, a conception that also reflected the influence of Carl Jung.

For many avant gardists sexual liberation became *the* rebellion. In 1961, poet Tuli Kupferberg wrote that "the prototype of The Underground is the *sexual underground.*" Novelist Ronald Sukenick argued that Reichian psychology appealed to him and others in the 1950s because Reich's ideas

provided an alternative radical value system to Marxist politics. "For me, and I think for many others," Sukenick wrote, "sex [became] a weapon and dissipation a form of dissent, instead of merely a way of having fun in defiance of the work ethic." Sex as rebellion was the central theme of Ed Sanders's little magazine *Fuck You: A Magazine of the Arts*, published in the early 1960s. The motto "Grope for Peace" suggests the combination of sexual (and typically profane) content with anarcho-pacifist politics that characterized the magazine.[43]

Other avant gardists followed the tradition of their predecessors and argued that individual and social health depended on free sexual expression. In a 1956 article in *Miscellaneous Man*, Lawrence Barth rejected Freud's contention that civilization mandated the sublimation of erotic instincts. Barth argued that "the natural functioning of human bodies *is* culture . . . [, and] true culture is possible only through allowing the basic natural functions of the body to operate as they must." Far from creating civilized culture, Barth argued, sublimation created "destructive impulses, dirty-mindedness, rape and other criminality." Declaring sexual drives to be "moral, natural," Barth maintained that "the negation of the body's genital and other instincts is the thing which is immoral." Finally, Barth answered the charge of anti-intellectualism by declaring that "nothing more surely conserves intellect than eliminating preventable neurosis." Critic Paul Goodman linked the Cold War, the arms race, and the burning of Reich's books by the Food and Drug Administration to sexual repression, lamenting that "it is into this insane asylum that I have to bring up my children." The themes discussed by cultural radicals paralleled those of contemporary post-Marxist Freudians such as Herbert Marcuse and Norman O. Brown.[44]

While most of the avant-garde writing on sex and society in the postwar years was little different from similar arguments made in the 1910s and 1920s by cultural radicals such as Emma Goldmann and Floyd Dell, a significant difference was that the later avant gardists replaced Freud with Reich and Jung as their authorities in these matters. Reich gave avant gardists a sexual critique of postwar society. A one-time student of Freud's, Reich went even further than his mentor in emphasizing the importance of sex to human psychology and society. Reich argued that sexual expression was vital to human health, both mental and physical. On this premise he created an argument against oppressive and repressive social and economic structures that appealed to cultural radicals. Reich also claimed to have discovered a sexual energy that permeated the uni-

verse, which he called orgone energy. This energy, Reich believed, could be tapped by sitting in telephone-booth-sized boxes called orgone energy accumulators. Goodman was one of many avant gardists enthusiastic about Reich. In 1945, Goodman wrote, "It is just because Reich wants to set free the forces native to each individual, which, in adults at least, are beyond the influence of advertising slogans and political propaganda, that his thought has such enormous libertarian dynamism."[45]

In the 1950s, many intellectuals discussed Reich's ideas, and some acted on them by seeking Reichian therapy or sitting in orgone boxes. Sukenick remembered that during the decade "practically every hip apartment or loft you walked into had . . . an orgone box." Intellectuals as diverse as little magazine editor Jay Landesman and writers Saul Bellow, Isaac Rosenfeld, Jack Kerouac, and Allen Ginsberg used orgone boxes with some regularity. A Reichian psychologist at the avant-garde Black Mountain College introduced students there to orgone energy. William Carlos Williams and Kenneth Burke discussed Reich in correspondence in the 1940s. William S. Burroughs introduced the Beat writers to Reich, Burroughs being especially influenced by Reich's social criticism.[46]

Reich's ideas did not impress all Americans, particularly officials at the Food and Drug Administration, who in the mid-1950s accused Reich of deceiving the public with fraudulent health claims. When Reich ignored an injunction to desist from selling his accumulators and literature, he found himself sentenced to prison for contempt and his books and machines destroyed. Reich's subsequent death in a federal penitentiary only served to confirm for many members of the avant garde that the sexual repression in American society produced an oppressive state.

The censorship of sexual content in literature was another example used by avant gardists to prove the oppressiveness of American society. Among little magazine editors who found themselves in trouble because of obscenity laws were Wallace Berman, editor of *Semina*, William V. Ward, editor of the *Provincetown Review*, and Irving Rosenthal, editor of the *Chicago Review* and *Big Table*. The successful defense of Ginsberg's *Howl* against obscenity charges contributed to the liberalization of obscenity laws.[47]

Many cultural radicals described sexuality as a force for spiritual and cultural regeneration, reflecting the influence of Jung. To make their point, members of the avant garde tried to recontextualize sex in terms other than Victorian and producer-culture values. Poet Manfred Wise, for example, examined a rather obvious source, the Song of Songs. Wise

commented that "few people realize the confirmation of body-love found in ancient scripts." He went on to declare that "no one can fully entertain the God-concept who has not had God personalized in the Body-and-Life of some beautiful human." Poet Lenore Kandel was more earthy: "my *God* the worship that it is to fuck," she wrote in *Fuck You*. Partch explained what he considered to be the stagnation of musical innovation in the mid-twentieth century by going back to D. H. Lawrence's notions of mind-body separation. Quoting Lawrence, Partch wrote, "We are afraid of the 'procreative body' and its 'warm flow of intuitional awareness,' and fear it is 'poison to the human psyche.'" Only by acknowledging and drawing on our own energy of physical generation could creative advance continue, Partch argued.[48]

For members of the abstract expressionist vanguard, sexual imagery was an especially potent symbol for the regeneration of society and values. In his abstract paintings of the 1930s, Clyfford Still used phallic images (precursors of the flame imagery of his postwar work). In paintings of the 1940s, Barnett Newman used biomorphic images resembling egg and sperm. This imagery reflected Jung's symbolic interpretations of the phallus as "universal creative power" and the egg as the "cosmic egg" from which all things grow. Sexual liberation, for members of the avant garde, represented not only a rebellion against Victorianism, but an affirmation of their hope for cultural renewal.[49]

Drugs and the Liberation of Consciousness

Just as the practice of free love was a way for cultural radicals to demonstrate their estrangement from bourgeois society, so the use of illicit drugs, especially marijuana, served as an expression of rebellion. But avant gardists also had more positive goals. Many of them believed that drugs could be used as tools to expand one's consciousness and deepen the one's creative insights. Not all members of the van advocated drug use, but those who did believed that mind-altering substances could help their cause of integrating art and life.

In this way, the use of illicit drugs, especially marijuana, became part of the stereotype of the "beatnik" in the late 1950s. For example, Paul O'Neil, writing in *Life* in 1959, said of Ginsberg: "Like most Beats he is a marijuana smoker." More bohemians used (and were often addicted to) alcohol, a legal drug, than ever became deeply involved with illegal drugs, but for those vanguardists who used illicit substances, marijuana was the

drug of choice. Cannabis was a substance well known in the jazz community, from where cultural radicals picked it up. Some cultural radicals also tried peyote and heroin, and, in the 1960s, some experimented with LSD, most notably Ginsberg. Ginsberg always claimed a serious purpose behind his use of drugs: marijuana was for "study purposes," not "party purposes," he insisted. Perkoff concurred, noting in his journal in 1956 that he and others in the Venice, California, bohemian community used drugs because "we are impatient for that opening of mind (and soul) that follows on the loosening of the fingers of tension."[50]

Ginsberg and other vanguardists used drugs to heighten their aesthetic awareness. They would use a drug and then go to a museum to look at paintings or read poetry, hoping thereby to gain increased understanding of the works observed and to stimulate their own creativity. Vanguardists would often write or paint while "high." In 1964, Ginsberg explained to Marcel Duchamp that the purpose of LSD-induced creativity was to "express myself *on the spot* when the moment comes that life brings me to a state of maximum-feeling-awareness-consciousness, i.e., epiphanous moments, mystical coherences, whatever label is useful." The story of how Kerouac wrote *On the Road* in three weeks sustained mostly by Benzedrine and coffee is perhaps the most famous example of how members of the avant garde used drugs to encourage creativity.[51]

Drug use also served as a way for cultural radicals to express their rebellion against American society and government. In 1961, writer Paul Bowles wrote that the "grown-ups" in "alcoholic countries" like the United States oppose the use of marijuana because "the user of cannabis is all too likely to see the truth where it is and to fail to see it where it is not. Obviously few things are potentially more dangerous to those interested in prolonging the status quo of organized society." Noting the "huge sadistic police bureaucracy" in each state that "persecute the illuminati" (i.e., drug users), Ginsberg declared in 1959 that "to be a junky in America is like having been a Jew in Nazi Germany." Using drugs and protesting against the illegality of drugs became, especially in the 1960s, another way that avant gardists could rail against the conformism and oppression that they saw in postwar America. Drug states, cultural radicals maintained, enabled people to transcend rationality and unleash creative forces in the subconscious that could be harnessed to the purpose of bringing art and life together. To oppose drugs was to oppose the liberation of human creativity and the innovations that could result.[52]

Not all vanguardists believed drugs were useful. Cage, for example,

opposed drug use on the same grounds that he opposed "Art": "both promise transcendence from mundane life." He argued instead that one should look and listen carefully to one's own experience and find beauty there. Gary Snyder argued that drugs, while often "eye-openers," were not suited for deep "vision and illumination-seeking." The constant use of drugs "leads nowhere," he wrote, "because it lacks intellect, will and compassion; and a personal drug kick is of no use to anyone else in the world." The Dalai Lama gave Ginsberg similar advice when the poet offered to get some LSD for the Tibetan spiritual leader during an audience in 1962. Their words seem to be confirmed in Perkoff's plaintive thought that he and his friends would not need to use drugs "if we were to achieve the state of initiate," but, unfortunately, he continued, "we are not initiates, any of us."[53]

Although members of the advance guard believed that the use of drugs could inspire creative insight and contribute to the integration of art and life, the results of their program were ambiguous at best. On the one hand, Ginsberg would use drugs throughout the 1960s to inspire his poetry—for example, his 1967 poem "Wales Visitation." On the other hand, Perkoff, Burroughs, and Orlovsky are among the many cultural radicals who did become addicted to drugs. In part following the example of their avant-garde predecessors, members of the 1960s counterculture used marijuana and other drugs. Again, the results were not always benign, though Snyder, despite his cautions about drug use, concluded that "the H.A. [Haight-Ashbury] scene, and LSD are all to the good—a revolutionary, step forward—to bring people . . . around to formal discipline where needed."[54]

Sukenick saw a self-destructive component in the drug use of Greenwich Villagers of the late 1950s and early 1960s. Rather than searching for enlightenment and liberation, Sukenick argued that many seemed to seek self-immolation because it was preceded by "incandescence." He recalled one of Bill Manville's "Saloon Society" columns in the *Village Voice* in which a bohemian commented on a recent casualty from a drug overdose: "Imagine, Bill, how strong that junk must have been. Imagine, not *only* to die—*but to turn BLUE and to die!*" Kerouac, of course, did not need illicit or exotic drugs to destroy himself—he chose the traditional drug of the working and bourgeois classes and drank himself to death in 1969.[55]

The Spiritual Quest

Members of the avant garde felt alienated from rational, technical, bureaucratic modernity in large part because, like generations of their predecessors, they believed that the value systems of contemporary society denied deeper spiritual realities. For many avant gardists, the problems of the modern world stemmed from just this alienation of human beings from their spiritual roots. Avant gardists generally did not find spiritual nourishment in the American mainstream religious traditions of Christianity and Judaism. Members of the cultural van instead followed several, often interrelated, paths to find a spiritual integration of art and life. For most, aesthetic creation was a participation in the creative, spiritual process of life. Some looked to mythology from Western and aboriginal, including Native American, sources to find universal spiritual meanings. Others turned to Eastern religious traditions, especially various forms of Buddhism. None of these approaches was exclusive; many cultural radicals combined different spiritual traditions.[56]

Many avant gardists felt something missing from their lives. The options they believed society offered them—scientific rationalism or middle-class materialism—did not provide them with a satisfactory sense of purpose or meaning. Little magazine editor John Fles, writing in *Kulchur* in 1960, expressed the restlessness in modernity experienced by many avant gardists: "The obvious question: Is the secular life enough, are we missing anything, anything renewing, vital? I don't know. . . . I don't think [Charles] Olson's 'Human Universe' is enough, at least for me, though it may be what is, the facts. I know I want something else, that, even, I have experienced something else: there are some things unaccounted for." Writing about the "Modern Painter's World" in 1944, Motherwell also addressed the spiritual crisis of modernity. He observed that the twentieth century had been shaped by the "spiritual breakdown which followed the collapse of religion." Into this vacuum of meaning, Motherwell argued, no "synthesized view of reality" as universally compelling as religion had emerged. Motherwell listed some contenders, however, as he dismissed science as "a method" and not "a view," and rejected the "property-loving . . . values of the bourgeois world." Motherwell held up artists as a "spiritual underground" whose purpose was to "guard the spiritual in the modern world."[57]

For most members of the cultural vanguard, innovation created a culture counter to the social and aesthetic norms of postwar America.

Through the process of innovative creativity they both expressed their dissatisfaction with what was and exposed the process of their search for something else. In both cases, their actions and expressions served as invitations to others to join with them. Thus, the spiritual quest was another aspect of avant-garde cultural politics.

Many cultural radicals experienced the process of creation itself as a manifestation of the spiritual life force that animates all things. Choreographer and dancer Martha Graham instructed her dancers to think of themselves as vehicles for "a vitality, a life-force, an energy, a quickening that is translated through you into action." Cage explained his understanding of the connection between the spiritual life and art with this story about Sri Ramakrishna:

> [Ramakrishna's] living and talking had impressed a musician who began to think that he should give up music and become a disciple of Ramakrishna. But when he proposed this, Ramakrishna said, by no means. Remain a musician: music is a means of rapid transportation. Rapid transportation, that is to life "everlasting," that is, to say, life, period.

Poets such as Snyder, Ginsberg, and Philip Whalen expressed in their work the idea that there was a spiritual reality present in the world both in creative visions and in the more ordinary experiences of work and sex.[58]

Painter Clyfford Still described the experience of regeneration that the creative process made possible for him:

> I seem to achieve ... ecstasy in bringing forth the flaming life through these large responsive areas of canvas. And as the blues or reds or blacks ... rise in austere thrusts to carry their power infinitely beyond the bounds of their limiting field, I move with them and find resurrection from the moribund oppression that held me only hours ago.

Painter Richard Pousette-Dart declared, "My definition of religion amounts to art and my definition of art amounts to religion." Describing the purpose of his art, he wrote, "I strive to express the spiritual nature of the universe. Painting is for me a dynamic balance and wholeness of life; it is mysterious and transcending, yet solid and real."[59]

The interest of cultural radicals in mythology and the primitive was not original; it reflected sources as diverse as the English romanticism of Wordsworth; the American romantic transcendentalism of Thoreau and Emerson, and the depth psychology of Jung. But these ideas were in sharp contrast to the more rational approaches of regionalist and realist art, of

the new criticism, and of the *Partisan Review*. While artists and critics in the previous movements and traditions sought to impose order on the chaos of history, the new artists looked to that chaos as a source of creative vision and spiritual growth. The avant gardist belief in vitalism both justified innovation and defined innovation as regenerative. What was important for artists in the van was to express their own spiritual struggles in the process of creating their work. In doing this, they believed they were expressing the struggles of their generation, even if their contemporaries in flannel suits did not recognize their own angst. As Kerouac asked in 1960, "When the hell will people realize that all living beings[,] whether humans or animals, whether earthly or from other planets, are representatives of God?"[60]

The Mythical Journey

Painter Mark Rothko, in writing that "without monsters and gods, art cannot enact our drama," effectively summed up the interest of many postwar avant gardists in primitive art, mythology, and spirituality. Most cultural radicals were well read in the literature of cultural anthropology and the interpretation of myth. For example, Pollock's library included J. G. Frazer's *The Golden Bough*, Ruth Benedict's *Patterns of Culture*, and Joseph Campbell's Jungian interpretation of myth, *The Hero with a Thousand Faces*. Lawrence Lipton noted that the libraries of the vanguardists he studied in California contained works by Freud, Jung, Franz Boas, Margaret Mead, Susan K. Langer, and Ernst Cassirer. The reading of American cultural radicals of this generation also reflected their strong interest in Native American culture. Pollock owned a collection of books on Native Americans published by the American Bureau of Ethnology, and he, like other avant gardists, studied Native American artifacts at New York's Museum of Natural History.[61]

Innovative artists believed that scientific rationalism and industrial modernity had created knowledge and material goods, respectively, but had not produced a symbolic language rich enough to explain the depth of human experience. The cultural radicals of the 1940s were not the first to make this argument, of course. Romantics always had done so.

By the twentieth century, anthropological interpretations defined "myth," usually also with reference to ritual, as a method of social organization, judging it neither as primitive nor (in its own terms) irrational in comparison with modern Western ideas. Psychological interpretations,

especially those of Jung, described myths as symbolic expressions of psychological struggles, often specific to the life experience of individuals, but also expressive of conflicts basic to all persons. Thus, for Jung, myths and rituals shape a collective unconscious of symbols common to all.

The counter-definition of myths as irrational expressions of "unreality" persisted, of course, throughout the nineteenth and twentieth centuries. This fact contributed to the alienation of members of the avant garde from their culture and to their interest in "primitive" mythology as an answer to the modern world view. T. S. Eliot's use of mythological material in *The Waste Land* is an obvious example. By studying these mythologies, Eliot and other members of the avant garde (including many abstract expressionist painters who were influenced by Eliot's ideas on this point) believed they could construct a new mythology that would be a force for regeneration for modern humanity. Members of the avant garde argued that the economic crisis of the depression, the horror of World War II, and the terror of the bomb had, in a sense, returned human beings to a primitive state of uncertainty and powerlessness before unknown forces, of crisis, and of tragedy. Vanguardists turned to the modern science of anthropology to learn about the primitive past and applied the insights gained to their creative work so as to return mystery and wonder to contemporary, rational society.[62]

Alienated from their society, the members of the vanguard believed that rationalism and materialism had produced social evils, culminating in the atomic bomb. "How live, accepting death?" asked poet and essayist James Boyer May in the *Grundtvig Review* in 1952, "How create, anticipating extinction?" In the atomic age, May argued, human beings needed to develop new myths that would provide people with a sense of meaning and purpose for their existence that scientific rationalism could not: "Atomic fission can render human beings neither nobler nor meaner," he asserted. Marjorie Farber, writing in the San Francisco little magazine *City Lights* in 1955, echoed May's remarks, arguing that what was useful for physical science was dangerous for human beings. "For twentieth century man who has the insights of modern depth psychology," Edward F. Edinger declared in *The Realist* in 1958, "the rationalistic negation of myth must be seen as an opposite extreme alienating man from his origins both in the individual and the historic sense." Western civilization, these cultural radicals argued, had reached an impasse; the only way forward was, in a sense, backward. By looking at so-called primitive peoples, avant gardists maintained, Americans could find the roots of their present crisis

and discover resources to help them find their way out of the crisis of modernity to a livable future.[63]

One way members of the avant garde proposed to bring about this changed consciousness was to revive older ideas about the power of word and image. Newman, for example, writing in 1947 about the art of the Indians of America's Northwest coast, noted that for the native artist, "a shape was a living thing, a vehicle for an abstract thought-complex, a carrier of the awesome feelings he felt before the terror of the unknowable." To the Native American artist, the abstract shape was "real," neither a formalist construction nor a "purist illusion." The artist, his society, and the artifact were integrated by a complex of meanings. There was no alienation. Perkoff applied this same idea to words. In the Autumn of 1956, Perkoff wrote in his journal, "In the days when man believed that the word itself brought and made things happen, was the actual cause of the god's existence, [they] had such words, such poems, to make corn grow, and rain fall, and protect [them]. . . . In our time, man doesn't believe this, and there is no community."[64]

The mission of the avant-garde artist, therefore, was to end alienation by, as Rothko wrote about the work of Still, "creating new counterparts to replace the old mythological hybrids who have lost their pertinence in the intervening centuries." Newman described the goal of cultural radicals as the creation of an "idea-complex that makes contact with mystery—of life, of men, of nature, of the hard, black chaos that is death, or the grayer, softer chaos that is tragedy." By returning to their origins and their psychological roots, members of the avant garde argued, modern people could come in contact with their true selves, selves from which industrial consumer capitalism separated them. The result of this reintegration of the self would be the regeneration of society.[65]

The Spirit of the Orient

The spiritual quest of American avant gardists at mid-century took many of them to the East. Alienated as many members of the avant garde were from American and Western values, the turn to the Orient seemed logical to them. Still, literary historian Carl Jackson is correct to point out that, given America's history as a cultural outpost of European tradition, a tradition to which American intellectuals have long looked for inspiration, the shift marked a significant cultural change. The turn to the East was not original with the postwar vanguard, however. While Henry James's

expatriation to England may have been prototypical, Lafcadio Hearne's expatriation to Japan modeled a different approach. At the turn of the century, the American Orientalist Ernest Fenollosa looked to a future fusion between Eastern and Western cultures, much as painter Mark Tobey and poet Gary Snyder would in the last half of the twentieth century. Japanese haiku interested Pound, who learned much about the arts of the Orient from Fenollosa himself. Jackson notes, however, that the late nineteenth century Orientalists and the 1950s avant garde looked to different Orients. As representatives of genteel culture in the rough and tumble world of the second industrial revolution, upper-middle-class intellectuals such as Henry Adams and Percival Lowell saw China and Japan as examples of "order and harmony" to which American civilization might aspire. The Beats, almost equally critical of industrial capitalism, looked to the Orient for "ecstasy and liberation."[66]

Asians themselves were perhaps less interested in spreading their culture to the West in general and the United States in particular, but there were notable exceptions. In 1893, Zen Buddhist master Soyen Shaku, for example, disregarded the advice of fellow priests and took Zen to the "land of the white barbarians" at the World Congress of Religions at the Chicago World's Fair. Shaku was reputedly the first Zen priest to visit the United States. He would not be the last. Through the writings of D. T. Suzuki and the Englishman Alan Watts, Zen Buddhism became well known as the Eastern spiritual tradition of choice among American avant gardists, especially those associated with the Beat movement.

For cultural radicals such as Rexroth, Ginsberg, Kerouac, Snyder, and Cage, Eastern thought provided an answer to the alienation they felt from modern American culture. From the materialism, rationalism, conformity, and fear they felt in Cold War America, these vanguardists turned to the East to find a new paradigm for society. To Kerouac, for example, the appeal of Buddhism lay in the first of the Four Noble Truths: "All life is suffering." This insight resonated with Kerouac's alienation from society and himself, and for a few years he tried to follow the spiritual discipline that Buddhist teaching presented as the answer to that suffering. Kerouac popularized Zen ideas in books such as *Dharma Bums* and *Desolation Angels*, predicting a back-to-nature "rucksack revolution" as millions of "Dharma bums" rejected the values of industrial society. Kerouac's enthusiasm for Buddhism waned by the late 1950s, however, and he returned to more traditional sources—Roman Catholicism and alcohol—to relieve his angst.

While Kerouac was the chief publicist for Zen, Snyder and Ginsberg offer examples of a deeper commitment and understanding of Eastern thought on the part of postwar avant gardists. Kerouac presented Snyder as the chief Dharma bum in the person of Japhy Ryder. This was in recognition of the help Snyder gave to Kerouac as the latter began his studies. Snyder's interest in Eastern thought dated from his youth, and after many years of study in the United States Snyder spent several years in a Japanese Zen monastery for further training. Snyder's interest in Eastern spirituality grew from his alienation from Christianity and his concern over the environmental destruction brought about by industrialism. Snyder interpreted Christian doctrines about human domination over nature as part of the environmental problem, and he turned East, at least in part, to explore "the possibilities of a civilized society operating in harmony with nature." Ginsberg became interested in the Orient after he stumbled on a book of Chinese prints in the New York Public Library. His spiritual journey took him from Zen to Hinduism to Tibetan Buddhism, where he found a spiritual home.[67]

These various religious perspectives shaped not only the world views held by postwar vanguardists, but also their aesthetics. Davidson argues that the Beat Buddhists can be divided into two groups based on different tenets of Buddhist practice to which they adhered. One group comprises writers such as Ginsberg, Kerouac, and McClure, who followed the way of Buddhist compassion *(karuna)*. In their poetry, this compassion is embodied in a receptive stance toward the world and experience. These poets attempted to be completely open to the spiritual reality present in everyday life and to present in their poetry spiritual insights just as they came upon them. An example would be Ginsberg's use of mantric forms in his poetry, as well as his attempts to deal poetically with his spiritual experiences by rejecting the use of the poetic persona and directly transcribing the spiritual voice.[68] The second group, which includes poets such as Snyder and Whalen, followed the path of Buddhist wisdom *(prajna)*. The poetry written from this perspective tends to be based on the discriminating use of detail derived from close observation of the physical world and everyday experience. While these aesthetics reflect different approaches to Buddhist enlightenment, both can be placed in a larger context of American poetry. The aesthetics of the first group showed, once again, continuity with Emerson and Whitman, the long line, improvisation, and jazz, as well as the Indian Vedic tradition that influenced nineteenth-century American romantics. The aesthetics of the

second group related them to Thoreau, to the shorter line of imagism as used by Pound and the early Williams, and the Chinese lyric tradition of poetry that influenced early modernist lyricism.

The ideas of Zen also influenced the aesthetics of John Cage. Margaret Leng Tan points out that two Zen ideas in particular were important to Cage's development: the concepts of unimpededness and interpenetration. *Unimpededness* is the idea that each person is the center of the universe and is, as D. T. Suzuki said, "the most honored of all." *Interpenetration* expresses the idea that each person should be able to learn from and connect with others and, indeed, with all around them. As we have seen, Cage developed a new aesthetic from a fusion of these two Zen ideas with Dada concepts. Cage concluded, first, that all sounds are equally valid, that there is "no need to cautiously proceed in dualistic terms of success and failure or the beautiful and the ugly or good and evil but rather simply to walk on." Second, he concluded that he should not try to force his own ideas and feelings on others with his music. By turning to chance operations, he could remove his ego from the composition process and free the sounds to be sounds open to appreciation by individual listeners on their own terms. This left the listeners, other "centers of the universe" in Zen thought, "free to be the centers." Cage's students adapted many of their teacher's insights to their work even if they did not practice Buddhist meditation, as Cage did.[69]

Conclusion

In his denunciation of the postwar vanguard, "The Know-Nothing Bohemians," Norman Podhoretz contrasted the primitive, irrational incoherence he saw in the contemporary rebellion with the advance guard of the 1920s. "The Bohemianism of the 1920s," Podhoretz wrote, "was a movement created in the name of civilization: its ideals were intelligence, cultivation, spiritual refinement." Regardless of whether Ernest Hemingway or Ezra Pound would have recognized this description, members of the new van did not read the past in Podhoretz's terms. Holmes described the 1920s rebellion as a "hollow" (though "magnificent") "debauch." The new movement of which Holmes was a part differed because, he wrote, "Our search is, I firmly believe, a spiritual one." Williams wrote that "the Beat Generation is basically a religious movement, essentially a moral movement."[70]

The commitment of many members of the avant garde to often rigor-

ous spiritual discipline and the desire of others to rediscover the mystical power of word and image testify to the aptness of the assessments by Holmes and Williams. Besides Eastern meditation, vanguard writers were interested in other spiritualities, such as animism (McClure), theosophy (Duncan), and cabalism (David Meltzer and Diane DiPrima). Podhoretz was correct in describing avant gardists as primitive and irrational. Whether this constituted a negative or a positive description was, clearly, a matter of point of view.

For members of the avant garde, alienated from the contemporary American world view, concepts of primitive mythology and Eastern spirituality seemed more "rational" and less "primitive" than the atomic bombs and Cold War ideology that Podhoretz and American society seemed to offer. Snyder argued that if a person followed the paths of contemplation, morality, and wisdom, she or he would probably "get pretty far out," and that, he concluded, was "better than moping around classrooms or writing books on Buddhism and Happiness for the masses, as the squares (who will shortly have succeeded in putting us all down) do."[71]

The ultimate goal of the spiritual quest, as of all avant-garde innovation, was to integrate art and life. Cultural radicals felt alienated from postwar America, a feeling they expressed in clear, often graphic, terms. But members of the avant garde believed that alienation was a "fallen" state. The true destiny of humanity, they believed, was to be fully connected with one's emotions, sexuality, and creativity. Postwar avant gardists rejected the political solutions proffered by the previous vanguard. But by building on the ideas of the first generation of radical innovators, members of the last American advance guard made the case in their life and in their art for a cultural politics of renewal and regeneration. Vanguardists looked beyond the present state of alienation to the future.

The Future

.

.

.

.

.

.

Members of the last American vanguard, like previous avant gardists, understood themselves to be explorers on the frontiers of the future. They did not believe that their work represented the future suddenly dropped into the present, but they did believe that their activities constituted the vital transition to the future. Cultural radicals maintained that the creative intellectual was the person in society able to envision most clearly the broad contours of what the future could be. For example, in 1956, the editors of the Los Angeles-based little magazine *Coastline* declared their purpose: "We keep our eyes open to the coastlines of the future, the unexplored continent of time which man is able to sense only in the instinct of profound creation." Members of the advance guard believed in the power of creativity to regenerate human culture so as to create a new future. The key to cultural renewal, they believed, was the ability of people to perceive their world and experiences in new ways.[1]

As believers in a better tomorrow, avant gardists shared the belief in progress typical of Western intellectuals since the eighteenth century. For many Americans, that belief was shaken by the Great Depression and World War II. But the return to prosperity and peace in the 1950s restored faith in progress and the future among most Americans, at least until the 1970s. Intellectuals, however, felt more deeply the challenges to the idea of progress and the future that occurred in the twentieth century. Writing in the *Nation* in 1955, Roderick Seidenberg noted that from the interwar years forward, utopian fiction became increasingly "more grim, more subtly brutal, more fateful and pessimistic." Cultural radicals also felt increased pessimism about the future. While most continued, in the postwar years, to articulate a hope in the future, their attitudes revealed a steady change in avant-garde ideas about that future.[2]

These avant-garde perceptions of the future ironically contributed to the domestication and end of the movement by the 1960s. In particular, during the 1950s and 1960s many avant gardists began to emphasize individual, subjective renewal over cultural renewal. Further, most radical innovators at mid-century placed less hope than their predecessors in technology as a positive contributor to the future, again choosing instead to emphasize subjective psychological factors. Likewise, American vanguardists became more skeptical of the idea of inevitable progress. Instead, they talked about cycles of progress, or they disparaged the whole idea of the future and argued that transformation would come in the present, if at all. By the 1960s, most intellectual innovators did not believe that one could meaningfully talk about culture or the future. They focused on their own creative and personal development, expecting that the future would not be much different, and certainly not better, than the present. Without the idea of the future, however, the concept of avant garde lost coherence and meaning.

Art and the Regeneration of the Self

Members of the avant garde believed that if they taught individuals how to look at the world around them in new ways, then those people would begin to challenge the values of their culture. Furthermore, avant gardists argued that enlightened individuals would begin to practice their new values in the way they lived and in this manner redeem culture. The future described by cultural radicals was one in which human beings were no longer alienated from themselves, their community, and the world.

Thus, for members of the postwar van, the theme of new vision replaced the social and political interests that concerned their Depression-era predecessors and have typically been a part of vanguard movements in general. The full impact of this change in view will be seen in Part III, which explores how these ideas made possible the appropriation of the avant garde into American society, a consequence that the members of the radical van did not intend.

The future advocated by members of the avant garde would come, they believed, through the liberation of human creativity. The artist, cultural radicals believed, provided the model for this liberation. Painter Mark Rothko insisted in 1943 that "the world is what the artist makes it." The creative innovations of the artist, radical innovators argued, formed the basis for renewal in society. Poet Louis Dudeck said, "The way to freedom in the future will lie through art and poetry. Only imagination, discovery of man's self and his relation to the world and to other men, can save him from complete enslavement to the state, to machinery, the base dehumanized life which is spreading around us." If others followed the example of the radical artist, painter Michel Seuphor declared in 1957, "everyone [could] cause a new spring to gush out, the flavor of which is not like any other." In these terms did members of the advance guard describe social renewal through the process of individual discovery.[3]

The centrality of the individual for avant gardists in the postwar years does not mean that community was no longer important to them. For most, the cosmopolitan ideal still had meaning. In 1950, Harry Holtzman and Martin James announced in the opening manifesto of their little magazine *Trans/Formation* that "The measure of man—what distinguishes man as man—emerges in his ability to *communicate, co-operate, construct*. . . . [Today] we are in a position to overcome cultural isolationism which would pit peoples and specialties against one another." Vanguardists also tried to achieve the cosmopolitan community in their own social relations. The New York-based abstract expressionists formed a recognizable community organized formally in the Eighth Street Club and informally at the Cedar Street Tavern around the corner. Similarly, in the case of the Beat poets, personal and aesthetic concerns linked the artists. Advance-guard intellectuals received a great deal of encouragement from their relations with their fellows.[4]

The cosmopolitan ideal began to transform in the postwar years, however. Increasingly, vanguardists valued the beloved community because of the support it provided for them to be themselves as individuals. Thus,

cultural radicals in the postwar years based their belief in the future on the regeneration of people as solitary individuals, not as members of a new community.

New Art, New Vision, New Being

How did avant gardists believe individual renewal would take place? They believed that the new music, literature, painting, and sculpture required people to see and hear differently. The result, cultural radicals argued, would be a new understanding of creative possibilities, a liberation of individual creativity, an expanded awareness of the purpose of life, and the development of new ways of living. For example, in 1957, John Cage wrote, "New music: new listening. Not an attempt to understand something that is being said, for, if something were being said the sounds would be given the shapes of words. Just an attention to the activity of sounds." Anne Waldman described the function of the poet as "the first person to begin the shaping and visioning of the new forms and the new consciousness when no one else has begun to sense it. . . . Pound once said, 'Artists are the antennae of the race.' Whether or not we have an audience, this strong visioning and shaping of a master poem informs the conscience of generations to come." In 1951, writer Jacqueline Johnson, wife of painter Gordon Onslow-Ford, described the work of her husband and other avant-garde artists as the "transformation of reality by a trans-formation of our own awareness."[5]

Cultural radicals communicated the idea of a transformed vision and new world to younger artists. Painter Elmer Bischoff, for example, re-membered the atmosphere at the California School of Fine Arts in the late 1940s. Douglas McAgy, the director, championed the abstract expres-sionists and hired painters Clyfford Still and Mark Rothko to teach at the school. Bischoff recalled that, though no one talked about the "service" art might perform for people, the students tended to believe that "their work might play a role in the forming of a better world—that it might assist toward deeper understanding between people. . . . That gestures in paint on canvas or gestures in welded metal and wood . . . and stone could become . . . liberating to all who had eyes."[6]

Cultural radicals believed that if they presented their works to as many people as possible, especially the younger generation, they would redeem the future. Allen Ginsberg wrote to his lover, Peter Orlovsky, "Bill [Bur-roughs] thinks new American generation will be hip and will slowly

change things—laws and attitudes, he has hope there—for some redemption of America, finding its soul." Ginsberg was perhaps not as confident as Burroughs, noting the "competition and deception" he saw in modern America, but Ginsberg believed redemption possible if everyone "lov[ed] all life. . . . More and more I see it [love] isn't just between us, it's a feeling that can be extended to everything."[7]

A historical pattern emerges from this evidence that differs from past interpretations of the postwar years. Many historians have noted a rhythm in American intellectual and cultural history in the twentieth century, as thinkers moved back and forth between focusing on self and focusing on society. In the 1920s, cultural radicals emphasized the intellectual's individual quest for the true self. In the 1930s and 1940s the social responsibilities of the intellectual took precedence. In the late 1940s and the 1950s, according to the standard interpretation, individual self-expression once more became important for intellectuals. In the 1960s, the responsibilities of the self to society would energize intellectuals once again. Such a reading of the postwar period is superficial, however. The evidence presented here suggests that the postwar avant gardists conceived of the self as arbiter of social values. They defined the good society as that in which all individuals experienced emotional fulfillment. This attitude underlay the avant-garde protest of the 1950s and the counterculture movements in the 1960s. The hippies represented a "mainstreaming" of avant-garde attitudes, and this "quest for the ideal self," as Peter Clecak calls it, continued to be a major theme in American society through the 1970s and into the 1980s. The new vanguard contributed an ideology to American culture that could undergird both social protest and individualism by subsuming society and culture under the quest for self-expression.[8]

Technology and the Future: Birth or Death?

After 1945, and in tandem with the increased focus on the self, many American vanguardists changed their understanding of the relationship between technology and the future. The members of the historic avant garde generally believed that technological and scientific creativity contributed to human liberation in much the same way that artistic creativity did. Technological optimism was especially typical of American cultural radicals. Many American and European avant gardists used technological motifs in their works; the machine imagery of American precisionists Charles Demuth and Charles Sheeler is an obvious example. The Hun-

garian vanguardist Laszlo Moholy-Nagy, a onetime member of the Bauhaus faculty who immigrated to the United States to escape Nazi oppression, epitomizes the attitudes of many first- and second-generation radical innovators toward technology: "The reality of our century is technology: the invention, construction, and maintenance of machines. To be a user of machines is to be of the spirit of this century. It has replaced the transcendental spiritualism of past eras." The optimism felt by early vanguardists about the possibilities of technology in life and art was part of the standard account made in the postwar years about cultural radicalism. For example, in a 1954 issue of the *Partisan Review*, critic Clement Greenberg described the turn-of-the-century avant garde as "the first to accept the modern, industrializing world with any enthusiasm. Even poets—thus Apollinaire—saw, at least for a moment, aesthetic possibilities in a streamlined future, a vaulting modernity; and a mood of secular optimism replaced the secular pessimism of the Symbolist generation."[9]

The last American van would not respond so favorably to technology, however. As noted in chapter 3, the bomb produced almost universally negative reactions from cultural radicals. Many innovators in the 1950s and 1960s would remain alienated from technology, science, and the rationalist mode of thought associated with both. As critic Meyer Shapiro noted in 1957, recent events had rendered "the values of technology less interesting and even distasteful" to contemporary intellectuals because, from their point of view, technical rationalism denied the expressive power of the self. Some cultural radicals, however, continued to affirm that art, science, and technology could together contribute to a positive future. For these intellectuals, the problem facing society was less the excessive reliance on scientific rationalism than a lack of balance between the subjectivity of art and the objectivity of technology and science.[10]

Many members of the last American vanguard were skeptical of their predecessors' faith in the technological future. The skeptics believed not only that technology such as the bomb threatened the future, but also that it came with a world view that placed the machine values of rationality and efficiency above the creative human values that members of the advance guard prized. American vanguardists viewed their society as, in the words of one critic, writing in 1949, a "sick or dying culture, strangling from over-civilization, over-mechanization and de-humanization, world wars, mass butchery, killing and degradation." Cultural radicals rejected a technocratic value system that described human beings as "assemblages of . . . biological, sociological, and other functions" and seemed to reduce hu-

man life to "a number in the coroner's table." This technocratic world was an avant gardist's nightmare. Indeed, Gary Snyder described a dream of "a new industrial dark-ages: filthy narrow streets and dirty buildings . . . unwashed illiterate brutal cops . . . tin cans and garbage and drooping electric wires everywhere." Snyder's dream was not unlike a scene from a William S. Burroughs novel. In works such as *Nova Express*, *The Ticket That Exploded*, and *The Soft Machine*, Burroughs described a dystopia in which technology ran amuck, or was used an instrument of tyranny and terror by the Secret Police, or both.[11]

While some saw a postwar world of social and economic advance, others saw a world of social and aesthetic squalor. Painter Mark Tobey observed that contemporary builders replaced structures embodying "human dimensions" with "uniform boxlike buildings which seem poor orphans of the once promising Bauhaus tradition," buildings that "never appear to have been touched by human hands." For Tobey, these buildings were a visible sign of an encroaching "impersonalism" that he believed to be "a child of our over industrialism and our belief in the material man." Editor James Boyer May echoed Tobey's concerns, declaring that intellectuals had "oversold material 'progress.'" He argued that the technological and scientific models that supported "Progress" had impeded aesthetic development:

> Emphasis on scientific method, from a notion that knowledge may be enlarged only through processes modelled on laboratory experimentations, has raised havoc with contemporary writing. The fanatical imagists have ignored that empirical devices apply only to materially and temporally limited research, and that over-concentration on them blocks speculative imagination. (In truth, in sciences themselves, the greatest advances have followed quite "unscientific" and essentially poetic theories.)

In a similar vein, psychiatrist James Russell Grant wrote in *Trace* in 1957 that "it is the poet who gives words their meaning, and . . . extends the realm of consciousness," while the scientist narrows it. Writer Frederick Kiesler declared in a catalog for a show of the surrealist painter Hans Richter at Peggy Guggenheim's gallery Art of This Century, "The vision of art precedes that of science." For many members of the advance guard, the creative imagination was the surest guide to the future.[12]

According to cultural radicals, much technology alienated people from their creative selves. Writer Robert Anton Wilson, for example, condemned television in a 1960 essay in the *Realist*. Calling television a "One-

Eyed Monster," Wilson declared that "we have lost contact with our own bodies, with the biological core-energies of life with their million year hungers, and are masturbating in front of TV sets instead of jazzing time to make it pregnant with a more aware future." T. J. Jackson Lears has argued that members of the late nineteenth-century bourgeoisie felt "weightless" as the processes of urbanization and technological development seemed to separate them from fundamental experience; similarly, Wilson and other twentieth-century avant gardists believed that their society left them alienated from the basics of living. According to cultural radicals, radio, television, and other media increased the variety of possible ersatz experiences in the postwar years, but real, quality experience remained elusive for most people. Technology was not the answer, vanguardists declared; a fuller life with a deeper sense of meaning had to be searched for in other places.[13]

The interest of radical intellectuals in myth and so-called "primitive" cultures is another expression of their desire to find a model for the future other than the scientific, rationalist, technologically progressive Euro-American one. Pointing to the example of the Native Americans, Barnett Newman observed in 1946 that "the many primitive art traditions stand apart as authentic aesthetic accomplishments that flourished without benefit of European history." Harry Partch was fully aware that the instruments he invented on which to play his music—various stringed instruments, modified reed organs, and numerous percussion instruments—were an "anomaly" for the mid-twentieth century, "primitive means to an expanding musical idea—and this in an age of universal admiration for mechanical miracles and universal acceptance of scientific authority." For Jack Kerouac, the values and way of life of the poor peasants of the earth, the "fellaheen" as he called them (after Oswald Spengler's *Decline of the West*), defined the only world that would last. On the road in northern Mexico, Sal Paradise, Kerouac's narrative voice, observed that the fellaheen

> had come down from the back mountains and higher places to hold forth their hands for something they thought civilization could offer, and they never dreamed the sadness and the poor broken delusion of it. They didn't know that a bomb had come that could crack all our bridges and roads and reduce them to jumbles, and we would be as poor as they someday, and stretching out our hands in the same, same way.

Avant gardists, therefore, urged Americans to look to non-industrialized cultures as well as to look deep within themselves.[14]

A second group of vanguardists continued to argue that both modern science and innovative art could contribute to a liberated human future. For example, painter Wolfgang Paalen wrote in 1945 that "art and science are indispensable complementaries; . . . only their cooperation will be able to create a new ethics." Composer Edgard Varèse, a member of the first-generation vanguard, served as a link between the generations. Before the technology of tape recorders and synthesizers had been invented, Varèse championed the development of such new musical technologies. In the years after World War II, he made use of emerging possibilities in electronic sound in compositions such as *Déserts* (1949–1954) and *Poème électronique* (1957–1958). Writing in the abstract expressionist-associated little magazine *Possibilities* in 1947, Varèse declared that while human understanding of space, time, and matter "is no longer what it was for us in the past," the arts have not yet completely expressed these changes. "Music," he maintained, "should be the first to reflect this revolution, as it could be the art to benefit the most." In lectures and essays in the 1950s, Varèse described electronics as "our new liberating medium," and he declared that technology "has freed music from the tempered system, which has prevented music from keeping pace with the other arts and with science." Varèse expressed special pleasure that "composers and physicists are at last working together and music is again linked with science as it was in the Middle Ages." The result, he believed, would be continued advances in music-making technology.[15]

John Cage, too, believed that technological development would contribute to the liberated future about which avant gardists dreamed. Cage's thought reflected the influence of media theorist Marshall McLuhan and technological utopian R. Buckminster Fuller. Cage argued, following Fuller, that by the end of the twentieth century, technology would enable all basic human material needs to be met. Furthermore, Cage contended, following McLuhan, individual attempts to "make life endurable" by transforming one's consciousness, such as Zen meditation or artistic creativity, now took place on a corporate level because modern communications technology created an "exteriorized" nervous system that linked human minds and emotions. The intelligent application of new technology, Cage maintained, could transform the collective human consciousness. And indeed, he said, the process was happening "inevitably" as technology created a new "global mind." Because of technology, therefore, Cage declared that "we can become people devoted to life rather than to competitiveness and the killing of one another." The technologi-

cal evolution of human society enabled people to concentrate on integrating art and life, according to Cage.[16]

Cultural radicals expressed their technological optimism by incorporating technology into their work. In 1952, for example, Cage produced one of the earliest compositions for tape. In the mid-1960s, Cage, Robert Rauschenberg, several members of the Judson Dance Theater, and other artists collaborated with engineers from Bell Telephone Laboratories to produce 9 Evenings: Theatre and Engineering (1966), a project defined by the goal "technology for art's sake." Rauschenberg also communicated the positive possibilities of technology in his works. In pieces such as Barge (1962–1963), Rauschenberg presented silkscreen images of technologies used for communication, transportation, and space exploration. In this work, the artist depicted technology as an agent that brought people together and widened human knowledge and experience. Rauschenberg also included images of military vehicles to suggest the negative possibilities of technology, but the overall impression was one of guarded optimism.[17]

Although the musical instruments he invented were not electronic, Patch also called for the development of new technology. He urged record companies and musical instrument manufacturers to follow the lead of chemical and electronic companies and establish research and development departments so that "music as an art might become imbued with the spirit of curiosity and investigation which characterizes our sciences." But Partch also argued that "forward looking composers" should be a part of these developments. Otherwise, the new electronic music would be just a technologically sophisticated version of the music of his day and "so much musical flim flam in a vacuum, so far as real values are concerned." Thus, many cultural radicals continued to believe that technology could further human creativity.[18]

The New Future: Contingent, Not Progressive

While members of the avant garde continued to look to the future in the postwar years, their conception of the future changed in the 1940s and 1950s. The confident faith of 1930s vanguardists in progress as a process of regular development did not survive the vicissitudes of Communist Party politics or the brutality of World War II. The new generation of

cultural radicals defined the future in evolutionary and cyclical terms. They believed life was a constant struggle and each triumph over adversity a temporary victory that could be overturned in the next conflict. New- man's 1945 painting *The Slaying of Osiris* illustrates this pattern of thought. Osiris, of course, was the mythical Egyptian king who was murdered, cut into pieces, and scattered across the country. His wife, Isis, pulled his pieces together and resurrected him. The story of Osiris thus symbolized the cycles of death and rebirth seen in the seasons and the circle of generations. Radical innovators like Newman looked to these mythological models to formulate their conceptions of human history and their hope for the future.[19]

In 1953, painter Jack Tworkov discussed the contingent quality of human experience in an essay in the avant-garde art journal *It Is*. Tworkov argued that "there is no foreseeable future. Man acts on his environment but his deeds do not necessarily accomplish his heart's desire." Tworkov used the example of the Russian Revolution to illustrate his thought. No Marxist in 1917, he said, could have foreseen the reality of Stalinism, nor accepted totalitarianism as the fulfillment of her revolutionary dreams. But Tworkov also turned to the example of the Pilgrims in America. He argued that modern America was not what the Pilgrims had in mind; but for all its faults, he preferred that world to the one the Pilgrims would have desired. According to avant gardists like Tworkov, the future was a gamble. One could never be sure how things would turn out. But if the evolution of human culture was not always to the good, it was not always destined to be bad either. Tworkov believed in the possibility of human action to accomplish the "heart's desire," especially the action of the advance guard: "Destiny's tools are the avant-garde. A man cannot make his life, but whatever he makes, that's his life. And since we never make and cannot make the same things, everything keeps on changing."[20]

In 1956, writer and little magazine editor Barding Dahl similarly de- clared his satisfaction that "the great damage wrought by the concept of endless progress towards perfection is on the mend." Dahl maintained that people were learning from psychology to "adjust" to the present situation and the possibilities inherent in it. As a result, he concluded, "we will again have great enterprises of the hand and mind which will be untroubled by the knowledge that the failure of the enterprise may or may not set back the charter date of utopia. Playing the game is what counts." Avant gardists did not know for sure what the future would be,

but they knew it would be different because the rising and falling of human evolution was inevitable. And human action, they believed, was part of that future.[21]

In the person of the hero, members of the advance guard connected their interest in myths and rituals of the past with their interest in the future and the self. Vanguardists drew their ideas about the hero from books such as Friedrich Nietzsche's *The Birth of Tragedy* and Joseph Campbell's *The Hero with a Thousand Faces*, and from their studies in anthropology and ethnography, including Native American traditions. For cultural innovators, the hero represented the power of human action to shape human destiny, or at least to argue with the forces that move through history. Whether they described the poet as a "shaman" or the painter as an "image-maker," members of the vanguard communicated their self-understanding to be creators of new patterns of thought that could restore meaning to life and thus create a purposeful and livable future. In 1949, painter Adolph Gottlieb declared the "times are out of joint" as "our aspirations have been reduced to a desperate attempt to escape from evil." Choreographer Martha Graham wrote that people sought "some pattern in which they can engage their destinies." She concluded that the artist should be an "angel" leading human beings to new destinies: "Not angel in the strict Christian sense of the word, but angel in the new sense created by the contemporary artist—a sense which is transforming the outdated hero of physical action into the new hero of spiritual action." Again, the future would not be created by reordering the political and economic realms, but by individuals transforming the spiritual or psychological realm. New "seeing" could produce a new culture, though not an immutable one.[22]

The Art of Now

While some cultural radicals redefined the future in terms of ancient myths and the cycles of nature, other members of the innovative van abandoned the future and focused on the present as the only reality. Adherents to the "art of now" tended to be slightly younger vanguardists, those born in the 1920s and later, who came of age intellectually after the war. Too young to have been directly influenced by the historical determinism of Depression-era Marxism, they were aware of the disillusionment felt by older innovators whose hope was betrayed by the Stalinists. More importantly, they were deeply alienated from postwar American

society and keenly aware of the menace of the bomb. The sense of alienation that inspired avant-garde creativity reached such an intensity in many postwar vanguardists that the idea of the future lost meaning.

In this context, the philosophy of existentialism found a receptive audience in American intellectuals. Existentialism appealed at several levels. The themes of absurdity and meaninglessness resonated with many vanguardists living in the shadow of the bomb. More hopefully, the notion that in the absence of absolutes only individual self-creation remained appealed to American intellectuals searching for a world view that gave meaning to action instead of passive despair. Many cultural radicals in the decade after World War II were aware of the new philosophy. Willem de Kooning remembered that "existentialism . . . was in the air, and we felt it without knowing too much about it." Mark Rothko incorporated some existentialist ideas into his writings.[23]

Rosenberg, in his description of abstract expressionism as "action painting," presented an existentialist interpretation of the movement. Rosenberg did not present an accurate depiction of the ideals of the abstract expressionist vanguard, but his interpretation of the artist expressing his or her quest for individual identity influenced a younger generation of artists who did not have the same cultural and intellectual concerns as the older vanguardists. The writings of Henry Miller, banned in the United States at this time but available in editions smuggled from abroad and in the lore of underground communities, exerted a similar influence. Miller, like the existentialists, was not interested in culture. He demonstrated in his work no desire to belong to a community or participate in cultural renewal. He merely depicted his experiences, affirming through the creative act only that he existed. Influenced by these ideas, a younger generation of avant gardists redefined innovation as the creative expression of their search for themselves. They claimed no responsibility for the future of the culture. Thus, existentialism contributed to the end of the advance guard.[24]

The turn by avant gardists from culture and the future to the art of now was influenced by Cage even more than by existentialism. Cage presented a concept of nothingness even older and profounder than existentialism, one rooted in Eastern philosophy. Cage combined Zen ideas, as popularized by Alan Watts and others, with historic vanguard notions about the union of art and life to develop his aesthetic of the present. Zen masters taught that both the future and the past were illusions; these times existed only in one's imagination. In truth, they

taught, the only time that really existed was the present. Watts summarized this line of thought by saying, "Zen is a liberation from time." Zen thinkers also rejected Western ideas of cause and effect. As Cage explained, "What is meant is that there are an incalculable infinity of causes and effects, that in fact each and every thing in all of time and space is related to each and every other thing in all of time and space." Since everything in the universe was related, no single line of cause and effect could be singled out. Thus, whatever one did reflected the influence of the past and shaped the future even as one could not hope to untangle the precise relationships. Cultural radicals who adhered to this point of view could consistently profess some responsibility for the future and advocate a radical presentism at the same time. Thus, Cage defined contemporary music not as the "music of the future" but as the "music present with us: this moment, now."[25]

The Art of Epiphany

Combining the Zen notion that one's attention should be on the present moment with the vanguard goal of integrating art and life, cultural radicals redefined their relationship to their art, their society, and their future in three different ways. First, and most importantly, these radical innovators emphasized even more emphatically than other avant gardists the priority of the moment of epiphany over an abstract future. Second, they argued that the creative process and the work—or, more often, the experience that resulted—were self-contained and needed no outside reference or goal to be complete. Third, present-focused vanguardists tended to create for a small community of the enlightened who could understand works that were often strikingly innovative technically even in comparison with the art of other radical innovators.

The new generation of avant gardists asked their readers or viewers not to look to the future, but to be participants and to learn how to pay attention to their own senses and to their observations of the world around them. These cultural radicals emphasized the possibilities for epiphany in the creative act and the present moment. In 1958, composer Christian Wolff described his music as follows:

> It goes in no particular direction. There is no necessary concern with time as a measure of distance from a point in the past to a point in the future, with linear continuity alone. It is not a matter of getting anywhere, of

making progress, or of having come from anywhere in particular. There is neither nostalgia nor anticipation.[26]

Stuart Z. Perkoff proclaimed his belief in the creative process and his commitment to a life for art on the night he spent on the beach at Venice, California, writing poems dedicated to the muse of poetry that he promptly burned in a driftwood fire. The idea of synthesizing art and life became less a definition of what human life should be and increasingly only a moment of epiphany. A larger audience learned of these ideas from Kerouac, whose peripatetic characters in *On the Road* found liberation and meaning in special moments, whether on lengthy, usually spur-of-the-moment, auto trips; in long, intimate conversation; or in the ecstatic climaxes of jazz music.[27]

Avant gardists who created for the present believed that art did not require any extraneous references or larger purposes. They rejected the mythological concerns of the abstract expressionist painters, for example. In 1958, painter and "happening" creator Allan Kaprow remarked on the influence of Jackson Pollock that his "concern with the unconscious, with primitive myth and ceremony, with the crisis of self-realization, in short, with the romantic urgency of creativity, are surely not factors in today's art."[28]

Nor did this new group of avant gardists look to their work as a means to the future and a new society. Rauschenberg recalled that as a young painter in the mid-1950s trying to make his way in the wake of the abstract expressionists, "the kind of talk you heard then in the art world was so hard to take. It was all about suffering and self-expression and the State of Things. I just wasn't interested in that, and I certainly didn't have any interest in trying to improve the world through painting." Cage maintained that art should be a simple "affirmation of life." Art should not, he wrote, "attempt to bring order out of chaos nor . . . suggest improvements in creation, but simply . . . wake us up to the very life we're living, which is so excellent once one gets one's mind and one's desires out of the way and lets it act of its own accord." Composer La Monte Young described his pieces as "theatrical, . . . inclusive, and intentionally purposeless."[29]

The aesthetic of the present also heightened both the sense of alienation and the sense of community among cultural radicals. For many avant gardists, the art of now provided an ideology counter to the future-oriented careerism of postwar America. For example, the members of the

Venice, California, vanguard community dedicated their lives to art. They created for their own community and worked at odd jobs only long enough to earn the minimum needed to support themselves. For the most part they did not seek notoriety beyond their community. They understood the life of voluntary poverty and artistic obscurity they pursued as a way of rebelling against the bourgeois ambition and careerism that their parents (and society) had tried to instill in them. The Venice bohemians appeared to have been aware of the irony that they were pursuing their antimaterialist dream in a place (Southern California) that to most Americans represented the ideal of material abundance and the cutting edge of the future.[30]

The model of artist as shaman was especially appropriate to these avant gardists. The shaman worked his magic for a community. His work was not preserved as a collector's commodity or a museum exhibit. Thus, Cage suggested that painters and poets turn away from permanent pigments and bindings and look to performance models such as dance, music, or Indian sand painting, activities that could not be historicized as part of the evolution of an art form. Cage's own work tends toward pieces that encourages sensory awareness or meditation, rather than aesthetic pleasures—work, that is, more in the tradition of ritual and spirituality. These artists believed that anyone could assume the role of shaman by liberating the creative energy within him or herself. Instead of looking to a future utopia, they called on individuals to integrate art and life now and be exemplars for others.[31]

Happenings

The themes of present epiphany over the future, self-contained work, and performance for a coterie are all illustrated by the new avant-garde art forms that emerged in the late 1950s: the "environments" and "happenings" developed by artists Cage, Kaprow, Jim Dine, Claes Oldenberg, Robert Whitman, and others. Environments are ordinary spaces (usually in a gallery) transformed by the artifice of the artist into a new surrounding that engulfs the viewer in the art. Happenings combine environments with "movement and activity" (as Kaprow put it) of a quasitheatrical nature. In both art forms, the experience of participation is more important than the objects assembled. As temporary installations that exist in improvisatory performance, there is nothing to go into a museum along with other objects for contemplation.[32]

The happening was developed independently by both Cage and Ka-
prow. The first happening is generally considered to be an event staged
by Cage and others at Black Mountain College in 1952. In a college
dining room in which paintings by Rauschenberg and Franz Kline were
displayed, Cage stood reading on one ladder, poet Charles Olson read
another text from another ladder, Rauschenberg played scratched phono-
graph records, David Tudor played the piano and the radio, and Merce
Cunningham danced among them all.[33]

According to Kaprow, the idea for environments and happenings de-
rived from his experience of viewing a 1950 show of paintings by Pollock.
Kaprow recalled how the paintings covered all the windowless walls of
the Betty Parsons Gallery, creating "an overwhelming *environment*, . . .
drenching and assaulting the visitor in waves of attacking and retreating
pulsations." Thus, for Kaprow at least, Pollock was less successful in
communicating psychological and mythical themes of the heroic quest
and the struggle to create meaning than he was at creating a completely
self-referential environment. Indeed, Kaprow described happenings by
saying, "They appear to go nowhere and do not make any particular
literary point."[34]

A couple of examples of happenings illustrate Kaprow's point. George
Brecht designed a happening called "Motor Vehicle Sundown (Event)"
(dedicated to Cage) that involved any number of motor vehicles arranged
in a field in which performers would, at sundown, follow instructions to
honk the horn, turn on the lights, or operate special equipment on their
vehicle such as sirens or ladders. La Monte Young's "Composition 1960 #
3" required the performer to ask everyone present to do whatever he or
she wished for the period of the composition. In all these works, the
present moment of participation/performance was what mattered. That
moment might transform one's way of perceiving, but the artist did not
provide a larger frame of reference in which to place that transformation,
nor a very clear goal for the transformation.[35]

To Kaprow, the transitory improvisations of the happenings created
the ultimate defense against historicism. He noted that "nearly every
artist, working in any medium from words to paint, who has made his
mark as an innovator, as a radical in the best sense of that word, has, once
he had been recognized and paid handsomely, capitulated to the interests
of good taste, or has been wounded by them." But happenings preserved
the artist from the pitfalls of success. The events could not be reproduced,
and the materials used to create the environment were "perishable" items

such as "newspapers, junk, rags, old wooden crates knocked together, cardboard cartons, . . . food, borrowed machines, etc." Happenings could not "be sold and taken home; they can only be supported." Thus, Kaprow concluded, the artist "embodies the myth of Non-Success, and remains isolated and proud."[36]

Conclusion

In the postwar years, members of the advance guard became split over their views of the future. The division was based on a turn from society to subjectivity, but it was also generational. Having rejected the Marxist social critique, cultural radicals turned to emotional and spiritual interpretations of the human predicament. The concern for society felt by many avant gardists became obscured by their focus on individual subjective states. Thus, while one segment of the last American vanguard tried to describe a redeemed future in terms of myth, another, generally younger group, focused on the here-and-now appreciation of the sublime moment. The two stances toward the future often produced only subtle differences in emphasis, typically a heightened awareness of historic avant-garde themes about the union of art and life. But subtle or not, the change had a profound effect on the relations between cultural radicals and their society.

By the late 1960s, probably a majority of innovative intellectuals believed that the present was more important than the future. Painter Frank Stella declared, "My painting is based on the fact that only what can be seen there is there. It really is an object. . . . All I want anyone to get out of my paintings, and all I ever get out of them, is the fact that you can see the whole idea without any confusion. . . . What you see is what you see." The title of one of writer Marvin Cohen's short pieces expressed the doubt of many intellectuals from the 1960s forward that questions about the future, culture, and meaning were even possible: "What Is the Real, Really? What Does It Mean? Or Do We Only Think It? *Is* There a Real? But What Is 'Is'? And What Does It Mean?" In 1963, pop artist Robert Indiana expressed his belief that art could do little to transform the world: "Pop does tend to convey the artist's superb intuition that modern man, with his loss of identity, submersion in mass culture, beset by mass destruction, is man's greatest problem, and that Art, Pop or otherwise, hardly provides the solution—some optimistic, glowing harmonious, humanitarian, plastically perfect Lost Chord of Life."[37] The

moment of epiphany was both self-referential and fleeting. For Indiana, as for others, the creative act had no influence on the future of culture.

Not only did innovative intellectuals abandon the historic avant-garde concern for the future, they also rejected the goal of integrating art and life. In 1963, Dine declared that he did not believe in the concept. Dine's use of common objects in his work did not mean, he said, that he was making a statement about art and life. "There's art and there's life," he maintained, "I think life comes to art but if the object is used, then people say the object is used to bridge that gap [between art and life]—it's crazy. The object is used to make art, just like paint is used to make art."[38]

By the 1960s, members of what had been the advance guard were repudiating much of the historic avant-garde ideology. This change in thought made possible the disappearance of the vanguard through institutional enthrallment and commodification in capitalist consumer culture. One of the first stages of this enthrallment was the appropriation of the avant garde by American Cold Warriors.

The End of the Avant Garde
1950-1965

.

.

.

.

.

.

The Cold War, Cultural Radicalism, and the Defense of Capitalism

.

.

.

.

.

.

olitical leaders of the Cold War between the United States and the Soviet Union defined the struggle as a war between cultures. The conflict between the "American way of life" and Soviet society was seen clearly in the so-called "kitchen debate" between Vice President Richard Nixon and Soviet Premier Nikita Khrushchev. In the kitchen of a model house at the 1959 United States National Exhibition in Moscow, the two leaders debated the merits of washing machines versus tanks. Of course, in the United States companies like Westinghouse produced both consumer goods and military hardware and the presidents of Procter and Gamble and General Motors both served as secretaries of war during the Cold War. The consumer culture and the militarized society were closely linked.

In one of the many ironic developments that contributed to the end of the avant garde, cultural Cold Warriors appropriated the vanguard as a weapon in the war of ideas between the United States and the Soviet

115

Union. To these Cold Warriors, avant-garde innovations demonstrated the freedom and superiority of Western democratic culture. As other Americans began to interpret the vanguard in this way also, the movement became domesticated as a demonstration of how basically good American society was. This outcome was ironic, because the politics of the Cold War alienated members of the avant garde. The cultural vanguard interpreted the conflict between the United States and the Soviet Union as both a threat to vanguard values and a betrayal of American ideals. But, to compound the irony, avant gardists also contributed to their own appropriation because their self-understanding paralleled many of the cultural themes advocated by Cold Warriors, in particular, the concept of cultural freedom.

The Avant Garde and the Politics of the Cold War

To radical critics, the Cold War meant militarism and an attack on dissent. Little magazine editor Horace Schwartz described the political situation as a "nightmare" in which Americans engaged in an irresponsible "orgiastic carnival of denying reality and embracing falsehood." If Thomas Jefferson were alive, Schwartz continued, he would "cut his throat for shame." To writer Leslie Woolf Hedley, "The air [was] charged with the stiff and sterile military mindlessness." From the perspective of the cultural vanguard, the political and social consequences of the Cold War were just one more example of a conformist society that lived a lie at the expense of authentic human existence. These radical critics, therefore, repudiated both the anti-Communism of Senator McCarthy and his allies and the liberalism of the architects of the Cold War. Vanguardists believed that they saw an American fascism evolving, but they also rejected the Marxist solution that had energized cultural radicals in the 1930s.[1]

In the opinion of radical intellectuals, the conflict between the Soviet Union and the United States was not about ideology but about power, specifically, political and economic power. Militarism and materialism, they argued, were part of the same formula to divert people's attention from what they really needed and from what was really going on. Gary Snyder believed he described both East and West when he said, "The national politics of the modern world exist by nothing but deliberately fostered craving and fear—the roots . . . of human suffering." Bull Lee, a

character in Jack Kerouac's *On the Road* patterned after William S. Burroughs, comments "They can make clothes that last forever. They prefer making cheap goods so's everybody'll have to go on working and punching timeclocks and organizing themselves in sullen unions and floundering around while the big grab goes on in Washington and Moscow."[2]

In the 1950s, cultural vanguardists feared that in its fight against Communism the United States would become totalitarian. Critic Lawrence Barth, writing in *Trace*, pointed to a rash of book censorship in the early 1950s and commented, "Just like that do we go down the road of Soviet Russia and Nazi Germany." While he acknowledged that the United States had a long way yet to go on the "sliding scale of repression," Barth stated confidently that "America is rapidly *becoming* fascist." He compared the United States with the Soviet Union and saw ominous similarities:

> Today the Soviet government's snooping, denouncing and jailing, its horrible automaton-manufacturing school system and vast emphasis on militarism and building weapons are in essence matched by the psychotic building of murder machinery here, by our congressional thought-control committees, our intense atmosphere of prying and name-wrecking. People in omnibuses and parks no longer speak aloud about anything that could be construed as "controversial," in what our ancestors once proudly called "the land of the free."[3]

The editors of *Inferno* expressed similar fears in advertisements for their little magazine: "*Inferno* publishes the works of the last free poets of the American dark age." Burroughs uses black humor to address these anxieties about the future of freedom in his novel *Naked Lunch*, a work described by avant-garde poet John Clellon Holmes as a retelling of George Orwell's *1984* by W. C. Fields. In 1956, Snyder suggested sarcastically that Allen Ginsberg conclude his poem "America" with a question:

> *America, what are you going to do to me for writing*
> *about you like this?*
> *are you going to snoop after me and let the air out*
> *of my tires[?]*

The following year, Ginsberg's book *Howl and Other Poems*, which included "America," was censored as obscene. Members of the avant garde experienced American society in the postwar years as stiflingly conformist. The international tensions of the Cold War served only to heighten

the concerns of avant gardists for individual expression and freedom of thought.[4]

Most members of the avant garde were so alienated by what they considered to be the extremes of the Cold War and the conformity present in the society around them that they rejected the mainstream political options before them. Vanguardists also generally rejected the radical alternative chosen by their predecessors: Marxism. Poet Oscar Collier, in a letter to writer and editor Judson C. Crews, expressed the opinion of many avant gardists: "I am not in sympathy, but am actively against any contemporary political movements. I am especially against Communism, Marxism, and scientific socialist movements of any kind." Some kind of anarchism was the political and social view adhered to by most members of the cultural vanguard.[5]

As we have seen, members of the vanguard felt deeply alienated from the "Eisenhower blandness." But the political alienation of cultural radicals went deeper than a rejection of the Republican Party. The liberalism of the decade seemed to most avant gardists to be at best a tepid solution to the serious problems in American society. Barth wrote in *Miscellaneous Man* that "generalized liberal exhortation solves very little so long as the human animal remains sexually sick at his core, irresponsible, inert." Barth argued that the political process was not the path to a more authentic existence; rather, people needed to look at human beings in a more basic, biological state. By replacing culturally defined needs and roles with needs that reflect human biology, especially needs for sexual expression, human beings could begin to shape a culture suited for human development. At its worst, liberalism was part of the problem. Burroughs thought liberalism was oppressive and advocated a radical libertarianism. As Burroughs wrote to Kerouac:

> You notice that any oppressive, meddling piece of legislation (anti-gun, anti-sex . . .) is always loudly supported by the "Liberal" press? The word Liberal has come to stand for the most damnable tyranny, a sniveling, mealy mouthed tyranny of bureaucrats, social workers, psychiatrists and union officials. The world of 1984 is not 30 years away.

To Burroughs, Kerouac, and other avant gardists, liberalism was just another side of the Eisenhower conformity, or, as Kerouac's younger readers would learn to say, liberalism was part of the problem, not part of the solution.[6]

The Cold War and the Coopting of the Vanguard

Cultural Cold Warriors commandeered the avant garde into mainstream society by linking lifestyle choices and personal freedom. Critic and social commentator Joseph Wood Krutch explicitly linked lifestyle, consumption, and freedom in an essay published in *House Beautiful* in 1951. Krutch characterized the Cold War as a contest between organic and mechanistic world views. Totalitarians, said Krutch, describe people as machines— manipulable and devoid of feeling. Those who believe in freedom, however, look for their models in the natural world where, Krutch maintained, "every individual leads its own individual, unique, and rebellious life." This war of ideas was being fought militarily and politically, but Krutch contended that there were some "simple, direct" actions by which people could choose up sides and contribute to the struggle "against the forces which are conspiring to rob us of our humanity." He argued that people's choices in taste and fashion were weapons in the war: "The houses we live in, . . . the very decoration of our walls, proclaim where our own sympathies lie and subtly influence our own convictions." In the choice of fabrics for clothing and upholstery, in landscaping, in house design, in the choice of objects on the mantelpiece, Krutch declared, people could express their individuality and freedom. He denounced the dictates of official fashion for "subtly, if not consciously, attempting to deny that we are organisms rather than machines" and advocated the use of natural materials and a return to the humanistic and naturalistic heritage of the Renaissance. While Krutch was implicitly anti-avant garde in his tastes, his description of the individual owes less to the world of nature than to Romantic notions from which avant gardism developed. Cold Warriors promoted avant-garde art precisely because they saw in the work the expression of the "unique and rebellious life" that distinguished the "free world" from the Communist world.[7]

Advocates of cultural diplomacy argued that the arts, especially innovative arts, could enhance the American (and Western) cause in the Cold War by demonstrating the freedom of the West to Communists behind the Iron Curtain and around the world, and by demonstrating the maturity of American culture to suspicious Western European allies. Columbia University philosopher Irwin Edwards, in a speech to art educators in 1951, declared that "the greatest triumphs of freedom, those of the spirit, which occur in art, are victories of disciplined knowledge, hallelujahs of ordered spontaneity." Rene d'Harnoncourt of the Museum of Modern

Art (MOMA) celebrated the intellectual forces of the eighteenth and nineteenth centuries that had "freed [human beings] from the restrictions of dogma" and resulted in, among other things, modern art. "The totalitarian state negates the very achievements that have made modern civilization possible," d'Harnoncourt declared. Totalitarianism is not the direction for human social evolution, he said. Rather, human beings need

> an order which reconciles the freedom of the individual with the welfare of society and replaces yesterday's image of one unified civilization . . . [with] a pattern in which many elements . . . join to form a new entity. . . . I believe a good name for such a society is democracy, and I also believe that modern art in its infinite variety and ceaseless exploration is its foremost symbol.

Art critic Aline B. Louchheim argued that "one of the ways in which we might gradually turn reluctant and uneasy military allies into friends would be to earn their respect for our contemporary culture." To do so, she maintained, required Americans to no longer be "antagonistic" to "our own most advanced, imaginative and best achievements in modern art and modern architecture."[8]

In contrast, many Americans in the postwar years believed that the avant garde was un-American and, thus, hardly a useful tool in the fight against Communism. Michigan congressman George A. Dondero, for example, believed that the Russian Communist Party had invented the avant garde to help it overthrow the Czar. He also believed that in the 1950s the leaders of the Soviet Union used cultural radicalism to undermine the West. During the 1950s, such attacks moved former MOMA director Alfred H. Barr to defend vanguard painting and sculpture and critic Gilbert Highet to defend innovative literature against charges of being Communist-inspired.[9]

The U. S. government, through a variety of agencies, supported cultural activities intended to demonstrate the freedom of Western countries in general and American society in particular. Thus, in the 1950s and 1960s the Central Intelligence Agency covertly funded the Congress for Cultural Freedom and the publication of *Horizon* to highlight the best in Western thought and culture, including many first- and second-generation vanguardists. During the 1960s, the Voice of America broadcast jazz to foster good feelings about America abroad. From the late 1940s to the mid-1950s, the State Department and the United States Information Agency (USIA) sponsored several international exhibitions of American

painting that featured a range of styles, including representatives of the various vanguard movements from the teens to the 1950s.

In 1956, the government discontinued international exhibitions of post-1917 American painting. The suspension resulted from protests raised in Dallas, Texas, about Communist-inspired art. In Dallas at that time, a coalition of anti-Communist and academic art organizations alleged that Communist artists painted several works in a USIA-sponsored exhibition called "Sport in Art." (The exhibit was shown in Dallas as part of a national tour before going to the Summer Olympics in Australia.) The U. S. government was not the only institution fighting the cultural Cold War, however, and other institutions filled the void. The Ford Foundation, for example, funded a journal of international modernism edited by James Laughlin of New Directions Press, art exhibitions, and the Congress for Cultural Freedom. But most important in the staging of exhibitions of contemporary work as weapons in the cultural struggle were the curators at MOMA.[10]

Under the leadership of MOMA Board of Trustees president Nelson Rockefeller, the international exhibitions organized by the MOMA especially highlighted the work of the abstract expressionists. These painters became weapons in the Cold War of ideas. Their themes of alienation and cultural renewal were deemphasized by MOMA curators, who presented the works as representative of the freedom of the non-Communist world. The cultural Cold War carried on by the MOMA was an unofficial continuation of previous government programs. The key figures at MOMA learned cultural diplomacy at the Department of State. Rockefeller's interest in cultural diplomacy, for instance, dated from his State Department service in the 1940s. One of his duties in the government had been to organize cultural programs, including several international exhibitions sponsored by MOMA. At the State Department, Rockefeller met two men who would also play key roles in the development of cultural programs at the museum. One was d'Harnoncourt, who came to MOMA in 1944 to organize foreign activities and became director of the museum in 1949. The other was Porter A. McCray, who directed international programming at the museum in the 1950s.

The cultural Cold Warriors at MOMA did not interpret the unconventional values of the avant garde as dangerous to the conventions of the American social and political system. Thus, they could safely send them abroad as examples of the sophistication of American high culture. Among the shows organized by MOMA in their cultural Cold War were "Modern

Art in the US" (1956), which featured a dozen abstract expressionists, and "The New American Painting" (1958), devoted exclusively to abstract expressionism. The curators at MOMA presented these American avant gardists as examples of the freedom of expression and dissent allowed in America, as Barr made clear in his catalog introduction for the exhibit, "New American Painting": "They defiantly reject the conventional values of the society which surrounds them, but they are not political *engages* even though their paintings have been praised and condemned as symbolic demonstrations of freedom in a world in which freedom connotes a political attitude." [11]

Given that members of the last American vanguard felt alienated from the technocratic consumer culture and the politics of the Cold War, these artists were not the best champions of the American cause. Ironically, reactionary critics like Dondero seem to have understood more fully, if not very clearly, the fundamental challenge posed by cultural radicals to American culture. Two factors enabled the abstract expressionists to be so used, however. First, the critics who mediated the abstract expressionist vanguard to the curators at MOMA misrepresented the artists' ideas through selective interpretations. Harold Rosenberg presented an existentialist interpretation of "action painting" that emphasized the idea of creative freedom and obscured the cultural, historical, psychological, and spiritual themes of the artists. Clement Greenberg presented a formalist interpretation of abstract expressionism that emphasized the place of the painters in art history, recentered the international art world from Paris to New York, and highlighted surface innovations only, ignoring the cultural politics of the avant garde.[12]

Second, the members of the avant garde contributed to their own appropriation. Many vanguardists spoke of creative freedom in ways similar to those of the cultural Cold Warriors. Radical innovators recognized the benefits of a free society without intending to be used as propaganda in a war of words and images. Their experience of being politically exploited in the 1930s caused them to reject overtly political uses for art and culture. In 1948, Leslie Fiedler declared that "the absolute claim to freedom in the creative act, in *going on writing* as we understand it, challenges many political systems and is challenged by them, most spectacularly these days by the Soviet communist world-view. . . . This is our sufficient task as writers." A little magazine editor justified artistic innovation in *Trace* in 1953 by saying, "If art in all of its forms is to remain free . . . it must be left to change and show all possible facets. We

have seen what can happen when conformity is exacted in Communist Russia, and what then happens to the artist. Totalitarianism in art is quite as objectionable as political totalitarianism." Cultural radicals emphasized the need to oppose restrictions on artistic freedom wherever they found them. They were willing to criticize both the Soviet Union and the United States. Their intent was never to hold up the "American way of life" as idyllic.[13]

Conclusion

Cold Warriors and avant gardists alike believed that culture was at the heart of the divisions of the postwar world. Joseph Wood Krutch, Nelson Rockefeller, and Leslie Fiedler all believed that beneath and beyond the political and economic divisions between the Soviet Union and the United States lay basic questions about how the individual and society relate, about freedom and creativity, about what being human meant. But while Krutch, Rockefeller, and others like them believed that these questions had been largely answered by the extant social arrangements of postwar American society, avant gardists like Fiedler felt differently. Radical innovators believed that while American culture may have raised many of the right questions, they were far from being satisfactorily answered.

Though alienated from the culture of the Cold War, the cultural politics of avant gardists intersected at key points with the ideals of Cold War liberals, especially the ideal of creative freedom. This intersection allowed representatives of culturally powerful institutions to appropriate the advance guard for purposes other than those intended by cultural radicals. The result was to coopt the avant garde as one of many style options in a free, pluralistic American society.

CHAPTER 7

Institutional Enthrallment

.

.

.

.

.

The assimilation of the advance guard that accompanied the Cold War gained the movement a place in cultural institutions from which it had historically been alienated. Museum curators and gallery operators placed the avant garde in a progressive interpretation of art history. By thus historicizing the movement, the art world gave the avant garde a pedigree, as it were, and legitimated innovative art for wealthy collectors and institutions. Educational institutions enthralled the movement as well. University administrators, especially at large state schools, expanded the fine art programs at their institutions, creating numerous new teaching positions. The prospect of being paid for their innovations led many cultural radicals to join college staffs. As a result of these transformations, the status of radical innovators changed from alienated outsiders to cultural insiders. These changes could be seen as the fulfillment of the advance-guard goal of a transformed culture and a new future. But when that future arrived, cultural

institutions were not fundamentally changed and the vanguard as such had disappeared.[1]

The Alienation of the Avant Garde from Institutions of Culture

Members of the avant garde had long felt alienated from the cultural institutions of a society that, from their point of view, did not value intellectual and aesthetic innovation. Vanguardists used words such as "provincial," "conservative," and "academic" to describe postwar American culture. These commentators expressed standard avant-garde critiques of the salons, academies, and journals of the genteel tradition, all of which for generations promoted an established aesthetic and resisted change. The *Salon des Refusés*, the Armory Show and other acts of resistance to the institutions of culture carried out by avant-garde artists are part of the movement's "mythology." In the first decades of the twentieth century, the word "provincial" resonated for American avant gardists as an expression of the American artist's frustration at his or her geographical removal from the centers of European resistance to genteel culture. American advocates of the genteel tradition formed a "conservative" opposition to vanguard innovation. In the years after World War II, the emphasis shifted. The "academy" took on more importance as American universities became increasingly central to the intellectual, artistic, and economic life of the nation and an important outlet for intellectuals.

Throughout the 1950s, advanced artists and writers continued to rail against the provincialism of postwar American culture. Kenneth Rexroth believed that culture in the United States had become pedestrian and provincial. He argued that American poets had "abandoned the international idiom of twentieth century verse." In America, he contended, the Revolution of the Word had been lost as artists either "sold out" or sank into obscurity. "Why," he asked, "did American poetry, a part of world literature in 1920, become a pale provincial imitation of British verse in 1957? We are back two generations behind Australia." Gallery owner Samuel M. Kootz also condemned the provincial nationalism that he thought characterized the criticism written about his client artists. In defense of abstract expressionist painter William Baziotes, for example, Kootz attacked critics who believed "that nationalism is more comfortable than internationalism, and that 'subject matter' is more important than plastic values." He accused the critics of having "made no attempt to

understand" Baziotes's works. Why did this situation obtain? Because, Kootz declared, "the artist heralds his own time while the critic remains in the status quo."[2]

Harry Partch believed that the conservative musical culture in America reflected a pervasive "sciolist and academic Europeanisme" that discouraged innovation. Partch rejected a musical system based, as he argued, on the "inherited forms and instruments of Europe's eighteenth century." A "healthy culture" encouraged diverse musical theories, Partch believed. Unfortunately, in the mid-twentieth century,

> anyone who even toys with the idea of going beyond . . . [the] legacies [of the past] for materials and insight is generally considered foolhardy if not actually a publicity-seeking mountebank. The door to further musical investigation and insight has been slammed shut by the inelastic and doctrinaire quality of our one system and its esthetic forms.

Cultural radicals believed that the constricting conformism and narrow nationalism that for them characterized postwar American society also pervaded the arts. Valuing individuality and creative freedom as they did, members of the avant garde necessarily felt alienated from the mainstream cultural life of their society.[3]

The Enthrallment of the Avant Garde by Museums and Galleries

It is ironic, then, that the avant garde became assimilated into the mainstream of American culture during the postwar decades. The enthrallment of the advance guard occurred in the context of an "art boom" fueled by the postwar prosperity. As prices for old masters, impressionists, and early modernist works rose rapidly, less wealthy collectors, both individuals and institutions, turned to the work of contemporary artists. Because of their low prices, these new artists also appealed to middle-class Americans who wanted to collect original art on a budget. Because contemporary vanguard work was so new and lacked the history of interpretation and sales that defined the old master market, collectors looked to a small number of museums, galleries, and critics for guidance about which artists were worth purchasing. The art boom, therefore, greatly increased the power of cultural gatekeepers.

The Museum of Modern Art (MOMA) was the most important avant-garde gatekeeper from the 1930s to the 1960s. The museum staff, espe-

cially director Alfred H. Barr, had been so successful in defining a style they called "modernism" that the museum began to be priced out of the market for the work of established artists such as Pablo Picasso and Henri Matisse. The painters of the abstract expressionist vanguard presented a way out of this difficulty.[4]

In the 1930s, many in the American art world had criticized MOMA for not exhibiting enough American artists. Barr answered these charges by saying that contemporary American art was not as interesting or innovative as European art. The situation changed in the postwar years. In the early 1950s, Barr and other curators hailed abstract expressionism as the new vanguard art. The 1952 MOMA show "Fifteen Americans" featured works by Jackson Pollock, Mark Rothko, and Clyfford Still, and the museum began to purchase paintings by these artists. By admitting these American innovators into the stream of artistic development defined by historic avant gardists such as Pablo Picasso, Georges Braque, Marcel Duchamp, Henri Matisse, and Joan Miró, MOMA defined a place in art history for the American vanguard. Barr even described Wassily Kandinsky as "the first abstract expressionist." An exhibition checklist from 1969 put the matter more explicitly: "Since 1945 America has been the scene of a succession of artists of world importance and prominence. The role of rescuing American art from its heretofore provincial situation and placing it at the center of the modern tradition fell to the generation of artists shown in this exhibition." Collectors looked to the museum for guidance, both formal and informal, about what works to purchase. By legitimating abstract expressionism as part of the evolution of Western art, Barr and other curators at MOMA created a demand for contemporary American art.[5]

Galleries also functioned to historicize the American avant garde. Kootz, for example, opened his gallery in 1945, following a successful career in advertising. He financed shows by contemporary Americans such as Robert Motherwell and William Baziotes by selling works by established painters, chiefly Picasso. Kootz legitimated his vanguard artists for collectors by choosing his artists carefully and presenting them as the heirs of the historic avant garde.[6]

Critics, and in particular Clement Greenberg, also assimilated the American vanguard into an academic art history. In his influential criticism published in the *Partisan Review* and the *Nation* in the 1940s and 1950s, Greenberg formulated a formalist, Hegelian understanding of art history based on the evolution of art toward increasingly purer form. After

Pollock's death, Greenberg, an early champion of Pollock, promoted two Washington, D.C., artists, Kenneth Noland and Morris Louis, as Pollock's successors. Greenberg organized exhibitions of Louis's and Noland's work and wrote articles about them. As a result, their work began to sell to museums and private collectors for increasing prices. The 1964 exhibit "Post-Painterly Abstraction" which Greenberg organized for the Los Angeles County Museum of Art, defined a whole period of art and advanced the careers of Noland, Louis, and artists such as Ellsworth Kelley and Helen Frankenthaler. The pattern exemplified by Kootz and Greenberg would continue in the 1960s and 1970s as another group of gallery owners and critics created and promoted the minimalist movement.[7]

As a result of the increased demand for contemporary innovative work, the institutional and economic situation for artists changed. At the most basic level, prices went up. In 1950, Jackson Pollock sold paintings for about $1,200. In 1955, a year before his death, he could sell works for $3,000. Ten years later, the artist's paintings sold for $35,000 and the prices continued to rise. By comparison, Jasper Johns, an artist from the generation after Pollock, sold pieces from his first show in 1958 for $1,200. In 1963, Johns sold works for $15,000 and by the end of the decade for amounts twice that figure. Similar examples could be adduced for the work of other avant gardists. Successful innovators no longer needed to be economically alienated from their society.[8]

The rising prices of avant-garde art in the 1950s transformed the institutional setting in which members of the vanguard worked. In New York City in the 1940s, fewer than twenty galleries showed avant-garde art, mostly European and mostly as one of many styles. Fewer than half a dozen galleries exhibited American vanguard work. By the 1970s, almost three hundred New York galleries promoted contemporary innovative art. And promote they did. In the pluralistic art world of the late 1960s and following, gallery operators found that "discovering" a new movement was the best way to distinguish their gallery from the competition. "Dealer-generated" movements proliferated, further contributing to the commercialization, lack of direction, and domestication of the avant garde. These changes appalled many vanguardists. Motherwell recalled how in the late 1950s he became "increasingly annoyed at how art [was] becoming more and more like the couturier business. I mean instant fashion, instant exploitation, instant everything." When Peggy Guggenheim, who had run an important surrealist gallery in New York City in

the mid-1940s, returned to the city in 1958 after a dozen years in Europe, she was dismayed to find that "the entire art market had become an enormous business venture. Only a few persons really care for paintings. The rest buy them from snobbishness or to avoid taxation."[9]

By the 1960s, the avant garde was "in," whatever feelings of alienation individual members may have experienced. The career of collector Robert Scull illustrates the new situation. A cab driver from the Lower East Side of Manhattan in the 1940s, by the end of the 1950s, he owned a fleet of taxis and was a millionaire. Having educated himself about the avant garde through evenings spent at MOMA, he began collecting post-abstract expressionist vanguard art. Critics credit him with being one of the collectors who made pop art into a movement. After purchasing Jasper Johns's ale cans sculpture *Painted Bronze*, Scull began receiving invitations to society parties. Long-time members of MOMA, Scull and his wife discovered that they could not break into the inner circle, which was dominated by old money and was less receptive to self-made men like Scull. He transferred his allegiance to the more "egalitarian" Whitney Museum of American Art. What was an avant gardist to do in such a situation, asked Frank O'Hara, a vanguard poet and MOMA curator, in 1961. "Youth wants to burn the museums. We are in them—now what? Better destroy the odors of the zoo." If one could no longer *épater le bourgeois*, O'Hara saw only one option: "Embrace the Bourgeoisie. . . . How [else] are we going to fill the large empty canvas at the end of the large empty loft? You do have a loft, don't you man?"[10]

The Avant Garde and the Academy

In the introduction to Partch's *Genesis of a Music*, the composer complained that "the door to [musical innovation] has been slammed shut." And yet, other parts of the book demonstrated that what Partch wrote was not entirely true. Partch's innovation received sponsorship and encouragement from some very important cultural institutions: American universities. Partch completed the book while a research fellow at the University of Wisconsin, and the work was subsequently published by the university's press. (In later years, Partch also received research appointments from the universities of Illinois and California.) Otto Luening, director of the Columbia-Princeton Center for Electronic Music, wrote the foreword to the book, and Partch acknowledged the "moral backing" he had received "from seats of some authority in our musical educational

institutions" in the persons of such composers and educators as Howard Hanson of the Eastman School of Music, Quincy Porter of Yale University, Gunnar Johansen, artist in residence at the University of Wisconsin, and Douglas Moore of Barnard College, Columbia University. The composer also received support from the Carnegie Corporation and the John Simon Guggenheim Memorial Foundation. Thus, despite his rhetoric, Partch's cause was not completely hopeless. His message had at least been acknowledged by some of the most important institutions and individuals of his day.[11]

Partch's experience proved typical of the relations between American colleges and universities and the avant garde in the postwar years. Institutions of higher education played a key part in the absorption of vanguard ideas and ideals into American culture.

"Academic" Culture

In the postwar years, members of the advanced guard increasingly used the term "academic" to describe American culture. This description was not just the repetition of an avant-garde shibboleth, nor was it meant only as a metaphor for "conservative, provincial culture," though the term could sometimes mean any of these. Rather, the word "academic" reflected the real importance of the university in American intellectual life in the middle of the twentieth century.

In the late nineteenth century, education reformers created the modern American university to validate the new bourgeois professions, particularly engineering and management. The curriculum changed from a traditional liberal arts education to one emphasizing science and scientific modes of thought. During the twentieth century, the American university emerged as one of the central institutions in intellectual life. Statistics tell part of the story: from 1900 to 1940, the number of college professors in the United States increased eleven-fold. By 1950, this number almost doubled again. By the middle of the twentieth century, colleges and universities had become the most significant employers of intellectuals. The independent "man of letters," who had been the mainstay of American intellectual life since colonial times, became obsolete. Many critics feared that intellectuals lost their capacity for independent critical comment on society once they became ensconced in academia. Irving Howe described the graduate school as an agent of conformity that "grinds and batters personality into a mold of cautious routine." Writing in 1948, critic R. P. Blackmur was resigned: "The writers will be in the universities.

The economic, political, and cultural drifts of our society are towards the institutionalization of all the professions."[12]

Cultural radicals shared these concerns, but they denounced the universities in much stronger terms than any other critics. From the perspective of members of the advance guard, the academy represented all that was bad in postwar American society: conformity, false values, and technocratic bureaucracy. Through the process of tenure, the rules for publication in academic journals, and the means of advancement in scholarly associations, critics maintained, the institution transformed generalist intellectuals into pedantic specialists. Instead of talking to their society about the great issues before them, intellectuals talked to other scholars in a language understood by only a few. Critic Michael Fraenkel wrote in *Death* that "the modern suicide hasn't the guts to shoot himself, so he kills himself inside and carries on otherwise . . . [finding solutions writing] criticism, instead of poems." Poet Robert Creeley remembered that in the late 1940s "the colleges and universities were dominant in their insistence upon an *idea* of form. . . . [It] was this assumption of a *mold*, of a means that could be gained beyond the literal fact of the writing *here and now* that had authority."[13]

In 1956, writer Leslie Woolf Hedley composed a satiric academic job interview in which the candidate described his publications, and in so doing lampooned the modernist canon and the journals in which most of the canonizers published:

> I wrote a review praising the poetry of T. S. Eliot for *Sewanee Review*, a review praising the *Sewanee Review* for *Kenyon Review*, a review praising the very sound Americanism of Ezra Pound for *Hudson Review*, a review against independent poetry for *Poetry Chicago*, a review praising the poets of New York for the *New Yorker* . . . [, and] I wrote an article stating that Wystan Auden, T. S. Eliot, Stephen Spender, John Crow Ransom and Allen Tate aren't published often enough.

Other writers also attacked the cultural conservatism and anti-avant gardism that they saw emanating from the academy. The editors of *Yugen* presented a fictitious award to academic poet W. D. Snodgrass for "outstanding achievement in nineteenth-century English verse," and Robert Bly conferred "The Order of the Blue Toad" on historian Jacques Barzun "for his middle-class hatred of art and poetry disguised as a defence of intellect."[14]

Vanguardists also charged that universities standardized creativity. Aca-

demia brought the bureaucratic specialization of industrial society into the creative realm with results that most cultural radicals considered deleterious not only to intellectual life but to life in general. Avant gardists believed that the academy was no place for a genuinely creative artist of any kind. Lawrence Ferlinghetti attended a reading at the San Francisco Poetry Center at San Francisco State University in 1956 and concluded that "writing workshops, if attended assiduously, can only lead to the death of the poet." Jack Kerouac dismissed colleges, in his 1958 novel *Dharma Bums*, as "grooming schools for the middle class non-identity which usually finds its perfect expression . . . in rows of well-to-do houses with lawns and television sets . . . with everybody looking at the same thing and thinking the same thing at the same time." Kenneth Rexroth minced no words and condemned colleges and universities as "fog factories": "Behind their screen the universities fulfill their social purposes. They turn out bureaucrats, perpetuate the juridical lie, embroider the costumes of the delusion of participation, and of late, in departments never penetrated by the humanities staff, turn out atom, hydrogen, and cobalt bombers—genocidists is the word." The academy, from the avant-garde perspective, directed human creativity away from innovative and transformative goals to conventional, constrained, and destructive ones.[15]

The Avant Garde Enters the Academy

The academy assimilated members of the avant garde almost in spite of themselves. The initial steps in this process came from the educational institutions. In the 1950s and 1960s, many educators believed that colleges had carried scientific rationalism too far and that, to compensate, communities of higher education needed an infusion of humanistic values. Harold Taylor, president of Sarah Lawrence College, argued in 1966 in a symposium on "The University as Cultural Leader," published in *Arts in Society*, that the artist "should be given a major place in the college and university" and, indeed, "should have been there all along." One way colleges and universities demonstrated their renewed commitment to the arts was in the construction of multimillion-dollar arts centers, including performance spaces, galleries, classrooms, and studios. For example, in the mid-1960s, a $3.3 million performing arts center was built at the University of Wisconsin at Madison and a $1.4 million center was built at the University of Illinois. By opening up universities to the humanities and the arts, administrators created opportunities that had not previously existed for avant gardists.[16]

The Music School of the University of Illinois was typical of the new university arts programs. The school began to expand in the late 1940s, along with the rest of the university. Academic arts did not mean exclusively avant gardism, and the University of Illinois was no exception. Music history and musicology were early strengths of the department. But ambitious younger faculty and music students discovered that avant-garde music, because it was new to the university, was an area where they could distinguish themselves. By the early 1960s, the Music School at Illinois gained national prominence as a center for the composition and performance of new music, especially electronic and computer music. John Cage was composer in residence at the school from 1967 to 1969, during which time he produced his multimedia happening HPSCHD.[17]

The University of Illinois School of Music is just one example of how cultural radicalism became incorporated into colleges and universities. Colleges also began to exhibit avant-garde art in their galleries. In 1948, the University of Illinois began a biennial exhibition of "Contemporary American Painting and Sculpture" that evolved into just one part of a general festival of contemporary art. Jackson Pollock exhibited several times at Bennington College between 1952 and 1958. In 1965, the Institute of Contemporary Art at the University of Pennsylvania sponsored an exhibition of works by Andy Warhol. During these same years, vanguard artists exhibited at the University of Minnesota; Smith College; Pennsylvania State University; the University of California, Irvine; the University of California, Berkeley; Brandeis University; New York University; and other institutions. Colleges also began hiring innovative artists, both on a temporary basis in composer, writer, and artist in residency programs and as permanent members of burgeoning academic faculties.[18]

Presented with these opportunities, many avant gardists began to reconsider their opposition to the academy and to see the university as a positive environment. They did so for a variety of reasons, including the money and the community. In 1960, novelist and University of Washington English instructor Robert O. Bowen wrote in the little magazine *Inland* that "the university is the only place the literary artist belongs today. Aside from his salary and the bookish company, he belongs because no other recognized place exists for a learned man in America. . . . There are no low-rent Left Banks today; there are no cafes where old masters hand down the lore to the beginner." Universities also gave some structure to the intellectual life of a far-flung continent. Richard Kostelanetz described the "network of universities" as the "closest semblance of an

'intellectual center' America has." Furthermore, colleges and universities provided support for innovative art. Rexroth, for example, despite his fulminations against the "fog factories," admitted that the Poetry Center at San Francisco State College did a great deal in the 1950s and 1960s to promote innovative poetry through sponsored readings of new poems and through classes and workshops on avant-garde poetics. (Rexroth did not find the effects of large grants from the Rockefeller Foundation to be deleterious to the Poetry Center either.)[19]

Some cultural innovators argued that the university method of technical specialization provided a better model for artistic exploration than the avant-garde model of *épater les bourgeois*. Composer Milton Babbitt was one such radical innovator. Babbitt worked in serial and electronic forms, taught at Princeton, and co-directed the Columbia-Princeton Center for Electronic Music. In his 1958 essay "Who Cares If You Listen," published in *High Fidelity*, Babbitt argued that experimental contemporary music was a music "for, of, and by specialists." He compared the tremendous changes that had taken place in music since the early twentieth century to the nineteenth- and twentieth-century "revolutions" in mathematics and physics. Babbitt further noted that neither of these disciplines was particularly intelligible to laypeople, yet nobody denounced this condition as elitist or bad for the culture. Why not, Babbitt asked, carry the analogy further and treat experimental music as a specialized, technical activity?

> And so, I dare to suggest that the composer would do himself and his music an immediate . . . service by total, resolute, and voluntary withdrawal from this public world to one of private performance and electronic media, with its very real possibility of complete elimination of the public and social aspects of musical composition. By so doing . . . the composer would be free to pursue a private life of professional achievement, as opposed to a public life of unprofessional compromise and exhibitionism.

Babbitt did not care if there was a public for new music, and neither did Richard Maxfield, who wrote in 1963,

> *Rather than popularizing such concerts,*
> *warn the audience away.*
> *Then only those who are receptive to the extraordinary*
> *will come*
> *And the atmosphere will be alert and open.*

For these composers, innovation produced new esoterica, not new culture.[20]

The increasingly theoretical orientation of innovative art in the post-war years also made teaching more respectable to cultural innovators. Oliver Andrews, a sculptor and long-time member of the art faculty at the University of California, Los Angeles, acknowledged that when he began teaching in the mid-1950s some artists viewed teaching as a questionable occupation because they believed art was about creating objects, not discussing them. With the innovations associated with conceptual art in the 1960s, however, knowledge became increasingly important for artists. The theoretical perspective of the teacher began to be valued, and this development made teaching acceptable for innovative artists. In the 1960s, art began to follow the course of music in the development of complex theory. The same occurred in literature as well, as avant-garde novelists such as Thomas Pynchon, John Barth, and William H. Gass wrote highly reflexive novels about the making of novels. As all the arts became increasingly based in philosophy, the university became the logical place for innovative activity.[21]

From the 1950s to the 1970s, the universities employed increasing numbers of vanguardists. In the 1920s, college teachers constituted 9 percent of the contributors to American little magazines. In the 1950s, the figure for avant gardists at universities appeared to be about the same. Thus, only four out of forty-four contributors to Donald M. Allen's *New American Poets* in 1960 had held full- or part-time academic employment, one of whom was Charles Olson, who had been rector of the innovative Black Mountain College for several years. But when Allen reissued his anthology twenty-years later as *The Postmoderns*, the status of the contributors had changed. More than half of the writers, including Allen Ginsberg, John Ashberry, Robert Creeley, and William Everson, held posts as university faculty. By the 1960s, more than 40 percent of the contributors to little magazines held academic positions, and by the 1970s the number rose to 60 percent and more. Clearly not all innovative artists found their way to universities, but academia had become significant as never before for the course of American avant gardism.[22]

Many cultural innovators did not think twice about becoming college teachers. Oliver Andrews is an example. Andrews graduated with a bachelor's degree from Stanford University in 1948. He spent a year in Europe and then worked as a draftsman in Santa Barbara. Andrews decided, however, that he wanted to make his living as an artist, and he developed a strategy to achieve that goal. He decided that he would make sculptures in his off hours, have some shows, get recognition, and use this résumé to

get himself a teaching job. His program proved successful. Andrews began making sculptures of wood, wire, and concrete at night. He had a show at the Santa Barbara museum, got a dealer in Los Angeles, won a prize at the Los Angeles County Museum of Art annual in 1957, and was featured in *Art in America* as a rising "new talent." The sculptor then applied for jobs in New York and California and was offered both. He accepted a job at the University of California, Los Angeles, because he sensed a growing dynamism in the California art world that seemed to indicate the coming of a West Coast rival to the traditional cultural hegemony of the East. For Andrews, being a college teacher and being a part of a vital cultural movement were not antithetical.[23]

Over time, even critics of "academic" artists accepted positions in colleges and universities. For example, in the 1960s Morton Feldman criticized Babbitt as the leader of the "academic avant-garde." In 1972, Feldman accepted the Edgard Varèse Chair of Music at the State University of New York, Buffalo. In the early 1960s, Irving Howe began teaching, first at Stanford, then at the City University of New York. Even Rexroth succumbed to the lure of the academy and taught at the University of California, Santa Barbara, from 1968 to 1974.[24]

Conclusion

The enthrallment of the American vanguard by what has been called the "knowledge-industrial complex" had paradoxical effects on the movement. On the one hand, the establishment of a sizable portion of the avant garde on university campuses signaled success for cultural radicals. A new culture was, after all, the goal of radical innovators. To be accepted into such traditionally conservative institutions indicated a transformation in the culture. In addition, members of the advance guard could further the goal of cultural renewal through their teaching.[25]

On the other hand, the academization of the avant garde suggested to many that the movement had ceased to be trail blazing and had become routinized. In 1955, a poet characterized the job of the contemporary writer to be consolidation because "there is no place else to go since there is a limit to how much play with punctuation or typographical composition is still interesting to us." Abstract expressionist painter John Ferren noted in a lecture given at the University of Florida in 1958 that "when the participating artist is asked to speak about the avant-garde, the crucial, generative phase has obviously passed. . . . The period called 'consolida-

tion' has arrived." By the late 1950s, abstract expressionism was becoming a mannerism and artists turned to other styles. As artists came to the California universities in the 1960s, they took a West Coast vanguard style of assemblage and happenings called "funk," developed by nonacademic innovators such as Bruce Connor and Wally Berman, and created an academic style called "Funk," characterized by critic Thomas Albright as "scholasticism's form of comic relief."[26]

More importantly, acceptance into the academy did not put vanguardists at the intellectual center of the university. American multiversities of the postwar years had no center. Cultural radicalism became just one more option in a pluralist system whose disparate parts had only the most tenuous of relations. If any goal linked the various parts of the university, it was the responsibility to provide students with professional training for their desired careers. Just as the reformed universities of the late nineteenth and early twentieth centuries validated the new middle-class professions, vanguard educators found themselves training students for the now respectable middle-class careers of creative writing instructor or academic composer of electronic music.

As constant innovation became the accepted definition of artistic practice, the ability to "make it new" lost cultural meaning and became merely a necessary career skill. In the competitive worlds of academia, publishing, and the East and West Coast art worlds, a vision of a redeemed culture became less important than the student's ability at, as one art instructor put it, "hustling, conning, and whoring." These, of course, were the same skills as the advertiser and salesperson in a competitive culture of consumption. The main thrust of American higher education in the postwar world was to train the managers of the consumer culture. Art galleries sold style to these affluent consumers. Avant-garde innovations became commodities in a culture of consumption.[27]

Consumer Culture Commodification

.

.

.

.

.

By 1965, the relationship between avant gardists and their culture had changed greatly. Increasingly, innovative intellectuals were no longer alienated outsiders but trendsetters in the realms of fashion and ideas. Their art was featured in corporate collections and advertising, their poetry and prose read and dissected on campuses and in coffee houses, and their behaviors imitated by rebellious young people from the suburbs. In one sense, the assimilation of the advance guard into American society could be described as a victory as the predominant culture reflected the influence of cultural radicalism in matters of style and taste and, to some extent, in values.

But the appropriation of the vanguard also indicated a defeat. Rather than radically transforming American institutions, these institutions adapted vanguardism to the prevailing corporate consumer culture. Businesspeople appropriated the avant garde into their institutions for prestige, public relations, and personnel management. The members of the

various institutions of the mass media transformed the avant garde by reducing cultural radicalism to lifestyle, status, celebrity, and fashion. Tamed as a consumer novelty or a lifestyle choice, the idea of the avant garde lost coherence. By the mid-1960s, the movement had become so attenuated as to have lost almost all historic meaning. No avant garde existed any longer that could constitute a radical force for a new future.

The Culture of Consumption

Historians have described how members of the European aristocracy and emerging middle classes began to define themselves as communities of consumption as early as the commercial revolution of the seventeenth century. A culture in which consumption shaped the mentality of the mass of people across social classes, however, did not begin to emerge fully until the industrial revolution of the nineteenth century. In the United States, the transportation and communication revolutions created the framework for a national market before the Civil War. Branded goods developed as the mass-market version of fashion, and advertising communicated the value of one brand over another to middle- and working-class consumers. By the first third of the twentieth century, the basic components of consumer culture were in place in the United States.

What defines consumer culture is not the purchase and use of goods, however, but the constellation of values that delineate the meaning of consumption. Consumer culture contrasts with the older producer culture in the conception of the economy and the individual. Scarcity defined the economy of producer culture; hard work, thrift, self-denial, and deferred gratification defined the internal qualities of the individual. In consumer culture, however, abundance characterized the economy. Adherents of the new value system emphasized leisure, spending, and self-fulfillment. In an economy of abundance, people believed that gratification no longer need be deferred: one could have everything immediately. For the other-directed denizens of consumer culture, individual qualities such as being liked or striving to develop an attractive personality replaced the inner-directed, producer culture emphasis on having a strong, moral character.

Consumer culture was not just a creation of twentieth-century merchants and advertisers, however; intellectuals contributed to the creation of the new culture. From European romanticism emerged not only the concept of avant gardism, but also the ideology of consumption. In

particular, the romantics defined a new form of hedonism, what Colin Campbell has called "modern self-illusory hedonism." Traditional hedonism focused on the maximum enjoyment of pleasurable objects and activities, such as food, drink, music, games, or sex. Romantics also argued that the search for pleasure was intrinsically good and that the emotional experience of artistic enjoyment brought about moral renewal. The new component added by the romantics was a belief in the power of the imagination to create and fulfill desires. A line from John Keats's poetry illustrates the importance of the daydream for romantics: "Heard melodies are sweet, but those unheard are sweeter." The daydream would become the foundation for modern hedonistic consumption, as advertisers focused people's imaginative associations on goods and the idea of consumption.[1]

Prosperity, Consumption, and the Crisis of the Individual

American consumer culture reached maturity in the prosperous years that followed World War II. The postwar economic boom resulted from several causes. Americans had accumulated personal savings from high-paying war work. Technological development created new industries in plastics and electronics. Government policy, such as support for suburban housing through low-interest loans and support for aerospace and other industries needed to fight the Cold War, also contributed to economic growth. In the 1950s, many Americans worked less and earned more, as working hours went down and wages and salaries went up in most occupations. The types of jobs at which people labored also changed, as fewer Americans worked in factories and the majority found employment in clerical, sales, managerial, and other "white collar" occupations. By the end of the 1950s, the majority of Americans were middle class, as defined by income level, compared to only a third in the years before the Great Depression. For many Americans, consumption symbolized having "made it" to the middle class. Millions of Americans moved from the cities to new housing developments on the urban periphery. They filled these houses with consumer items, from kitchen appliances to television sets. Historian John Patrick Diggins characterized the postwar years as the "proud decades" after Americans witnessed the triumph of the nation over the crises of depression and war and the seeming fulfillment of the material promise of American life. Commentator Walter Lippmann

observed, "We talk about ourselves these days as if we were a completed society, one which has no further great business to transact."[2]

Not all observers shared the complacency described by Lippmann. Members of the advance guard, of course, felt deeply alienated from American society, but they were not the only individuals to criticize the social implications of the postwar political economy. Social critics not associated with the avant garde, such as William Whyte and David Riesman, also expressed concern about the new "managerial personality." These critics argued that the idea of the individual adhered to by Americans from the eighteenth century forward no longer reflected social realities. The traditional American conception of individualism emphasized being in charge of one's economic, social, and political destiny. The farmer, the entrepreneur, and the professional all depended on their own resourcefulness and hard work for success. In the postwar years, Riesman, Whyte, and others described the new, bureaucratic context in which many Americans found employment as one in which the individual was no longer the complete master of his destiny. As salaried employees, white-collar workers depended on others for their livelihood, much as factory workers had since the industrial revolution. Individual qualities of personal character seemed less important in the context of carrying out of bureaucratic functions; one was encouraged to follow the rules and get along with others in the organization. The postwar prosperity meant increased opportunity for many Americans, but also challenges as the meaning of individual existence became less clear.[3]

Consumerism offered a solution to these "problems of prosperity" in the construction of a distinct image through consumption. Consumer culture values emphasized individual self-expression and the freedom to define one's own life "style." For example, in 1952, the editors of *House Beautiful* announced a new era of "free taste." Joseph A. Barry described a "Second American Revolution"—not a political one, but one of "style." The people of America, Barry declared, "are writing another Declaration of Independence—this time from the would be dictators of the American home." Rather than bow to the prescriptions of the editors of fashion and decorating magazines or distant Parisian designers, Barry contended, Americans increasingly exercised "the courage of their tastes" by "taking over the direction of their own homes and their lives." Citing Riesman's *The Lonely Crowd*, Barry argued that the chief problem facing Americans in the early 1950s was "how to be an individual in a society dependent on mass production." His answer: "Like life in nature, you must give your

personal expression, your taste, free play—or you will emerge like an end-product on an assembly line of canned culture." One's home should not, he said, be a "rubber stamp" of official taste, or mirror the "impersonalism" of the office environment. By choosing "free taste," Barry contended, Americans were "reclaiming their manhood" from conformist society. "They are," he declared, "today's happy warriors. They believe in one thing: free taste exercised by free men." He concluded, echoing the *Communist Manifesto*, "The truly free man cannot be beaten. . . . He—no you, *you* have a world to discover and possess, especially yourself."[4]

The articles and illustrations in *House Beautiful* describe the development of a personal style as an individual exercise in freedom. This idea of personal lifestyle derives from romanticism and avant-garde ideas about individual self-expression. The political, sociological, and psychological context of these essays transformed the home into a decisive center of action in Cold War America. But behind the rhetoric of freedom there remains the coercion of consumption. The editor of *House Beautiful*, Elizabeth Gordon, encouraged the development of the "other-directed-personality" (diagnosed by Riesman) by her advice to readers to look for the signs of changed style not just "in your own purchases," but "in the new possessions of your friends" and "in the 53 pages [of *House Beautiful*] that follow." These pages included an essay by critic Joseph Wood Krutch advising readers on "How to Develop Discrimination." The editors also provided what they described as a "forecast of American taste—*your* taste," with seeming obliviousness to the self- fulfilling nature of such a forecast.[5]

The Alienation of the Avant Garde from Consumer Culture

Members of the postwar avant garde felt alienated from American consumer culture. Most vanguardists believed that materialism was the basic value of the American people and a central problem that needed to be solved if American culture were to be renewed. In 1951, avant-garde editor Horace Schwartz noted in his magazine, *Goad*, that the cultural tradition of the United States seemed often to "consist in the pitiful phrases 'free enterprise,' and 'American Way of Life.'" This critique of commercialism was not new for the American avant garde, or for the avant garde in general. Like their predecessors, postwar vanguardist critics argued that for Americans progress seemed to be defined only in

material, economic terms. Furthermore, they argued, Americans based aesthetic and other moral (for aesthetic questions were moral questions to advanced intellectuals) evaluations on quantitative measures, such as price or the possibilities for profit or social advancement. So intent were Americans on economic success, wrote surrealist Parker Tyler in 1945, that their imaginations were "inflamed . . . with the sense of material luxury." In 1961, poet Gary Snyder declared, "Modern America has become economically dependent on a fantastic system of stimulation of greed which cannot be fulfilled, sexual desire which cannot be satiated, and hatred which has no outlet except against oneself or the persons one is supposed to love."[6]

As inhospitable as this context seemed to cultural radicals, little magazine editor James Boyer May argued that such an environment was fertile ground for the avant garde. May noted that the largest number of little magazines came from countries that were "hosts to conformative negativisms," while at the same time not outright dictatorships. "Thus," May continued, "their largest numbers have budded in the U.S.A., 'free' world leader with a science-guided industrial economy emphasizing material welfare." May's point supports Renato Poggioli's contention that the only authentic bourgeois art is anti-bourgeois. The conformism and material striving of America in the 1950s seemed to be the perfect setting for the avant garde.[7]

Many cultural radicals, however, did not consider the prevalent value system to be conducive to great art. Clyfford Still described his paintings as anachronisms because they expressed values in opposition to the scientific and business-oriented values he saw as dominant in the United States. In the late 1940s, rather than have his paintings coopted as decoration for corporate offices or penthouse apartments—a complete denial of their content—Still asked gallery owner Betty Parsons to withdraw them from public view and sale. Harry Partch did not have much hope for the "significant evolution of American music" given the "American genius for perverting a spark of individual imagination into a commodity for nationwide distribution." And indeed, how could one expect otherwise, when, according to Beat poet Gregory Corso, writing in 1961, the most powerful spokespeople for American values were not Benjamin Franklin or Thomas Jefferson but "strange red-necked men of industry." In the decades after World War II, radical intellectuals felt completely alienated from a culture defined by the quest for profit, economic success, and social status.[8]

Furthermore, members of the advance guard believed that the pursuit of material success was not only a wrong-headed goal, but also one that stifled the human spirit. Because humans are, in the vanguard view, creative, spiritual beings, too much attention to material concerns causes the spirit to atrophy. Incapable of creative expression or appreciation, the true self is destroyed. In 1945, poet Wendell Anderson described the younger generation as "already slave material for the assembly line, the yoke of a union and a job, good voters and enjoyers of their necessities . . . the gadgets . . . the luxuries of our modern world . . . which is around their ankles and necks like a ball and chain." This enslavement to the material boded ill for the future of the United States. Citing his favorite authority, Allen Ginsberg wrote to his father, Louis Ginsberg, "Whitman long ago complained that unless the material power of America were leavened by some kind of spiritual infusion we would wind up among the 'fabled damned.'"[9]

Members of the avant garde did not distinguish between militarism and materialism. In the 1950s, most cultural radicals agreed with little magazine editor David Koven that both were linked: "The dynamics of the society lead only to war and destruction," Koven wrote in 1956. "Remember, without a war, or the threat of war, this whole economy would collapse." Thus, these critics contended that the unhealthy value system of the American people, combined with the great military power of the government, placed at risk not just the future of the country, but the world as well. In 1949, editor Jay Waite of *Gale* declared that the United States was like "a child with two shotguns, four knives, a bottle of acid and nothing to do with his time"—in short, a menace to himself and to others.[10]

Avant-garde alienation from post-war prosperity also resulted from the vanguardist's own uncertain economic role and social status. Without official patronage, creative intellectuals since the nineteenth century have lived in a difficult and ambiguous position, forced to be producers in a free-lance art market, but regarded by many people as parasites who consume without producing anything of "real" value. Members of the avant garde preferred, of course, to think of themselves as producing work that was important to their society, and they rejected the idea of economic success if it meant compromising their principles. Snyder remembers that in the 1950s he and his colleagues had "a choice of remaining laborers for the rest of our lives to be able to be poets." But even if artists preserved their integrity, could they be heard? "The poet,"

declared Waite in 1949, "is forced to labor under conditions that demean his person and atrophy his art. He can't be found for the jumble of stuff and things; he can't be heard above the roar of production." Under these circumstances, the temptation was great to say, as *Contour* editor Christopher Maclaine suggested in 1947, "To hell with Art," and join the Chamber of Commerce. The alternative was to labor to change society.[11]

The Absorption of the Avant Garde into Corporate Culture

Given the hostility between the avant garde and consumer culture, how did the absorption of the one into the other occur? One agent of the domestication of the avant garde was businesspeople who integrated the avant garde into corporate culture. The other agent was the mass media. This section will focus on how American businesspeople contributed to the commodification of the avant garde through the use of innovative art in advertisements and design and in corporate collections and sponsored exhibitions. In addition, we will see how members of the art world helped assimilate the avant garde into corporate culture by applying the latest commercial marketing techniques to the sale of art.

The process of commercial canonization began in the 1910s, when American advertisers and designers began to use avant-garde images and motifs. Members of the advertising elite of the 1920s understood themselves to be "modernizers." They believed that part of their role, beyond selling the client's product, was to educate people about the changes taking place in society and culture in the industrial world. Many of them turned to avant-garde artists for images the advertisers considered to be appropriate for a technologically advanced, urban, industrial world. They also believed that association with high art brought prestige to their products. Modern art, ad man Earnest Calkins said, "offered the opportunity of expressing the inexpressible, of suggesting not so much a motor car as speed, not so much a gown as style." Thus, advertisements in magazines such as the *Saturday Evening Post* and the *Ladies Home Journal* introduced Americans who had no exposure to museums and galleries to innovative art by, or in the style of, such artists as Pablo Picasso, Charles Sheeler, and Charles Demuth.[12]

During the 1930s, most advertisers returned to more traditional designs as competition in a depressed economy turned their attention from aesthetically appealing ads to basic hard-sell styles. An exception to this

trend was the promotion of modern design by industrialist Walter Paepcke, whose firm manufactured packaging. In 1935, Paepcke established an art department in the firm to develop new designs for everything from stationery to advertisements. Paepcke hoped that the association of the company with modern design and art would create the image of a company dedicated to innovation and also contribute to cultural uplift.

Paepcke's explanation for the ad campaign applied to all of his design interests. "Simplicity, conciseness, [and] unity of design and thought and line," he said, would characterize the advertisements. Text would be limited and the illustration emphasized in order to give the viewer "something interesting to look at which he could associate with us" and thus associate the company with "originality, imagination, and taste." In this way, he concluded, "the techniques of modern artists would identify us with current developments in applied graphic art which were—and are—so important to packaging." Over the years, the company used in their advertising work by artists such as Willem de Kooning, Man Ray, Fernand Léger, Henry Moore, Jean Helion, and Herbert Bayer. A writer in *Harper's* described Paepcke's company as the "most daring" corporate advertiser because it "used abstract paintings in full color for their decorative and shock effect in magazines." Other American businesses soon followed the example of the container firm in the use of contemporary art in advertising.[13]

Direct industrial patronage of the arts also became an increasingly important source of funds for the art world beginning in the late 1930s, and became even more significant in the postwar decades. Corporate patronage included the sponsoring of contests, performances, tours, and exhibitions. For example, in 1945 a major cola manufacturer began sponsoring an annual painting competition, offering thousands of dollars in prizes, a national tour, and the printing of twelve of the paintings in a widely distributed calendar. The firm sponsored this show, as other firms did, as a mixture of public relations and advertising. Most companies supported very conventional works, but many corporations always included some vanguard work.

Merce Cunningham and his avant-garde dance company, for example, benefited from corporate sponsorship. A chance meeting at a cocktail party between the development director of the Cunningham troupe and a director for a multinational oil company resulted in funding for part of a South American tour by Cunningham and his dancers. Concerns about public relations and politics motivated the managers of the Venezuelan

subsidiary of the oil company to fund Cunningham. The businesspeople wanted to pacify criticism of the firm by student activists. Knowing the appeal of avant-garde culture to students, the company financed a week of dance concerts by Cunningham's group in Caracas and distributed thousands of free tickets to students. John Cage said that the week in Venezuela was "the best thing on the whole tour." The oil company reaped public relations benefits that brought them increased stability.[14]

Corporations also served as patrons by purchasing art for their own private collections. In the early 1960s, the managers of a large public relations firm established a division devoted to helping corporate clients buy paintings and sponsor exhibitions. Under the leadership of David Rockefeller, a large New York bank developed an extensive collection of avant-garde paintings and sculptures. Corporate managers collected art as an investment and as a form of personnel management. Like Paepcke before them, businesspeople in the postwar years believed that innovative art in their offices would inspire their workers to innovation. For example, in 1962, the managers of a major cigarette manufacturing firm decided to redecorate their corporate offices in a modern manner, including new designs in furniture and avant-garde art. A company spokesperson explained the criteria used by company officials to choose art for the corporate collection (and also for corporate-sponsored avant-garde exhibitions): "Art that would shatter the routine view of things, that would force all of us to see things from new perspectives, that would coax us into thinking of things in novel ways." These words also describe the goals that vanguardists had for their work. In this particular corporate context, however, "new perspectives" meant new ways to market a product. Here, as elsewhere in the business world, the advance guard suffered the ironic fate of becoming a tool for corporate image making.[15]

At the same time that Paepcke was bringing art into business, a public relations expert and artist's agent named Reeves Lewenthal decided to bring business methods to art. Lewenthal's experiences in the art world and the business world convinced him that members of the former used ineffective and outdated marketing techniques. "The gallery system," Lewenthal contended, "is doomed. The rich collector class is dying out. There is no use in the galleries' sitting around and complaining and waiting for the few old collectors who are left to come in and buy an occasional picture. American art ought to be handled like any other American business." Accordingly, in 1934 Lewenthal founded the Associ-

ated American Artists to market prints by American artists to middle-class purchasers. Lewenthal first attempted to sell five-dollar prints in department stores, but went on to have his greatest success selling prints through mail-order. In the 1930s and 1940s the Associated American Artists featured the accessible modernism of regionalist painters Thomas Hart Benton, Stuart Curry, and Grant Wood. Lewenthal also promoted his artists to advertisers, as in a cigarette campaign that featured the paintings of Benton. In this way, he and others contributed to bringing avant-garde art into advertising.[16]

In the postwar years, Lewenthal, ever sensitive to shifts in taste, began to sell abstract prints and sculptures at stores in New York, Chicago, and Beverly Hills. He updated his mail-order business to include popular consumer items such as fabrics, ceramics, greeting cards, calendars, lamp-shades, and place mats, many of which featured abstract styles. Thus, Lewenthal continued to contribute to the domestication of modernism. By the 1950s, however, Associated American Artists faced stiff competition from interior design firms, furniture makers, and other household accessory manufacturers who also produced items featuring avant-garde styles.

In 1962, painter Ad Reinhardt declared, "No art as a commodity or a jobbery. Art is not the spiritual side of business." The commercialization of the advance guard concerned Reinhardt and other cultural radicals. If the avant garde did not quite become the spiritual side of business, the movement certainly became an important part of the business side of business. In an economy of abundance in which consumption was the goal, the avant garde fulfilled a need. Innovation assimilated to design and advertising aided in the construction of product images. Innovation incorporated into public and personnel relations helped to shape corporate images. Such was not the goal of members of the avant garde. The realities of the market economy, however, required avant gardists to accept money from almost anyone who was buying. But both cultural radicals and businesspeople of the twentieth century challenged the values of producer culture. The members of the advance guard advocated liberation through creative self-expression. The corporate leaders advocated liberation through consumption. In the end, the merchants of consumption defeated both producer and avant-garde cultures. By the 1960s, creative self-expression and consumption were all but indistinguishable.[17]

The Media and the Mediation of Culture

The mass media also functioned as a promoter, connecting the vanguard with consumer culture during the postwar years. Along with national advertising, the mass media became a key institution in the dissemination of consumer-culture values. Both advertising and the media developed their modern form at the same time, and both tended to communicate prepackaged and fragmentary information with the intent that their products be consumed rather than understood. Advertisers and the editors of mass-market magazines denuded the American avant garde of cultural concerns and reduced the movement to celebrity, lifestyle, status, and fashion.

Throughout the twentieth century, the editors and writers of the mass media functioned as gatekeepers who controlled the information that reached the public. While the rhetoric of the media proclaimed their objectivity, certain institutional factors operated to distort the information presented, thus projecting the avant garde to the postwar public through a defective lens.

Three characteristics of the mass media account for these distortions. The first was the fragmentation of information. The mass media presented information as a plethora of facts about the world with little context of meaning or interpretation. The media created what Neil Postman has called a "peek-a-boo world" in which one event or person pops into view, disappears, and is followed by another.[18] The second distorting characteristic was the use of sensationalism. Editors favored stories that appealed to the emotions of their readers, especially feelings of wonder, excitement, or fear. Such an editorial strategy favored the presentation of "odd" behaviors or images over the presentation of serious ideas, such as those of members of the avant garde. The third characteristic was the creation of pseudo-events. Pseudo-events, according to Daniel J. Boorstin, are manufactured occurrences presented in the media for self-serving motives. The phenomenon of celebrity is the pseudo-event most relevant to the avant garde. Celebrities are individuals well known for being well known, whatever meritorious contributions they may have made to society. Typically they are entertainers who are not intrinsically important. The concept of celebrity unites fragmentation with sensationalism and focuses public attention on personality rather than ideas or other substantive content. Together, these three characteristic distortions of the mass

media had a particularly deleterious influence on modern avant-garde movements.[19]

Celebrity and the Avant Garde

The model of artist as revolutionary leader heroically showing people the way to the future has been a standard one since the romantic period and was especially prominent in the age of the avant garde. In the twentieth century, the hero has been transformed into the celebrity. Personality has become the focus of presentation rather than ideas or accomplishments, which are often lacking for celebrities in any case. Often such presentation serves commercial purposes, as in the case of conductor Arturo Toscanini, who, throughout the middle decades of the century, personified the nexus of celebrity, culture, and commerce in his job as conductor of the NBC Symphony Orchestra.

Neither the vanguardists' social critique nor their desire to integrate art and life in a radically new world appeared in popular media. In the postwar years, painter Jackson Pollock emerged as an avant-garde celebrity and established a pattern followed by other artists with increasing frequency as the years went by. Of all the abstract expressionist painters who could have been highlighted, the choice of Pollock was fortuitous from a media standpoint because he was a shy man and tended to direct attention to his works rather than theorize about them. That is not to say that Pollock lacked ideas or intentions, only that he was less communicative about them than were other abstract expressionist painters such as Robert Motherwell, Barnett Newman, or Clyfford Still. Newman and Motherwell especially wrote extensively about their aims and ideals. But Pollock's limited "paper trail" and reluctance to express theoretical concerns provided an unusual opportunity for the media to transform him from radical innovator to celebrity artist.

The editors of *Life* magazine decided to publish a feature story on Pollock after the painter was mentioned in the "*Life* Round Table on Modern Art" in October 1948. The article appeared in August 1949, and the writer focused almost exclusively on personality and work methods, saying nothing about the artist's motivations or the intellectual milieu from which his work came. The writer noted "inexplicable" qualities of Pollock's paintings and decided to make these qualities the center point of Pollock's personality, describing him as "brooding and puzzled-look-

ing." The accompanying photograph shows the painter with furrowed brow, crossed arms, a cigarette dangling from his mouth, standing before one of his large canvases. The tone of the piece is patronizing, the author getting much fun out of Pollock's use of a trowel and the ash and insects that accidently ended up in the paintings. But Pollock was also described as an independent man whose work was an expression of his personality, and as the only one who knew when a painting was completed. Pollock's quirky paintings were presented as a result of his quirky personality, but it was *his* personality. In a bureaucratic society, he was a rebel who followed his own intuition, a man as self-made as his art.[20]

The moody rebelliousness of the public Pollock found a counterpart in the popular method actors of the 1950s: Montgomery Clift, Marlon Brando, and James Dean. The editors of *Time* made the comparison explicit in a 1956 article about Pollock and other abstract expressionists entitled "The Wild Ones," after the 1953 Brando film *The Wild One*. The image of Pollock as a Brando character became established in the popular media and influenced the way other artists thought about him. Painter George Segal recalled stories about Pollock from Segal's student days at New York University: "They told me he was violent, deep, inarticulate, he drank too much, was passionate, revolutionary, but HIMSELF only in his paintings." Segal remembered that this description always put in his mind "Marlon Brando's brooding, pouting profile" as Stanley Kowalski in *A Streetcar Named Desire*.[21]

Pollock the celebrity was not solely the creation of mass media publicity; Pollock himself contributed to the image. In the early 1950s, photographer Hans Namuth began taking a series of famous photographs of the artist. Pollock became obsessed with the idea of the artist as actor and discussed with friends the appropriate "persona" for the modern artist in order to be ready for the next session with Namuth. He took to wearing cowboy boots, something he had not done since his youth, to emphasize his Western origins and the individualism, freedom, and primitivism that the West connoted (another media stereotype). In 1956 the image was completed when Pollock died in a car crash in the manner of James Dean. The linkage of Pollock and the avant garde with *Rebel Without a Cause* indicated the banality of celebrity journalism. Ironically, cultural radicals were explicitly rebels *with* causes.

For the famous, celebrity promised financial reward. Artists discovered that through the notoriety of being a celebrity they could distinguish themselves from others and translate that distinction into increased com-

mercial success, if not lasting fame. Thus, ambitious artists transformed the idea of avant-garde innovation from a serious purpose into a marketing technique. Their ultimate purpose became to turn, as Philip Fisher put it, "a style into a brand."[22]

Following Pollock's example, other members of the avant garde manipulated the media more successfully to create a celebrity image for themselves, what Dick Hebdige describes as the "artist as star." Painter Larry Rivers followed Pollock's course as artist celebrity. In the late 1950s, Rivers appeared on game shows and in *Life* magazine; his marital problems and drug taking were well publicized. Likewise, Norman Mailer established the pattern of postwar celebrity writer. The title of Mailer's 1959 work, *Advertisements for Myself,* proclaimed that, as critic Lillian Feder noted, "the self has become an image." The celebrity presented images of excitement and self-fulfillment to an audience searching for, as Norman Podhoretz remarked with reference to Mailer, "not so much a more equitable world as a more exciting one." In 1958, the managers of the New York jazz club the Five Spot Cafe advertised it in the little magazine *Yugen* as the "Home of Thelonius Monk, jazz-poetry, [and] America's leading painters, sculptors, composers, actors, poets, people." Seemingly, there was no better place to look for artist-celebrities.[23]

Andy Warhol epitomized the innovative artist as celebrity. He deliberately courted fame, as if being famous as an artist was the same as being significant. In a culture of consumption, he was probably right. From his youth, image had concerned Warhol. In the 1950s, he began combing his hair in the style worn by Truman Capote in the jacket photograph of Capote's first novel, *Other Voices, Other Rooms,* a photograph that itself was highly stylized. Throughout his life, he carefully constructed a public image. In the early 1960s, Warhol added to his Capote image a leather jacket and sunglasses (in the biker style of Brando from the movie *The Wild One,* also a theme for one of Warhol's paintings).

The idea of artist as celebrity carried over into Warhol's work. His paintings and films had the qualities of "pseudo-events" in that their significance rarely went any deeper than their surfaces. Warhol characterized his work as "empty" of feeling and meaning, commenting to an interviewer, "If you want to know all about Andy Warhol, just look at the surface of my paintings and films and me, and there I am. There is nothing behind it." His interest extended only to what he saw. Warhol's use of images from the mass media, of publicity-style photographs, and of the mechanical technique of silk screening, often using repetitive imagery,

focused attention on surfaces. In his films, the use of the long take produced a similar repetitive quality. Warhol's works were, as Patrick Smith argued, "homages to . . . ," that is, to whatever object happened to be the subject.[24]

Warhol believed that people would look at these objects because he was famous and he was looking at them, and perhaps people would see common objects as special because of their association with a celebrity. Critic Kynaston McShine described this belief as "the alchemy of fame": the ordinary transformed into the extraordinary by the celebrity's artistic gaze.[25]

This alchemy had some parallels with historic vanguard beliefs about the integration of art and life. But in Warhol's work the goal seemed to be the integration of celebrity and life. The new vision he offered was that people would see soup cans as celebrities of the art world, not that they would learn to perceive everyday life as an aesthetic experience.

Warhol, of course, was not the first artist to use ordinary, mass-produced objects as art. Indeed, for the 1989 Museum of Modern Art Warhol retrospective, Robert Rosenblum's catalog essay, in the best tradition of the museum, provided a distinguished pedigree for Warhol, including cubism and Dada. But these earlier avant gardists relied on the authority of their vision, not their fame, much less their popularity, to transform the perception of their audience. Furthermore, these earlier cultural innovators tended to oppose the institutions of the art world because they believed that these institutions created the distinction between art and life. Warhol, however, based his strategy for achieving fame on the power of art world institutions such as galleries, museums, and magazines to create an artist's reputation. He relied on these institutions to validate his vision and make him a credible artist.[26]

With celebrity status came the opportunity to make money. The artist's name on a work made the painting valuable. Throughout the 1970s, portraits commissioned by collectors and celebrities provided Warhol with a large part of his income. Warhol's name associated with a product made the merchandise valuable. Warhol advertised his services as product endorser in the *Village Voice* in 1966: "I'll endorse with my name any of the following: clothing, AC-DC, cigarettes, small tapes, sound equipment, Rock 'N' Roll records, anything, film, and film equipment, Food, Helium, WHIPS, Money; love and kisses Andy Warhol." Over the next two decades he endorsed two airline companies, a liquor interest, an electron-

ics manufacturer, a news magazine, a shampoo, and an investment banking firm.[27]

Warhol indeed created a "brand" for himself, producing art and films in quantity in a studio he knowingly called "The Factory." Warhol transformed the advance-guard movement into a media event. The bias of modern mass communications toward sensation and celebrity, as well as the romantic tradition of describing the artist as a bohemian rebel, combined to create "celebrity vanguardism." Because the members of the avant garde tended to describe their alienation in personal and individual terms rather than social ones, the cultural concerns of the advance guard could be ignored and the eccentricities of personality brought to the fore. Perhaps because of his experiences in advertising and commercial art, Warhol grasped, almost intuitively, how the media worked. He combined his media knowledge with the rhetoric of the avant garde to re-create himself as a celebrity, thus helping further to subsume the advance guard into the culture of consumption.

The Avant Garde as Lifestyle

The mass media commodified the avant garde by focusing on superficial aspects of the artist: his or her taste in clothing, music, and hairstyle; cleanliness; vocabulary; and employment (or lack thereof). The media thus drew attention to that constellation of qualities that would come to be called "lifestyle." This focus on lifestyle would be particularly true for the Beat vanguard. The Beat movement attracted attention in 1956 with the *Howl* obscenity trial. The publication of Jack Kerouac's *On the Road* the next year created even more publicity, beginning a Beat fad among many younger Americans. Initial discussion of the Beats in the mass media tended to be at least grudgingly favorable and to demonstrate that the writers had at least some understanding of what these cultural radicals were about. For example, literary critic Gene Bara wrote in the *New York Herald Tribune* that the Beats were "mystics, and their mystique is the self." Other reviewers described Kerouac as the F. Scott Fitzgerald or Ernest Hemingway of the post World War II generation. In some cases, writers felt positive expectation about how the movement might develop. Leslie Cross wrote in the *Milwaukee Journal* in 1957 that "the winds from the west are free and may (let us hope) whisk away at least some of the stuffiness that has settled over so much American writing in the 1950s."[28]

The situation changed rapidly, as journalists turned from attempts at serious explanation of the writings of the last American vanguard to caricature and ridicule. Norman Podhoretz's condemnatory piece in the 1958 *Partisan Review*, "The Know-Nothing Bohemians," seemed to set the tone for subsequent commentary. Podhoretz denounced Allen Ginsberg, Kerouac, and the others as irrational, immature, and incompetent. Journalists linked the Beat vanguard to the alleged youth rebellion, another media stereotype of the decade, and to movie star James Dean. Journalists assumed that the Beat writer was inarticulate, withdrawn from the world, and a literary poseur. Following the Sputnik launchings, San Francisco newspaper columnist Herb Caen coined the derisive nickname "beatnik," which helped to further the media theme that the Beats represented an adolescent phase rather than a serious vanguard movement. A *Time* writer described them as a "pack of odd balls who celebrate booze, dope, sex and despair." The level of discourse is illustrated by the fact that writers in both *Time* and *Life* mentioned that Beat poet Gregory Corso boasted that he never combed his hair, "Although," Corso was quoted as saying, "I guess I'd get the bugs out of it if I did." [29]

In this way, the attention of the mass media turned increasingly from the literature and ideas of the Beats to descriptions of their "lifestyle." The lead-in photograph illustrating Paul O'Neal's *Life* magazine story on the Beats summed up the superficial presentation. The photograph, allegedly depicting a Beat "pad," had been, according to the caption, "recreated in [a] studio shot using paid models." The picture included, however, everything a prospective Beat needed for "uncomfortable living": a mattress on the floor, bongos, marijuana, empty beer cans, a typewriter with an unfinished poem, Charlie Parker and Miles Davis records on the phonograph, a "beat chick dressed in black," and a "bearded beat wearing sandals, chinos and turtlenecked sweater." The stereotype became so pervasive that when a San Francisco television station sent a camera crew to North Beach to film a poet's "pad," the journalists did not believe that the neat apartment, filled with books, paintings, and attractive furniture of a contemporary design, presented the appropriate appearance. The producer covered the coffee table with cigarette butts and liquor bottles and then began filming. The almost complete identification of Beat with a particular lifestyle rather than intellectual content could be seen in this description of Japanese so-called "Zen beatniks" published in *Look* in 1963: "Along with blue jeans, dark glasses, coffee milling and an anti-haircut movement, Japan's beatniks

have adopted freethinking and free-acting with amazing alacrity." Writing from Japan, Gary Snyder noted to Lawrence Ferlinghetti in 1960 that "b.g. [beat generation] is becoming widely publicized in Japan . . . — emphasis on L.A. type crowd and coffee shops and funny clothes. . . . But I think the b.g. will become another half-understood fad here among the teen-agers."[30]

The avant garde became a commercial property. A San Diego department store began to advertise a line of "beachnik" swimsuits. A Beat character was added to the popular television program *Dobie Gillis* as well as to the radio soap opera *Helen Trent* and the comic strip *Popeye*. MGM produced a movie, *The Beat Generation*, and a publisher of pulp fiction issued *Beatnik Party*, whose characters, according to the cover copy, were "crazed with strange desires" and "sinful passions." A group of clever avant-garde poets and photographers in New York City established a "Rent-a-Beatnik" service in the late 1950s and were very successful until the IRS closed them down for nonpayment of taxes. Jazz musicians popularized by the Beats (Kerouac appeared on album covers) became successful, and young people copied the jazz musician's "style": Gerry Mulligan's haircut, Dizzy Gillespie's beret. Jazz performers also made advertisements for cigarettes, clothes, hair products, and, of course, records. In 1966, poet John Ashberry complained that "Grove Press subway posters invite the lumpenproletariat to 'join the Underground Generation' as though this were as simple a matter as joining the Pepsi Generation which it probably is."[31]

Besides journalists, cultural radicals themselves contributed to the reduction of the avant garde to lifestyle accoutrements to be picked up by rebellious young people. Lawrence Lipton wrote *The Holy Barbarians* (1959) as an explanation and defense of cultural radicalism. The effect of the book, however, with its glossary of Beat terms, stereotypical photographs, and superficial discussions of Zen Buddhism, drug taking, and other bohemian behaviors, was to further the trivialization of the advance guard.[32]

Lipton had pretensions of being a serious avant-garde artist, but he made his living as a hack writer of short stories, radio scripts, and, with his wife, a series of very successful detective pot-boilers. As Lipton wrote to Kenneth Rexroth, "I was capable of doing the very thing I had the most contempt for—and doing it well." The irony was compounded by Lipton's failures at serious fiction and poetry in the 1940s and 1950s.[33]

Divorced, Lipton moved to Venice, California, in the mid-1950s, at-

tracted by the low rents. There he met the bohemian community made up of Stuart Z. Perkoff, Wallace Berman, and others. In the Venice avant garde, Lipton believed he had found the embodiment of his idea of the poet as "New Barbarian," a concept he described in a long poem. The new barbarian would, Lipton declared,

> *restore*
> *The sense of wonder; men made brothers*
> *Not in name alone, but deeper,*
> *in the ritual ring. Fresh sacraments,*
> *New meanings valid for our time,*
> *A world reborn, a new hierogamy.*

Lipton decided that his future as an avant gardist lay in popularizing the Venice vanguard.[34]

Lipton's thought, such as it was, presented a mass of contradictions. He did not believe in commercialism, but he did believe in commercial success. He thought that if a book or a poem were good, then millions of people would want to read it, and that if an idea were true, then millions of people would change from their old ways of thinking and accept the new. Lipton believed that the avant garde needed only a skilled publicist to succeed. All he had to do was present to "the public" the ideals of the advance guard: their voluntary poverty; their dedication to creativity; the liberation they found in drugs, jazz, and free love. Published at the time of the Beat fad, *The Holy Barbarians* received much media attention and became a best seller. Although the Venice vanguard community had little direct relationship to the Beats, the two elided together in the public mind, a union that Lipton implied in his book and did nothing to dispel.

Combined with the presentation of the avant garde in the mass media, Lipton's work contributed to the commodification of the avant garde as lifestyle. Consider, for example, the contrast that Lipton drew between the 1920s and the 1950s vanguards:

> In the 1920s, Chuck Bennison [pseudonym for a Venice bohemian] . . . would have quit his advertising agency job, as Sherwood Anderson did, but he would not in the twenties have shed his necktie, put on Levis and gone to live in poverty in a slum, seeking "new ways of knowing" through pot and trance and far-out jazz as he did in the fifties. Sherwood Anderson's was not a total rejection of American lifeways and values.

Nor would the young people and tourists who began to flock to the Village and North Beach truly reject American values. They would tend

to focus on the most easily applied avant-garde "ideas": Levis, jazz, and, in the middle and late 1960s, marijuana. Cultural slumming became common as many young Americans concluded, as novelist Ronald Sukenick put it, "All right, if art is life, then who needs art?"[35]

A friend of John Cage's told him that her teenaged son came home from work one day and announced that he would not be home for a couple of days. "What's up?" Cage's friend asked. The son explained, "Tomorrow night after work, I'm driving to Albany with Danny Sherwood [a friend] for a cup of coffee, and I'll be back for work the following day." When the boy's mother pointed out that he could have a cup of coffee in the kitchen without driving all night, he answered, "Don't be square. Read Kerouac." The story was not atypical. Joyce Glassman, Kerouac's lover at the time, wrote from New York City to Allen Ginsberg and Peter Orlovsky in 1957 that "HOWL is being sold in drugstores now and the West End is full of young, would-be hipsters who laugh and say 'Well, I'm on the road,' or 'Think I'll go to Frisco today.'"[36]

Writing back to the Oklahoma-based *White Dove Review*, Greenwich Village correspondent Wes Whittlesey reported that while the Village was the place for the avant garde and many there really believed in freedom and creativity, many more used the idea of "freedom of conscience" as a "license for sexual promiscuity." Perkoff distinguished between "working artists" and "beatnikians," whom he characterized as "non-doers who have all the personality of a used condom [and] . . . really are a drag."[37]

The absorption of the Beat "lifestyle" into postwar society was fraught with additional ironies. The writers for *Time, Life*, and other media presented the Beat vanguardists as silly and deplored their lack of moral values. At the same time, however, they popularized the superficial aspects of the vanguard rebellion among young people who felt alienated from the bourgeois conformity of the decade. In this way, the media controlled the rebellion. By discrediting the substance of the vanguard critique of America, the mass-media popularizers enabled a "safe" rebellion that did not undermine the consumer culture, but rather created a new consumption community.[38]

The Avant Garde and Status

The mass media further merchandised cultural radicalism to American society by associating the advance guard with status. Journalists who associated the vanguard with wealth, fashion, and success made for a more favorable reception of cultural radicalism. But the presentation of the

advance guard as a lifestyle symbol of status trivialized the important cultural concerns of the movement. Radical innovators did not envision that alienation would end in social climbing.

In the spring of 1951, for example, *Vogue* magazine featured the latest in evening wear from Saks Fifth Avenue and Lord and Taylor being modeled in front of paintings from Pollock's show at the Betty Parsons Gallery (Alexander Liberman, creative director at *Vogue*, was a friend of Betty Parsons). The paintings shown included canvases that would become two of the artist's most famous works: *Lavender Mist* and *Autumn Rhythm*. The author of the brief accompanying text noted that some observers described the paintings as "idiotic," while others thought them the work of a "genius." "Among the latter," the writer commented, "are some of the most astute private collectors and museum directors in the country." Pollock's understanding of myth and symbol, which gave meaning to his work, was not mentioned in the text and implicitly denied by the functional use of the paintings as backdrops. Pollock's message was reduced to style, even fashion and sophistication, without content or intentionality.[39]

In 1955, the editors of *Fortune* presented the avant garde as a smart investment. "Is it possible to draw useful parallels between investment in the art market and investment in the stock market?" asked two writers for that magazine in 1955. "Roughly, it is," they answered. The commentators compared old master paintings to "gilt-edge securities"; paintings associated with modernist movements, such as impressionism and the School of Paris, to "blue chip" investments; and the works of the contemporary avant garde to "speculative or 'growth' issues." Among the radical innovators mentioned as good speculative investments were Mark Rothko, Robert Motherwell, Clyfford Still, Jackson Pollock, Willem de Kooning, Larry Rivers, William Baziotes, and Franz Kline. By 1958, a writer for *Life* could describe "a worldwide boom in the advanced styles of U.S. painting which are still controversial at home." The writer's tone suggested that Americans might learn something from the "record crowds" turning out in Japan and Europe to see the new American work and maybe pay more favorable attention to contemporary artists.[40]

In 1968, the *Saturday Evening Post* ran a cover story on choreographer and dancer Merce Cunningham. The cover photograph featured Cunningham in lurid makeup designed by Robert Rauschenberg. But lest the *Post*'s readers get the wrong idea, writer Donal Henahan noted that Cunningham had been praised in the pages of the *New York Times*, had

received numerous grants from prestigious foundations, and oversaw an organization with a budget in excess of $200,000. Henahan described Cunningham as the "son of a country lawyer" who had become "the leader of the dance avant-garde." Cunningham's work might be a trifle strange, but he represented the American tradition of hard work rewarded by success—the avant gardist as Horatio Alger hero. (This issue also included an interview with Vice President Hubert Humphrey about his candidacy for president and a guest editorial by General Curtis LeMay advocating nuclear proliferation.)[41]

In 1958, an article in *Life* carried the heading, "From Shock to Respect." The reference was to public responses to innovative art work, but it aptly described how writers and editors for mass media publications changed their attitude toward the advance guard—from dismissal in the 1940s, to a mixture of condescension and respect in the early 1950s, to acceptance by the late 1950s. The change occurred as members of the avant garde gained respect and acceptance from cultural and commercial institutions. For example, Cage's 1943 New York debut conducting a percussion ensemble received a condescending notice in *Life* magazine. The writer described the performers as "earnest, dressed-up musicians" and noted that "the audience, which was very highbrow, listened intently without seeming to be disturbed at the noisy results." An article in *Newsweek* in 1946 referred to paintings of Robert Motherwell and Adolph Gottlieb under the heading "A Way to Kill Space."[42]

Beginning in the late 1940s, the tone in the popular media became, if not sympathetic, at least more open to modernist and radical work. In *Promenade* in 1949, critic Alfredo Valente discussed the psychological themes of the work of Gottlieb in a fair manner, concluding that "for those clinically interested, this show is outstanding for what is happening in the neon-lighted ateliers." In 1956, a writer for *Time* magazine joined praise and disdain for the abstract expressionists: "Advance guard painting in America is hell-bent for outer space. It has rocketed right out of the realms of common sense and common experience. That does not necessarily make it bad." By the end of the 1950s, *Time* and *Life* writers celebrated the "coming of age" of American art as represented by avant gardists such as de Kooning. By the 1960s, Cage received sympathetic notice in the *Saturday Evening Post*. As avant gardism became established in the art world, the style watchers of the mass media, not wanting to be left behind, revised their tone.[43]

Avant gardists such as Warhol were not unaware that what they were

doing had status appeal. Whipple McCoy, who edited a little magazine for editors of little magazines in the 1940s, believed that increased advertising could earn editors the money they needed to continue publishing their magazines. He recommended little magazines to advertisers because "the influential, intellectual and prominent people who read, write, and/ or edit little magazines are not only more educated and informed than the average, they also represent a far greater buying power." Many cultural radicals took a more sardonic approach to the status appeal of their work. In 1960, Walter De Maria designed a happening that he called the "Art Yard." The Art Yard was a hole in the ground, and digging the hole was a key part of the event. De Maria envisioned "artlovers and spectators" who "would come to the making of the yard dressed in Tuxedoes and clothes which would make them aware of the significance of the event they would see."[44]

The audience receptive to avant gardism, including art lovers and speculators, expanded in America in the postwar years because more Americans had the money, leisure, and education necessary to appreciate cultural activities. Some people in this audience had sympathy for the aims of the avant garde; others viewed innovative culture as a means of status differentiation. The media played an important role in the creation of what critic Thomas Hess called "black-tie Dada." By incorporating the avant garde into the status anxieties of the middle and upper classes, the media once again helped transform cultural radicalism into a style option. The domestication of a whole century of vanguard activism is captured in an advertisement for *Show* magazine in 1964:

> From the backyard cookout to the business conference, conversational reference points have shifted in the last few years. Eliot is more T. S. than Ness, Danny Thomas' view of Toledo has lost ground to El Greco's, and the Ives who have it are both Burl and Charles. In the midst of today's cultural renaissance, you've *got* to know who's who and what's what in the very lively arts.

One's sure guide, of course, was *Show*.[45]

Pluralism and the Commodification of the Avant Garde as Novelty and Fashion

A fluidity of movements marked the avant garde from the beginning. These movements shared a more or less consistent world view and sense

of purpose. In postwar America, these continuities dissolved as the concept of the avant garde came to be reduced to stylistic innovation alone. Several interrelated factors caused this development. One cause was the consumer-culture commodification of the avant garde through celebrity, status, and lifestyle promotion in the media. Another cause was the institutionalization of the avant garde in galleries and museums. A third way in which the avant garde became enthralled in the culture of consumption was as a fashionable novelty in a pluralistic society.

In the 1950s, American sociologists popularized the concept of pluralism to describe the eclectic mixture of ethnic and interest groups in American society. In time, the word became a media shibboleth for the various world views, lifestyles, and other sociological varieties that, commentators argued, characterized American society. Pluralist theorists glossed over real differences of race and class that divided American society. They did so in part because the postwar prosperity raised the standard of living of so many Americans. Furthermore, the values of consumer culture permeated all levels of American society, creating something of a new consensus.

This was one of the contexts for the breakdown of the avant garde from a cultural movement to a mere quest for novelty. Cultural radicals provided style obsolescence in the arts just as manufacturers did for consumer goods.

Modern consumer culture is predicated on the belief that consumption can satisfy psychological needs. Through the fashion system, consumers are constantly presented with superficially "new" choices to meet those needs. Style obsolescence, the most developed form of fashion, originated in the development of branded goods in the late nineteenth century. Manufacturers transformed packing into packaging in order to distinguish their product from another maker's. In the 1920s, automobile manufacturers took this idea one step further with the annual model. Now not only were the cars of one company distinct from another in design, but the design changed regularly. The same company could offer a new choice to consumers every year. Through advertising, manufacturers educated consumers about the latest designs and helped consumers to see that the styles of last year were "out of date." Producers applied the idea of style obsolescence to a whole range of consumer goods, such as furniture and appliances, and stimulated regular demand for goods only superficially obsolescent.

Consumption and the avant garde intersected in the area of design.

The integration of art and life through good design of utilitarian objects was the goal of the German Bauhaus. Designer Lazlo Moholy-Nagy characterized this goal as "design for life." Moholy-Nagy was one of many former Bauhaus faculty members who found their way to the United States after the Nazis closed the school; others included Ludwig Mies van der Rohe, Joseph Albers, Walter Gropius, and Herbert Bayer. Many of them became teachers at important American universities. Moholy-Nagy, with the help of Chicago industrialist Walter Paepcke, founded the School of Design to carry on the Bauhaus program. Robert Jay Wolfe, onetime dean of the school, later chaired the design department at Brooklyn College. As a result of the Bauhaus and the interest of many advertisers in modernist design, the functionalist aesthetic favored by the German designers became an integral part of American design.[46]

Avant-garde design became domesticated in the taste-making mass media and advertising in the postwar years. For example, the "free taste" promoted by the editors of *House Beautiful* in 1952 tended toward Bauhaus-inspired functionalism in furniture design and geometric abstraction in painting. Writer Sara Little noted that new designs in china were "clearly showing the influence of modern sculpture," an indication that people were "beginning to associate art forms with daily living." Little and others not only appropriated avant-garde design, they also appropriated the ideal of uniting art and life. For Little, good design could transform setting the table from "a chore into a satisfying form of self expression," comparable to the "pleasure any artist experiences in choosing his colors and composing his picture. It is one way to make a creative art of daily living." Little transformed the avant-garde goal of creative liberation into consumer choice. Similarly, a 1963 furniture advertisement published in *Art in America* pictured a businessman seated at a functionalist-style desk, with a Picabia print on the wall over the credenza. The caption read, "Whether your taste be for romantic or modern idiom, you will find . . . [our] furniture to express it. Many distinguished art collectors are also proud possessors of . . . [our] furniture, in their homes and in their offices." Innovative design, status, and a canonized avant garde here come together.[47]

Innovative designers were aware of the possibility of being coopted. Moholy-Nagy himself had written, "A promotion of novelty for the sake of novelty . . . tends to create the illusion of new organic demands where no need exists. Usually it is nothing but an artificial stimulation of business." What Moholy-Nagy feared came to pass. Modernist design became

another tool in the production of style obsolescence. Many members of the advance guard considered this development a positive one. Sculptor Oliver Andrews argued that radical innovators, by breaking the bounds of art, enabled many people to perceive the importance of conducting their life with an individual style. This awakening to style seemed to be confirmed by investigators for the Stanford Research Institute, who reported in 1960 that "better off and better educated" consumers were "consciously turning from mass conformity" through the purchase of product innovations, especially in automobiles and appliances. This same group of affluent and educated Americans constituted what Alvin Toffler termed the "culture consumers." They increasingly spent their leisure time (and budget) on cultural activities, including avant-garde culture.[48]

The members of the advance guard also contributed to the subsuming of the movement by the culture of consumption. Beginning in the late 1950s and continuing to the 1990s, avant-garde innovation produced an incoherent pluralism rather than a cohesive movement for change. This pluralist confusion originated in the vanguardist link between innovation and cultural renewal. Cultural radicals believed, as we have seen, that through artistic innovation they could create a new social vision among people. They tried, therefore, to open the fields of creativity by emphasizing the process of creativity and the destruction of the boundaries that separate art and life.

Cultural radicals did not succeed at social reconstruction in part because they did succeed in widening the field of acceptable innovation. Cage gives some idea of this change in his hyperbolic recollection that "when I was young, you had either to follow Stravinsky or Schoenberg. There was no alternative. Now, of course, there are 1,001 things to do, and I think that that's partly a result of the kind of step that not only I took, but others took." In 1958, composer and critic William Flanagan described the state of music as "chaotic" because of the diversity of styles and attitudes.[49]

Likewise, the New York School that emerged as the successor movement to abstract expressionism included a diversity of stylistic approaches that belied the contention that such a school existed. In 1967, painter Paul Branch declared, "There is no avant-garde today. Everything gets known too quickly for there to be any space between the scouting party and the main body of troops. Perhaps there is an avant-garde of quality— but there is no particular look or unifying style that embraces the few works that have real quality." Similarly, Donald Allen divided the poets in

his *New American Poets* anthology into five more or less coherent groups based on their different aesthetic ideas. Critic Sonya Rudikoff described the problem of pluralism in 1957 in the *Partisan Review*. Noting that artistic generations now lasted only a few years, she asked, "Where, who, what, is the avant-garde today? . . . If Larry Rivers, say, is avant-garde, then is de Kooning one of the Old Masters? And then presumably Miró, Matisse, Picasso are prehistoric, the giant race before the Flood."[50]

At the same time, a shift in focus by many cultural radicals from the future to the present changed the context of innovation. Regeneration became a completely individual matter rather than a cultural one. Without belief in a common culture, vanguardists found the distinction between purposeful innovation and change for the sake of novelty increasingly difficult to maintain. Poet Gregory Corso, in a letter to his publisher, Lawrence Ferlinghetti, indicated the ambiguous situation in which cultural radicals found themselves. Citing and revising Ezra Pound's dictum, Corso wrote, "Make it new? aye, but better than that— make it ever new!" To "make it ever new" could be an affirmation of continuous cultural regeneration—or it could be a justification for what critic Irving Howe termed "a neurotic quest for novelty," without a larger purpose.[51]

California painter David Park described the changes that took place in his style in the late 1950s: "Art ought to be a troublesome thing, and one of my reasons for painting representationally is that this makes for much more troublesome pictures." Park reduced avant-garde alienation and innovation to a simple formula resulting in work that is defined as "new" in terms of being different from the prevailing avant-garde style but not in terms of the artist's relationship to a culture in need of renewal. Cage answered critics of the ever increasing pace of artistic innovation with a metaphor from Norman O. Brown: "He sees art as food going right through the body . . . and then . . . you use it up and you need something new." Noting that no one would ask him to regurgitate a steak he had eaten ten years before and eat the meat over again, Cage concluded, "We must have something else to consume." Just as the culture consumers desired new designs in automobiles, so they desired new designs in art. Art that was valued for being new and was no longer seen as threatening by the middle class. Avant gardists provided what the consumers wanted and reduced innovation to a self-conscious quest for novelty. In 1969, critic Harold Rosenberg concluded that the "avant-garde today means a flurry of fashion, whether in painting, sex, or insurrectionary politics."

And, he added, "the period required for 'fashionablizing' an avant-garde has become shorter and shorter."[52]

In a consumer culture, novelty also functions as an outlet for emotions that cannot be expressed in everyday life. As American society became increasingly bureaucratic, a new emotional style emerged, one that Peter Stearns calls "American Cool." The style of cool was basically one of emotional restraint. But certain places in society became safe arenas in which to express emotions: sporting events, horror movies, and artistic venues such as theaters and galleries. Thus, the emotional howl of a poet such as Ginsberg, especially at a live reading, or the meditative emotions inspired by a Rothko painting both functioned for many Americans as catharses for emotions that were difficult to express in other settings.[53]

In all these ways, innovation became yet another means of merchandising the advance guard in the American consumer culture.

Conclusion

Many cultural radicals were aware of what was happening to them and were appalled. Poet Robert Duncan wrote to his friend Robin Blazer in 1957 that "the real necessary retreat [for the poet] is from the whole goddamned promotional and their exploitation thing." In 1958, the editors of the *Provincetown Quarterly* declared in their inaugural manifesto that they rejected conformity to "Madison Avenue," and that "it is the duty of the artist to paint towards self-realization and not for a market quotation." Avant gardists tried to find ways of avoiding commercialization. Conceptual artists such as Donald Judd and Robert Morris argued for a highly theoretical and ephemeral art that could not be commodified. Pop painter Robert Indiana described abstract expressionist paintings as "decorative" and thus likely to become standard decoration "in the American home." But Indiana was certain that pop art would not suffer the same ignominious fate: "There is a harshness and matter-of-factness to Pop that doesn't exactly make it the interior decorator's Indispensable Right Hand." He was wrong, of course, and pop art became the most popular art movement of the 1960s.[54]

Ironically, the members of the avant garde contributed to the making of consumer culture. A motivational psychologist, speaking in the 1960s, described one of the difficulties in changing from producer to consumer culture: "We are now confronted with the problem of permitting the average American to feel moral . . . even when he is spending; even when

he is not saving. . . . One of the basic problems of prosperity . . . is to demonstrate that the hedonistic approach to his life is a moral, not an immoral one." Cultural radicals also rejected producer values. Rather than restraint, they argued for liberation; instead of deferred gratification, they called for self-fulfillment. But the vanguard's quest for self-fulfillment contributed unwittingly to the movement's undoing. Confusing self-fulfillment with self-indulgence, journalists, businesspeople, and advertisers linked the avant-garde quest for a new culture with the emerging corporate culture of consumption by disassociating the avant gardist's ideas from their actions and by focusing on superficial qualities.[55]

The successful integration of the vanguard into the culture of consumption was indicated by writer David Boroff in the *New York Times Magazine* in 1964. Boroff commented that the Beat rebellion was long dead. "It offered a ready-made vehicle for rebellion and protest . . . a few years ago," but today, he declared, "college intellectuals are far too sophisticated for such simpleminded gestures." Kerouac, the writer continued, if read at all, seemed to the students "a relic from the past." But Boroff also noted the continuing influence of the media image of the movement:

> Bohemianism as a cult has virtually disappeared from the campus, yet it is everywhere. It has been assimilated into the mainstream. The young woman with loose-flying hair and black stockings may well be majoring in elementary education, and the young man with a beard is a pre-law student having his last fling. Bohemianism is dead, but its artifacts are all around.

Reduced to a lifestyle, the avant garde became one more commodity in American consumer culture.[56]

The End of the Avant Garde
1965-1995

.

.

.

.

.

.

The Convention of Innovation and the End of the Future

.

.

.

.

.

.

I n 1980, the German philosopher Jürgen Habermas pronounced this verdict on modernism: "Modernism is dominant but dead." Habermas's dictum describes the ironic fate of the avant garde. Vanguardists strove to transform their culture, and by the middle of the twentieth century, the vanguard nemesis, the genteel culture, had been destroyed. A new culture emerged in which advance-guard influence was strong, but it was not the culture envisioned by radical innovators. In part, the avant guard had succeeded. But their success was also their dissolution.[1]

At the end of the twentieth century, the language of the avant garde was often still used. But the reality was that many alienated vanguardists had been coopted by their culture, innovation had become convention, and few intellectuals still believed in the idea of a future cultural redemption.

Alienation to Integration

The argument of this work is that by the 1960s the avant garde had been appropriated into American culture and that this appropriation destroyed the movement. The objection could be raised, as I have noted, that this integration signalled a victory for the avant garde. The counterculture and new left could be pointed to as examples of how avant-garde ideas entered mainstream culture and transformed society. The counterculture, it could be argued, destroyed the stuffy, conformist culture of the 1950s and opened to young people new vistas of consciousness and possibilities of lifestyle. The new left, one could maintain, challenged the Cold War ideology and brought an end to the Vietnam War.

This argument has cogency. Members of the last American vanguard certainly contributed to the ideology of the new left and the counterculture, and many took part in these movements. Allen Ginsberg and Gary Snyder participated in the 1967 Human Be-In at Golden Gate Park in San Francisco. In 1968, Ginsberg joined the protest against the Vietnam War at the Democratic National Convention in Chicago and chanted mantras to keep the peace between demonstrators and the police.

Daniel Moore's Floating Lotus Magic Opera Company, a combination of commune and theater for the Berkeley hippie community, illustrated the avant-garde influences on the counterculture. Moore's operas combined music, dance, ritual, and Eastern philosophy with drug use, ideas of sexual liberation, and contemporary political and ecological concerns. Moore said his purpose was to bring about a "consciousness revolution" that he explicitly contrasted with Marxist ideas of revolution. This revolution, he believed, would create a very different world. "The Floating Lotus," Moore declared, "is an idea projected into the future when wars peter out, with people living in seclusion in the mountains, whose life style is a synthesis of all art forms, all human experience." The goal of an integrated art and life was part of Moore's vision, as it was of others in the 1960s.[2]

But the movements of the 1960s really demonstrated the same processes of cooptation by and absorption into consumption communities and cultural institutions already described. Many of the activists of the new left and proponents of the counterculture, especially in the early stages of the movements, believed that they would witness the transformation of American society. Instead, the media distorted the movements and absorbed them into consumer culture just as it had the cultural

radicals who preceded them. The coverage of the new left by the news media trivialized, polarized, and finally marginalized the movement. While a few leaders became media celebrities, the movement disintegrated into factionalism and nihilistic violence. The counterculture became just another consumer-culture lifestyle. The music of the movement, rock and roll, became a mainstay of the established recording companies. The symbolic dress of the hippies became a counterculture conformity that produced high sales for the manufacturers of denim. As one underground journalist observed in 1970, "The Establishment is slowly finding ways to exploit the radical movement."[3]

The commodification of the counterculture occurred not just because of the opportunism of the merchants of consumption, but also because many of the young never really repudiated the values of consumer culture. They bought different things than their elders—marijuana rather than martinis, blue jeans rather than Brooks Brothers suits, stereos rather than washing machines—but they defined their lifestyle by their purchases as did millions of other Americans who were unsympathetic to counterculture aims. As vanguard publisher Don Carpenter observed to his friend, poet Philip Whalen, in 1966, "The hippies . . . all fancy themselves enemies of the state but in fact they are not. Enemies of the state are known by what they put on paper, not their haircuts, clothes and drug taking habits, all of which can be shucked off in no time and model citizens emerge." In the movements of the 1960s, avant-garde ideals reached and motivated to action a large number of people, but the results were hardly what vanguardists desired. As Sally Banes points out, the avant garde "circulated transgressive ideas in what would . . . become acceptable packages." The aesthetic of epiphany and the general rebelliousness of cultural radicals produced an "acceptable package" that mobilized thousands of middle-class college students and also provided new novelties for consumption.[4]

The opposite of alienation is integration. The paradox of the avant garde since the 1960s is that the two have not been mutually exclusive. The art of political protest is a case in point. The civil rights and antiwar movements of the 1960s inspired many innovative artists to respond with their own work, and during that decade political art assumed an importance that it had not had since the 1930s, an importance that continued through the 1980s. Artists organized exhibitions, demonstrations, and other activities to protest, in the words of the organizers of the 1970 New York Art Strike, "war, racism, and oppression." Frederic Rzewski, for example, was an activ-

ist composer. His compositions include a cantata, *Struggle*, based on texts by Frederick Douglass, and the song *Attica*, based on a text Rzewski found in the 1960s underground magazine *Ramparts*. But Rzewski did not find himself on the periphery of American culture. His theme and variations on a Chilean revolutionary folk song, "El Pueblo Unido Jamás Será Vencido," premiered at the Kennedy Center in Washington, D.C., with pianist Ursula Oppens. In the 1980s, Robert Rauschenberg founded the Rauschenberg Overseas Cultural Interchange (ROCI) to use art to promote intercultural understanding and peace. The project received favorable notice from *Time* magazine critic Robert Hughes, who declared that "in the ROCI project one may eventually see the flowering of Rauschenberg's mature identity, the arcadian as utopian, spinning a poetry of affirmation out of an opaque and hideously conflicted time."[5]

Protest art, born of alienation from the prevailing culture, thus gained acceptance into institutions of culture. This is not to say that everybody liked the work or approved of its messages. But the affiliation with American society indicated an important change in the context of avant gardists. In a context where alienated protest is expected, the work loses a great deal of impact.

Innovative artists of the 1970s and 1980s also continued to be absorbed by the commercial world. In 1968, David Rockefeller was instrumental in founding the Business Committee for the Arts (BCA), an institution dedicated to encouraging, through publicity and education, business contributions to the arts. A manager for a multinational oil company declared that the company funded art projects because "the arts serve . . . as a social lubricant. And if business is to continue in big cities, it needs a lubricated environment." Many business leaders seemed to agree: in 1985, business contributions to the arts totaled $698 million (compared to $163 million from government sources).[6]

Corporate managers funded, generally through their public relations and advertising budgets, a variety of arts projects for reasons already discussed: to improve the image of the firm and to increase sales. Businesspeople also argued that the arts were an essential tool to winning the Cold War against Communism. In answer to a 1969 survey of industrialists sponsored by BCA, a majority of respondents agreed with the statement that

> the ultimate dedication to our way of life will be won, not on the basis of economic achievements alone, but on the basis of those precious yet intangible elements which enable the individual to live a fuller, wiser, more

satisfying existence. We must . . . [bring] our cultural achievements into balance with our material well-being through more intimate corporate involvement with the arts.

Some corporate executives linked support for the arts with conservative economic policy. Businessman William Blount declared in a 1980 BCA pamphlet that

> art and commerce . . . each require as much freedom as possible to survive and prosper. . . . Are we [businesspeople] instruments of the federal government? No, . . . we fight against it. So does the artist. . . . [Freedom] is being persistently eroded everywhere by ill-advised and ill-conceived regulation, taxation, and other forms of government control. . . . So we are engaged in an important work in furthering the arts. . . . [We] are helping to keep open those avenues of freedom along which art and commerce both travel.[7]

In Blount's view, businesspeople and avant gardists were both rebels in the same cause.

Though business leaders tended to sponsor traditional forms of art, they also funded the advance guard. A BCA publication reproduced a 1968 advertisement for Merce Cunningham's dance company and the Brooklyn department store funding the performance. The copywriter, noting proudly that the firm was the first to have a private subway station and to give an elephant to the zoo, declared that the company was "not only contemporary but also often in the avant-garde!" This text indicates not only how conventional the avant garde had become by the late 1960s, but also how the meaning of avant gardism was misunderstood. In the 1970s and 1980s, the managers of a Minneapolis bank collected what they described as "radical and upsetting" works, such as photographs by the English artists Gilbert and George. Lynn Sounder, the curator of the collection, explained: "Art is the most powerful visual symbol of this organization's commitment to change, which is why our collection upsets people." In the 1970s and 1980s, advertisers also continued to find so-called avant-garde art useful to sell products. Composer Philip Glass, dancer Twyla Tharp, and painter Ed Ruscha were among the many innovators who made advertisements in this time period. All of these presentations of and uses for the avant garde indicate the trivialization of the movement that occurred as cultural radicalism became tamed and enthralled by American commercial culture.[8]

The advance guard also became fused with mainstream American society through government funding. Government funding for the arts be-

came increasingly important from the 1950s forward, first through state and local arts councils, then through the federal programs of the National Endowment for the Arts (NEA) and the National Endowment for the Humanities (NEH). Thus, for example, the Lincoln Center for the Performing Arts, with state and local funding, presented avant-garde film, music, and dance. The NEA, through grants to the Coordinating Council of Literary Magazines (CCLM), funded the publication of innovative literature in little magazines. Work connected to the historic avant garde never figured prominently in NEA or NEH budgets, and not all innovators welcomed the money awarded their colleagues; but that innovations once (and sometimes still) considered radical could receive funding from government agencies further indicates that an alienated vanguard had become incorporated into American society in the last decades of the twentieth century.[9]

In 1959, the administrators of the University of Chicago censored the *Chicago Review* because the editors intended to publish excerpts from William S. Burroughs's novel *Naked Lunch*. Just over twenty years later, Burroughs was inducted into the American Academy of Arts and Letters. Yesterday's avant garde had become today's literary establishment. Increasingly, today's "avant garde" was also today's establishment. Alienation did not preclude a creator's integration into society. Furthermore, from the mid-1960s forward, continuous artistic innovation was solidly linked to institutions of American culture.[10]

Innovation to Convention

The pluralism in which American art and literature became embedded in the 1960s became even more pronounced in the following decades. Music historian Nicholas E. Tawa characterized the postwar musical scene as "a most wondrous babble," and the phrase aptly described the diversity of American art and music in the last decades of the twentieth century. Was there amidst this confusion an authentic vanguard movement? Some commentators argued that there was. Douglas Davis, in a 1982 essay in *Art in America*, contended that new forms such as earth sculpture and performance art represented an advance guard determined to resist the commodification that consumed its predecessors. Likewise, Richard Kostelanetz maintained in his 1982 collection, *The Avant-Garde in Literature*, that a new literary avant garde emerged in the 1960s defined by a self-reflexive concern with language and a tendency to "miscegenate" across

accepted genre boundaries. Art historian Henry M. Sayre argued in 1989 that after 1970, "a distinct and definable avant-garde in American art and literature . . . [had] organized itself in opposition to an apparently recalcitrant set of assumptions, shared by mainstream museums, galleries, magazines, publishers, and funding agencies, about what constitutes a 'work' of art."[11]

Sayre, Kostelanetz, and Davis all argue ably that the avant garde continues to operate in America. They posit a community alienated from American culture, producing radically innovative work that is typically resistant to acceptance by the commercial world of art and publishing. Most of these innovative artists believe that their work challenges the perception of viewers, and some of these creators argue further that the resulting new perceptions could contribute to changing the culture.

These arguments can be tested against the case of a contemporary movement claiming avant-garde status: the feminist art movement, probably the strongest candidate among recent innovations for the mantle "avant-garde." While largely resistant to commercial commodification, the feminist van is well established in institutions of contemporary American culture and illustrates the ironies attendant on the end of the avant garde. Cultural radicalism has become a convention, rather than a revolutionary movement for cultural renewal, in modern America.

In the 1970s and 1980s, feminist artists constituted a new movement. Women alienated from a commodified and male-dominated art world created works that expressed women's experience. Judy Chicago remembered an early show at California State University, Fullerton, at which she clearly stated her feminist intentions, and yet "male reviewers refused to accept that my work was intimately connected to my femaleness." Instead, these critics interpreted Chicago's and other women's work in formalist terms. The most extreme example was the work of a friend of Chicago's who included bloody tampons in her piece. A critic described these as "white material with red spots."[12]

The feminist innovators also discovered that while they could learn from male vanguardists, these men, too, often did not appreciate the challenges facing talented women, in art or any field. Dancer Yvonne Rainer, while appreciative of John Cage's important contributions to vanguard aesthetics, criticized his stated purpose of not attempting "to bring order out of chaos nor to suggest improvements on creation, but simply to wake up to the very life we're living, which is so excellent." Rainer contended that "only a man born with a sunny disposition" could

make such an apolitical statement. She affirmed the use of chance techniques developed by Cage, but not "so we may awaken to this excellent life; on the contrary, so we may the more readily awaken to the ways in which we have been led to believe that this life is so excellent, just, and right."[13]

The work of the feminist vanguard took a variety of forms, but was generally motivated by the goal of gaining recognition that women's experiences and perspectives are as important as the male experiences and views that had long been accepted in the art world. For example, in the 1980s, the Guerilla Girls, the self-styled "conscience of the art world," used posters to inform and denounce the discriminatory practices of New York galleries and other institutions of the art world. Some of the most innovative feminist works were performance pieces. In *Interior Scroll*, for example, Carolee Schneemann disrobed, outlined the contours of her body with paint, read from a text while assuming various poses from a life modeling class, and then read from another text, which she unraveled from her vagina, that commented on the differing perceptions of men and women. Other women pursued collaborative approaches, often using traditional "women's" skills such as weaving and pottery making, as in Judy Chicago's 1979 installation *The Dinner Party*. Composer Pauline Oliveros designed works that combined meditation, music, and theater. In pieces such as *Crow Two* (1975), she instructed the musicians to meditate rather than continue playing for the benefit of the audience. Oliveros thus challenged basic notions of art and performance by using ritual to create a nurturing environment. According to their champions, these artists, as well as others such as Laurie Anderson, Jenny Holzer, Cindy Sherman, and Barbara Kruger, continued to challenge traditional notions of art as well as the commercial and sexist values in the avant-garde tradition.[14]

While these women artists did experience alienation from their society, and much of their work proved to be both shocking to the sensibilities of many Americans and resistant to commercial appropriation, they were not avant garde in the historic sense. The feminist movement focused on alienation, but not on a renewed culture in the future achieved through aesthetic innovation. Despite the artists' increased ideological awareness, their work was hardly more advanced technically than the performance aesthetic of the late 1950s and early 1960s. Rather, feminist work focused on a program that, while it highlighted real challenges faced by women in the art world and other spheres, was presentist and narrowly political.

Their goals did not always fit into a larger, cosmopolitan vision. In David A. Hollinger's terms, species-centered discourse was replaced by an engendered ethnos-centered discourse.[15]

Ironically, the feminist art movement and other politically motivated or inspired movements presented a means to protect art as an institution, rather than to overturn the institutions of art in the manner of the historic vanguard. Art, these artists proclaimed, must be considered a major player in contemporary social and cultural debates. In making such a statement, artists in the post-vanguard made the important point that art has functions other than being decorative or making a fashion statement, the unfortunate fate of previous vanguards. But in entering the political debates of their times so directly, these artists were clearly trying to move from the position of alienated outsiders to that of cultural insiders. This is in sharp distinction from the avant-garde view that a new vision is needed to liberate one's consciousness from the categories that frame cultural debate and begin afresh. (This attempt to save art from irrelevance in the consumer culture is also naive: as we have seen, the custodians of culture in business and the art world will interpret art objects as they will; the artists' intentions have little impact. Even political art can be used to make a fashion statement.)[16]

The insider status of the feminist art movement is further demonstrated by the strong links between the movement and universities, museums, and state and federal funding sources. For example, in 1968 Schneemann presented her performance piece *Illinois Central* at three different campuses of the State University of New York. She presented her 1974 piece *Up to and Including Her Limits* at the University Art Museum at the University of California, Berkeley. For many of her performances, Schneemann received money from the New York State Council for the Arts and the NEA. Judy Chicago's *Dinner Party* was installed at the San Francisco Museum of Modern Art. Oliveros taught at the University of California, San Diego, where *Crow Two* was performed, and was composer in residence at Stanford University, the University of Washington, Wesleyan University, the Walker Art Center, and the Cleveland Museum. Laurie Anderson not only had commercial success with her performance videos and tours, but she was one of several feminist artists, including Cindy Sherman and Jenny Holzer, shown in 1990 at the Hirshhorn Museum of the Smithsonian Institution, Washington, D.C. Such strong and steady support from institutions of the established culture indicate that innovative art remains coopted into the culture.[17]

Obviously, not everyone in late twentieth-century America approved of what these and other artists were doing. In the 1980s and 1990s, critics of NEA grants to radical artists created a great deal of controversy. A case in point is that of feminist performance artist Karen Finley. In 1990, an NEA panel awarded Finley a grant. Critics objected to the award on the grounds that the nudity Finley included in her performance was obscene. The artist maintained she was making a statement against pornography. NEA chair John Frohnmayer sided with the critics and disapproved the grant. The result was a well-publicized controversy between innovative artists and their supporters, and critics of the artists and the NEA. Another feminist performance artist, Rachel Rosenthal, turned down her NEA grant in protest.[18]

While not wishing to diminish the reality of the "culture war" taking place in the late twentieth century, impugn the integrity of these artists, or deny the validity of many of the criticisms of contemporary America that they raise, these events must be put in perspective. Finley's opponents did not deny her right to perform. Indeed, within a month of the denial of her grant, she performed at Alice Tully Hall in Lincoln Center, a place that has as good a claim as any to being the heart of the cultural establishment in modern America. The controversy was about the use of public funds for such a performance. Martha Wilson, the director of a performance space in New York City that received NEA grants to stage innovative works, defended the grants: "The artists today are saying, 'I'm proud of being an American; I pay my taxes; I'm a loyal citizen, and I have a right to be supported as a member of my culture.'" For artists to claim both the status of being avant garde and the right to public monies is clearly contradictory. This is not to say that they should not be funded, or that if Finley, Rosenthal, and others refused such funding they would become avant garde. Rather, these events demonstrate that innovation without a fully developed sense of alienation has become the norm. In part, this represents the success of what formerly might have been the avant garde.[19]

In the end the cultural innovators of the twentieth century largely succeeded in their goal of destroying the Victorian producer-culture concepts of culture and aesthetics and replacing them with notions of art as a rebellious and continuously innovative activity. The avant garde has, in short, become a convention of late twentieth-century culture. Though not an uncontested convention, from the 1960s forward, the idea of avant gardism has been so well assimilated into the commercial and cultural

institutions of modern America that to speak of a van leading the way to the future has ceased to be socially and culturally meaningful. The future dreamed of by previous avant gardists has become the present reality of radical art commandeered to support the cultural status quo.

The conventionality of the avant garde can be seen in the general acceptance of the avant-garde definition of art, the relations between innovative art and commerce, and the continued institutionalization of the new art into the universities. By the last decades of the twentieth century, the avant-garde understanding of art had become, in an attenuated form, the standard definition of art in popular usage. In 1993, a Florida art educator declared that "the whole place of [the] arts in society is to question, to explore, to broaden people's perspectives." In 1992, a *New York Times* writer declared, "Science, like art, has to do with challenging our presuppositions, shaking up our world view, changing us." The focus on innovation and changed perception presented in these definitions echoes historic avant-garde aims. The idea of alienation is, significantly, missing. But when people expect art to shock them, to "challenge them," the artist who produces such work is not likely to experience alienation. That the *New York Times* writer was using art to define science indicates that he assumed his audience would accept this definition of art. Both commentators appear oblivious to the ahistorical character of their definitions, another indication of the conventionality of their ideas. Yet their notions about art would not have been possible before the late nineteenth century; it is a measure of the success of the members of the avant garde that their understanding of art should be the frame that defines all art.[20]

The idea of the avant garde as a convention of commerce is illustrated by the uses made of the innovative artists by real-estate developers. In the 1970s, the movement of artists to the SoHo section of Manhattan resulted in the well-publicized revitalization of a decaying industrial district. By the 1980s, developers exploited this process for their own profit. Developer J. Burton Casey describes in a BCA pamphlet how his company included artist residences in the redevelopment of an Austin, Texas, warehouse district. Using money from the promotion budget of the project to subsidize low-rent studios for artists, the firm managed to persuade people that "it was avant-garde/cutting edge to locate in that part of the city rather than feeling as if they were moving to the slums," Casey reported. The Los Angeles Museum of Contemporary Art served a similar function in the redevelopment of the Los Angeles city center in the 1980s. The examples could be multiplied of the links between art, especially innova-

tive art, and urban redevelopment. American businesspeople continued to find uses for what had been an alienated avant garde.[21]

In the decades since the 1960s, the avant garde has continued to be a convention at American universities. In 1989, for example, at the Ohio State University, a multimillion-dollar art center was opened, dedicated "to present the leading edge of the arts of our time . . . and to encourage the creation of daring new works for the future." The rhetoric supporting the Wexner Center was that of the avant garde. The first exhibits illustrated the same process of legitimation through historicization that has become standard in museums and galleries of modern art. The genealogy presented at the Wexner Center focused on the innovators from the late 1950s forward, including Cage—described in a brochure as "the patriarch of experimental music"—and pop, conceptual, and minimalist art. The conventionality of the Wexner Center was further demonstrated by the performances scheduled for the first year. These included established figures such as the Martha Graham Dance Company and Trisha Brown, and the latest "stars" of performance art, including Laurie Anderson, the Kronos Quartet, Karen Finley, and Rachel Rosenthal.[22]

In an age during which so much art is self-reflexive, there was remarkably little reflection on what being avant garde meant. Curators at the Wexner Center presented new works not so much as radical breaks with the past but as part of historical continuum of art history. In this manner, the Wexner Center legitimated the avant garde since 1960 by historicizing it, much as the Museum of Modern Art did for abstract expressionism. Critic Hilton Kramer pointed out the appropriateness of the fact that construction of the Wexner Center was largely funded by Columbus, Ohio, retail magnate Leslie Wexner. Having made a fortune by making the chic and trendy affordable and marketing it to middle-class young people, often with advertising that placed the clothing in the context of the New York art world, Wexner brought the chic and trendy New York art world to the nation's middle classes.[23]

The End of the Future

In 1986, a writer in the *Public Relations Journal* declared that companies that took the "risk" of supporting controversial art would communicate that they were "progressive, adventuresome, and concerned with the future." While business leaders may see the future in innovative work, most creative intellectuals do not believe that the future is connected to

their work. In the last decades of the twentieth century, the Cagean aesthetic with its focus on celebrating the present moment continued to influence many. At the same time, other intellectuals, influenced by structuralist and poststructuralist thought, argued that the language a person uses to describe his or her world also to a large extent creates that world; thus, it is impossible to go beyond the subjective and describe or prescribe a future for others. As a result of these developments, the idea of the future has become an irrelevant abstraction.[24]

Starting in the 1960s, radical innovators have rejected the idea that their work communicates significantly to their culture. Painter Jasper Johns declared in 1964, "I am concerned with a thing's not being what it was, with its becoming something other than what it is, with any moment in which one identifies a thing precisely, and with the slipping away of that moment, with any moment seeing or saying and letting it go at that." Novelist and critic Raymond Federman wrote in his 1975 essay "Surfiction—Four Propositions in the Form of a Manifesto" that "the writer will no longer be considered a prophet, a philosopher, or even a sociologist who predicts, teaches, or reveals absolute truths." Rather, he declared, the writer "will stand on equal footing with the reader in their efforts to *make sense* out of the language common to both of them, *to give sense* to the fiction of life. In other words, as it has been said of poetry, fiction, also, will not only mean, but it will be!" The new attitude was founded on the rejection of the cultural concerns that preoccupied members of the historic avant garde. Johns, Federman, and other intellectuals rejected the idea that their work communicated to a collective unconscious or the mythic concerns of humanity. They saw their work as constructed objects, and nothing more.[25]

Both structuralist and poststructuralist thinkers of the late twentieth century argued that language defined people's mental landscape and de-limited what they could perceive. Whatever might be "out there" on the other side of an individual's subjectivity was alien to him or her. Nothing comes to a person's mind except through filters of perception and language. The life he or she perceived, therefore, was, as Federman said, a "fiction." The change from the historic avant-garde notion that perception is the way to liberation, to the notion that people are all more or less prisoners of their own perceptions, is astounding. And yet, as we have seen, poststructuralist concepts evolved from avant-garde ideas about the power of language, image, and perception.

The ideas of both the historic vanguard and the poststructuralists were

rooted in the rejection of older notions about the immutable givenness of the world. The first generations of avant gardists challenged the Victorian producer-culture picture of a stable world by arguing that changing the premises of perception also changed the world. In the late twentieth century, intellectuals came to the conclusion that if there was no immutability but only our own subjectivity, then no one subjective picture could be privileged over another. Therefore, no one could describe the future for anyone else. One individual's description becomes prescription for another.

Conclusion

The condition of pluralist disorder and presentism that characterized the late twentieth-century West is often described as postmodernism. The term *postmodern* is fraught with ambiguities, not least of which is the question of whether such a thing as postmodernism even exists at all. Some critics have argued that all the qualities of modernism are present in the successor: the synthesis of styles and forms, self-reflexive irony, self-consciousness about the work of art as a work of art, the rejection of history. There are, indeed, many continuities between the two. There is one key distinction, however: what Jean-François Lyotard characterized as the central idea of postmodernism—the disbelief in metanarratives. *Metanarratives* are the stories that create a unified culture. They describe where a culture has been, what gives meaning and purpose to life, and where the culture is headed.

The avant garde emerged from a conflict over metanarratives at the end of the nineteenth century. Two conflicting "modern" metanarratives emerged to replace Victorian producer culture: the modernist culture identified with the avant garde, on the one hand, and consumer culture identified with modern industrial capitalism, on the other. The outcome of the cultural conflict, however, was determined less by the differences between the two than by the similarities. The (dis)integration of cultural radicalism resulted from the close ideological connections between the avant garde and the new middle class that created the culture of consumption.

The middle-class promoters of consumption presented an ideology of abundance that promised self-fulfillment. Redemption in consumer culture meant the re-creation of the self as popular personality, a re-creation that prominently included mass-produced consumer goods. Members of

the avant garde also tended to be of middle-class origin, and their ideals paralleled those of the promoters of the consumption ethic. The members of the vanguard rejected producer-culture ideas of psychic and emotional scarcity. Avant gardism was, as Daniel Bell points out, an ideology of abundance. Avant gardists believed in the unlimited potential for self-fulfillment and cultural redemption through creative innovation.

Cultural radicals unwittingly contributed to their absorption through their critique of producer values, especially in the first decades of the century. As avant-garde culture and consumer culture developed, the latter proved the more powerful cultural force. The alienation of members of the advance guard ended in commodification. Commodified as celebrities, avant gardists provided entertainment. Commodified as a life-style, avant gardism defined a consumption community for rebellious individuals. Commodified as a status symbol, vanguardist culture created an avenue of advancement for social-climbing bourgeois. Commodified as innovation, the van provided intellectual support for style obsolescence. The avant garde merged with the consumer culture—part therapy, part business.

The commodification of the avant garde also resulted from ideological weaknesses of the avant garde, in particular the failure of the idea of the future. In the 1950s, many members of the last American van began to focus exclusively on the present rather than the future. What mattered for these cultural radicals was the process of creation in the moment. This presentism resulted from an extreme individualism. The hope of redemption became completely focused on the creative act of each individual in the present moment. This belief was, essentially, a rejection of the idea of culture.

Historically, vanguardists, whatever their differences, believed in culture as a more or less unified entity defined by basic underlying beliefs that people share, often unconsciously. Alienated from Victorian producer culture, avant gardists tried to change the premises of their culture through innovation. Members of the postwar vanguard rejected the quest for what Sidrah Stich calls the "sublime symbol" or the "redemptive myth" that could unify a vanguard culture. Instead, cultural innovators pursued individual creativity in a context of pluralism. Without the focus on a culture with a future, the avant garde lost direction and purpose as a movement.[26]

Innovation for the sake of innovation became the sine qua non of a now incoherent movement. In this context, individuals and institutions

could devise their own meanings for artistic innovations. In the universities, such innovations were translated into specialized academic disciplines. In business, the slogan "make it new" meant internal innovations to increase productivity and external innovations to increase consumption. Historicized as the culture of the twentieth century, the avant garde was no longer a radical force shaping the future. The age of the avant garde was over.

Notes

.

.

.

ABBREVIATIONS USED IN NOTES

AAA	Archives of American Art, Smithsonian Institution
AAAR	American Abstract Artists Records, AAA
AGP,CU	Allen Ginsberg Papers, CU
AGP,SU	Allen Ginsberg Papers, Department of Special Collections, Stanford University Libraries
BPP	Betty Parsons Papers and Gallery Records, AAA
CLBR	City Lights Books Records, UC,B
CU	Rare Book and Manuscript Library, Columbia University
DMacdP	Dwight Macdonald Papers, Manuscripts and Archives, Yale University Library
JCP	Judson C. Crews Papers, UCLA
JKP	Jack Kerouac Papers, CU
KRP	Kenneth Rexroth Papers, UCLA
MCP	Malcolm Cowley Papers, The Newberry Library
MRP	Mark Rothko Papers, AAA
POP	Peter Orlovsky Papers, CU
PWP	Philip Whalen Papers, CU
REDP	Robert Edward Duncan Papers, UC,B
SPP	Stuart Z. Perkoff Papers, UCLA
UC,B	Bancroft Library, University of California, Berkeley
UCLA	Department of Special Collections, University Research Library, University of California, Los Angeles
WBP	William Baziotes Correspondence and Papers, AAA
WTBP	William T. Brown Papers, AAA

NOTES TO CHAPTER I

1. David Bernstein, editorial, *The New Talent*, July-August-September 1935, 1–2.

2. Virgil Thomson, *Virgil Thomson: An Autobiography* (New York: E. P. Dutton, 1985), 422. Irving Howe, ed., *The Idea of the Modern in Literature and the Arts* (New York: Horizon Press, 1967), 24.

3. Robert Estivals, Jean-Charles Gaudy, and Gabrielle Vergez, *L'Avant-garde: Etude historique et sociologique des publications periodiques ayant pour titre "L'avant-garde"* (Paris: Bibliothèque Nationale, 1968), 21–22.

4. Donald Egbert, "The Idea of the 'Avant-Garde' in Art and Politics," *American Historical Review* 73 (1967): 339–366.

5. Mikles Szabolcsi, "Avant-garde, Neo-avant-garde, Modernism: Questions and Suggestions," *New Literary History* 3 (1971–1972): 49–50. Renato Poggioli, *The Theory of the Avant-Garde*, trans. Gerald Fitzgerald (Cambridge: Harvard University Press, 1968), 9–12. Egbert, "Idea of the 'Avant-Garde,'" 359–360.

6. Oscar Cargill, *Intellectual America: Ideas on the March* (New York: Macmillan, 1942), 176–310, 537–767. Merle Curti, *The Growth of American Thought* (New York: Harper and Brothers, 1943), 710–714. Henry F. May, *The End of American Innocence: A Study of the First Years of Our Own Time, 1912–1917* (New York: Algred A. Knopf, 1959). Lewis Perry, *Intellectual Life in America: A History* (Chicago: University of Chicago Press, 1984), 324–344, 417–424.

7. John Higham, ed., *New Directions in American Intellectual History* (Baltimore: Johns Hopkins University Press, 1979); for Higham's description, see xvii. Warren I. Susman's contribution does treat psychology, but in a popular, not avant-garde, context; see 212–226.

8. For a summary of the origin of the term *postmodern* and the ideas associated with it, see Thomas Docherty's introduction to his anthology, *Postmodernism: A Reader* (New York: Columbia University Press, 1993), 1–31. John E. Toews, "Intellectual History after the Linguistic Turn: The Autonomy of Meaning and the Irreduciblity of Experience," *American Historical Review* 92 (1987): 879–907, quotation on 882.

9. There are many ways to carry out a project in the history of intellectual discourse. My approach to the subject has been shaped by David A. Hollinger. See his *In the American Province: Studies in the History and Historiography of Ideas* (Baltimore: Johns Hopkins University Press, 1985), 130–151.

10. Friedrich Nietzsche, *The Will to Power* (New York: Random House, 1968), 423, 434, and passim.

11. Donald Kuspit, *The Cult of the Avant-Garde Artist* (Cambridge: Cambridge University Press, 1993), 1–27. David A. Hollinger, "How Wide the Circle of 'We'? American Intellectuals and the Problem of the Ethnos since World War II," *American Historical Review* 98 (1993): 317–337.

12. Milton Singer, "The Concept of Culture," in David L. Sill, ed., *International Encyclopedia of the Social Sciences* (New York: Macmillan, 1968), 13: 527–541. Raymond Williams, *Culture and Society* (London: Chatto and Windus, 1958). Warren I. Susman, *Culture as History: The Transformation of American Society in the Twentieth Century* (New York: Pantheon, 1984), 69–72.

13. Richard Kostelanetz, for example, defines the avant garde almost exclusively in terms of aesthetic innovation in *Dictionary of the Avant-Gardes* (Pen-

nington, N.J.: A Cappella Books, 1993), xiii–xvi. Ludwig Wittgenstein, *Philosophical Investigations*, 3d ed., trans. G. E. M. Anscombe (New York: Macmillan, 1958), §§66–67.

14. George Lichtheim, "Alienation," *International Encyclopedia of the Social Sciences*, 1: 264–268. Raymond Williams, *Keywords: A Vocabulary of Culture and Society* (London: Croom Helm, 1976), 29–31.

15. The classic description of genteel attitudes is George Santayana, "The Genteel Tradition," in *The Winds of Doctrine: Studies in Contemporary Opinion* (New York: Charles Scribner's Sons, 1926), 186–215. Lorne Huston, "The Theory of the Avant-Garde: An Historical Critique," *Canadian Review of Sociology and Anthropology* 29 (1992): 79. Daniel Joseph Singal, *The War Within: From Victorian to Modernist Thought in the South, 1919–1945* (Chapel Hill: University of North Carolina Press, 1982), 6. Daniel Walker Howe, "American Victorianism as a Culture," *American Quarterly* 27 (1975): 507–532.

16. Editorial, "Round," *Blues*, Fall 1930, 26. Singal, *War Within*, 6–8. Charles Altieri, *Painterly Abstraction in Modernist American Poetry* (Cambridge: Cambridge University Press, 1989), 61.

17. Poggioli, *Theory of the Avant-Garde*, 27–28.

18. Peter Bürger, *Theory of the Avant-Garde*, trans. Michael Shaw (Minneapolis: University of Minnesota Press, 1984), 19–26, 47–54.

19. Since avant gardists are not the only intellectuals involved in innovative activity (scientists come to mind as counter examples), Poggioli's point is well taken. Poggioli, *Theory of the Avant-Garde*, 27–28.

20. Hollinger, *In the American Province*, 56–73.

21. Irving Sandler, *Triumph of American Painting: A History of Abstract Expressionism* (New York: Harper and Row, 1970), 102.

22. Neil A. Chassman, ed., *Poets of the Cities: New York and San Francisco, 1950–1965* (New York: E. P. Dutton, 1974), 59. Allen Ginsberg to Lawrence Ferlinghetti, 30 September 1958, CLBR.

23. Elaine de Kooning to William T. Brown, ca. 1952–1953, WTBP. For de Kooning at Black Mountain College, see Lee Hall, *Elaine and Bill, Portrait of a Marriage: The Lives of Willem and Elaine de Kooning* (New York: HarperCollins, 1993), 81–86.

24. The community of the *White Dove Review* can be seen in editorial comments and advertisements in the issues 2, 3, 4, and 5, published in 1959 and 1960.

NOTES TO CHAPTER 2

1. Daniel Aaron, *Writers on the Left: Episodes in American Literary Communism* (New York: Harcourt, Brace, and World, 1961); Waldo Frank quoted on 49.

2. Fanya Foss, "The Exile and Revolution," *New Hope*, August 1934, 15. John Gassner, "Politics and the Theatre," foreword to Morgan Himelstein, *Drama Was a Weapon: The Left Wing Theater in New York, 1929–1941* (New Brunswick, N.J.: Rutgers University Press, 1963), xi. Peter Blume, "American Artists Today," *New Masses*, 12 May 1936, 20.

3. The activist is quoted in Vivian Gornick, *The Romance of American Communism* (New York: Basic Books, 1977), 221. Bill Jordan, "Magazine Notes," *Left Front*, May-June 1934, 20.

4. The John Reed Club goals are quoted in Helen Harrison, "John Reed Club Artists and the New Deal: Radical Responses to Roosevelt's 'Peaceful Revolution,'" *Prospects* 5 (1980): 242–243.

5. Samuel Putnam, "Painting Is Dead; Painting Go Red, Part II," *New Hope*, September 1934, 11. Wallace Phelps [William Phillips], "Three Generations," *Partisan Review* 1 (1934): 52. Wallingford Riegger, quoted in Ronald L. Davis, *The Modern Era, 1920 to the Present*, vol. 3, *A History of Music in American Life* (Malabar, Fl.: Robert Krieger, 1981), 217.

6. Aaron, *Writers on the Left*, 208–209, 211.

7. Louis Lozowick, "Towards a Revolutionary Art," *Art Front*, July-August 1936, 12–14. Hans Eisler, "Reflections on the Future of the Composer," *Modern Music* 12 (1935): 180–186.

8. Stuart Davis, "Art and the Masses," *Art Digest*, 1 October 1939, 34. Davis quoted in Cécile Whiting, *Antifascism in American Art* (New Haven: Yale University Press, 1989), 89.

9. Seymor Stern, "Principles of New World Cinema," *Experimental Cinema*, [February] 1931, 29. Similar points were made by David Platt, "The New Cinema," *Experimental Cinema*, February 1930, 1; and the editors, "Statement," *Experimental Cinema*, [February] 1931, 3.

10. Phelps, "Three Generations," 49–55; quotations on 51 and 53.

11. Donald Egbert, *Social Radicalism and the Arts, Western Europe: A Cultural History from the French Revolution to 1968* (New York: Alfred A. Knopf, 1970), 67–113; Karl Marx quoted on 100. Leon Trotsky quoted in Peter Clecak, *Radical Paradoxes: Dilemmas of the American Left: 1945–1970* (New York: Harper and Row, 1973), 288. Stuart Davis's ideas about "Color-Space People" are discussed in Karen Wilkin, *Stuart Davis* (New York: Abbeville, 1987), 185.

12. Kay Rankin quoted in Sally Banes, "Red Shoes: The Workers' Dance League of the 1930s," *Village Voice*, 24 April 1984, 78. Grigorst Schneerson, "The Changing Course of Russian Music," *Modern Music*, January-February 1936, 24.

13. Gassner, "Politics and the Theatre," x–xi.

14. Kenneth Rexroth to Malcolm Cowley, [ca. late 1937 or 1938], MCP.

15. David A. Hollinger, *In the American Province: Studies in the History and Historiography of Ideas* (Bloomington: University of Indiana Press, 1985), 74–91, especially 85.

16. Grant Webster, *The Republic of Letters: A History of Post-War American Literary Opinion* (Baltimore: Johns Hopkins University Press, 1979), 209–251. John Crow Ransom quoted in James E. B. Breslin, *From Modern to Contemporary: American Poetry, 1945–1965* (Chicago: University of Chicago Press, 1984), 15.

17. Philip Rahv, "Trials of the Mind," *Partisan Review*, 5 (1938): 9. William Phillips, "Thomas Mann: Humanism in Exile," *Partisan Review* 5 (1938): 7.

18. Kurt List, "The State of American Music," *Partisan Review* 15 (1948): 88–90. Also in 1948, composer Nicholas Nabokov supported a different starting point for contemporary composers: the rhythmic innovations of Stravinsky. The model

is different, but the principle is the same. See Nicholas Nabokov, "The Atonal Trail: A Communication," *Partisan Review* 15 (1948): 580–585.

19. *American Abstract Artists* (New York: Riverside Museum, [1941]), n.p., and George L. K. Morris, *American Abstract Art* (New York: Gallerie St. Etienne, 1940), n.p., both in the AAAR. George L. K. Morris, "Art Chronicle: American Abstract Artists," *Partisan Review* 6 (1939): 63. For the history of the American Abstract Artists, see Thomas Tritschler, *American Abstract Artists* (Albuquerque: University of New Mexico Art Museum, 1977); Susan Carol Larsen, "The American Abstract Artist Group: A History and Evaluation of Its Impact upon American Art" (Ph.D. diss., Northwestern University, 1975); and Melinda A. Lorenz, *George L. K. Morris: Artist and Critic* (Ann Arbor, Mich.: UMI Research Press, 1982).

20. Clement Greenberg, " 'American-Type' Painting," *Partisan Review* 22 (1955): 179–180, 196.

21. Hollinger, *In the American Province*, 84–86. James Gilbert, *Writers and Partisans: A History of Literary Radicalism* (New York: John Wiley and Sons, 1968), 188–233.

22. John Crow Ransom quoted in Breslin, *From Modern to Contemporary*, 16. Gerald Graff, *Professing Literature: An Institutional History* (Chicago: University of Chicago Press, 1987), 195–208.

23. Philip Rahv and William Phillips, "Our Country, Our Culture," *Partisan Review* 19 (1952): 284. Breslin, *From Modern to Contemporary*, 11.

24. William Barrett, "The Resistance," *Partisan Review* 13 (1946): 479. Paul Goodman, "Advance-Guard Writing, 1900–1950," *Kenyon Review* 13 (1951): 380. Clement Greenberg, "The State of American Writing," *Partisan Review* 15 (1948): 876. F. W. Dupee, "The Muse as House Guest," *Partisan Review* 25 (1958): 455–458.

25. Gerald M. Monroe, "The American Artists' Congress and the Invasion of Finland," *Archives of American Art Journal* 15 (1975): 14–20. John Clellon Holmes, "Crazy Days, Numinous Nights: 1948–1950," in Arthur Knight and Kit Knight, eds., *Beat Vision: A Primary Source Book* (New York: Paragon House, 1987), 86–87.

26. Lawrence Barth, "Digging the Roots of Our Chaos," *Miscellaneous Man*, April 1956, 10–12. James Courzen, "The True Social Awakening," *Grundtvig Review*, 20 September 1951, 2.

27. Kenneth Rexroth, "The Reality of Henry Miller," in *Bird in the Bush* (New York: New Directions, 1959), 155. Stuart Z. Perkoff is discussed in John Arthur Maynard, *Venice West: The Beat Generation in Southern California* (New Brunswick, N.J.: Rutgers University Press, 1991), 62. Barnett Newman quoted in Clifford Ross, ed., *Abstract Expressionism: Creators and Critics: An Anthology* (New York: Harry N. Abrams, 1990), 123. William Baziotes, "A Speech for a Television Program Scheduled at Hunter College," MS, ca. 1957, 3, WBP.

28. Oscar Collier to Judson C. Crews, [ca. 1946], JCP. Kenneth Rexroth to Allen Ginsberg, 12 July 1952, AGP,SU. Kenneth Rexroth, *Bird in the Bush*, 105. Clyfford Still to Betty Parsons, 20 March 1948, BPP. The *Partisan Review* did publish a poem each by Allen Ginsberg and Gregory Corso in the late 1950s. Furthermore, work by Kenneth Rexroth and William Carlos Williams had been published in the magazine from the late 1930s through the 1940s. By way of

contrast, it should be noted that during the 1940s and 1950s the *Partisan Review* also published two of T. S. Eliot's *Four Quartets* and twenty-five poems by Robert Lowell, a good indication of where the literary sympathies of the editors lay.

29. Stuart Z. Perkoff Journal, [ca. September 1956], SPP. George Leite, editorial, *Circle*, Summer 1948, 1.

30. Leslie Woolf Hedley, *Inferno Quarterly*, no. 10 [1954]: 35–36. "Editorial Gesture," *Neurotica*, Autumn 1949, 3–4.

31. Webster, *Republic of Letters*, 3–59. Thomas Kuhn, *The Structure of Scientific Revolutions*, 2d ed. (Chicago: University of Chicago Press, 1970), 150. Allen Ginsberg, "Notes Written on Finally Recording 'Howl,'" in Thomas Parkinson, ed., *A Casebook on the Beat* (New York: Crowell, 1961), 30. Norman Podhoretz, "The Know-Nothing Bohemians," *Partisan Review* 25 (1958): 313, 316. Allen Ginsberg to Peter Orlovsky, [May 1958], POP. Robert Duncan to Sanders [Russell], [21 November 1944], REDP. Kenneth Rexroth, *American Poetry in the Twentieth Century* (New York: Herder and Herder, 1971), 132–133.

32. Allen Ginsberg to Dwight Macdonald, [14 March 1964]; Macdonald to Ginsberg, 13 April 1964; Ginsberg to Macdonald, 14 August 1964; all in DMacdP.

NOTES TO CHAPTER 3

1. Stuart Z. Perkoff, "The Suicide," *Miscellaneous Man*, November 1956, inside back cover.

2. Renato Poggioli, *Theory of the Avant-Garde*, trans. Gerald Fitzgerald (Cambridge: Harvard University Press, 1968), 103–128. Kenneth Rexroth, *American Poetry in the Twentieth Century* (New York: Herder and Herder, 1971), 16–18.

3. Clement Greenberg, "Art Chronicle: The Situation at the Moment," *Partisan Review* 15 (1948): 82–83. Jack Tworkov, "Four Excerpts from a Journal," *It Is*, Autumn 1959, 13.

4. Kenneth Rexroth, "Unacknowledged Legislators and 'Art Pour Art,'" in *Bird in the Bush* (New York: New Directions, 1959), 12. David Platt, editor of *Approach*, quoted in Anthony Linick, "A History of the American Literary 'Avant-Garde' since World War II" (Ph.D. diss., University of California, Los Angeles, 1965), 49.

5. William Carlos Williams, "Asphodel, That Greeny Flower," in *Pictures from Brueghel and Other Poems* (New York: New Directions, 1962), 165–166.

6. Douglas Woolf, "Radioactive Generation," *Inland*, Autumn 1960, 33–34. Rexroth, *American Poetry*, 131–132.

7. Spencer R. Weart, *Nuclear Fear: A History of Images* (Cambridge: Harvard University Press, 1989), 103, 392.

8. Kenneth Rexroth, "Kenneth Patchen: Naturalist of the Public Nightmare," in *Bird in the Bush*, 95–97.

9. Peter Blanc, "The Artist and the Atom," *Magazine of Art* 44 (1951): 150, 152.

10. Dwight Macdonald's responses to the bomb were published in the August and September 1945 issues of *Politics*. They were reprinted under the title "The

Bomb" in *Memoirs of a Revolutionist* (New York: Farrar, Straus and Cudahy, 1957), 169–180; quotation on 169.

11. A. Pankovits, quoted in Harry Russell Huebel, Jr., "The Beat Generation and the Bohemian Left Tradition in America" (Ph.D. diss., Washington State University , 1970), 67. Morris Graves, quoted in Kenneth Rexroth, "The Visionary Painting of Morris Graves," in *Bird in the Bush*, 58.

12. [Robert Bly and William Duffy], "A Note on Hydrogen Bomb Testing," *The Fifties*, 1959, 51. Clyfford Still quoted in Stephen Polcari, *Abstract Expressionism and the Modern Experience* (New York: Cambridge University Press, 1991), 115. Allen Ginsberg and Gregory Corso, "Interview with William S. Burroughs," *Journal for the Protection of All Beings*, 1961, 81.

13. "The New Look Is the Anxious Look," *Neurotica*, Spring 1948, 48. Leslie Woolf Hedley quoted in Linick, "American Literary Avant-Garde," 75. E. V. Griffith quoted in "Editors Write," *Trace*, August 1954, 16–18. Kenneth Patchen quoted in Rexroth, "Kenneth Patchen," 100.

14. Allen Ginsberg to Peter Orlovsky, [16 July 1958], POP. Sidra Stitch, *Made in USA: An Americanization in Modern Art, the '50s and '60s* (Berkeley: University of California Press, 1987), 166–167.

15. Rexroth, *American Poetry*, 131–132. Barnett Newman quoted in Thomas Hess, *Barnett Newman* (New York: Museum of Modern Art, 1971), 37.

16. Macdonald, *Memoirs of a Revolutionist*, 169.

17. Ibid., 178.

18. Harry Hershkowitz, "Why Death?" *Death*, Summer 1946, 3. Douglas Woolf, "Radioactive Generation," *Inland*, Autumn 1960, 34. Allen Ginsberg, untitled, MS, ca. 1958, Orlovsky File, AGP,SU.

19. Leslie Woolf Hedley quoted in Linick, "American Literary Avant-Garde," 75. Kenneth Rexroth to Dwight Macdonald, 4 October 1945, DMacdP.

20. Paul Goodman, "The Emperor of China," *Possibilities*, Winter 1947–1948, 13.

21. Parker Tyler, "Art," *View*, Fall 1946, 37. A show of paintings at the Betty Parsons Gallery in 1947 also featured bomb-inspired works: two versions of a painting by Hans Hoffman, *The Furyo*; and a painting by Pietro Lazzari, *Burnt Offering*; see Edward Alden Jewell, "New Phase in Art Noted at Display," *New York Times*, 28 January 1947, n.p., New York Public Library Pamphlet File, BPP.

22. Judson Crews, "The Atom Bomb Cathedral," *Climax*, [no. 1], 1955, 35. James Boyer May, "Return to Pelagianism," *Experiment* 5 (Spring 1950), 331.

23. "Bomb" was first published as a flyer in 1958 by City Lights Books and later as a foldout in Gregory Corso, *The Happy Birthday of Death* (New York: New Directions, 1960), between 33–34. The incident at Oxford is described in Barry Miles, *Ginsberg: A Biography* (New York: Simon and Schuster, 1989), 243.

24. David Riesman, Nathan Glazer, and Reuel Denney, *The Lonely Crowd: A Study of the Changing American Character* (New Haven: Yale University Press, 1950). Irving Howe, "This Age of Conformity," *Partisan Review* 21 (1954): 7–33.

25. S. E. Laurilla, "The New Man," *Miscellaneous Man*, April 1956, 1–3.

26. James Boyer May, *Twigs as Varied Bent* (Corona, N.Y.: Sparrow Magazine,

1954), 7. E. E. Walters, "Editors Write," *Trace*, October 1953, 17–18. David Meltzer, "Journal of the Birth," *Journal for the Protection of All Beings*, 1961, 69.

27. Howe, "This Age of Conformity," 19, 20. Norman O. Brown, "Apocalypse: The Place of Mystery in the Life of the Mind," *Harpers*, May 1961, 46–49.

28. Amiri Baraka interviewed by Debra Edwards, "LeRoi Jones in the East Village," in Arthur Knight and Kit Knight, eds., *The Beat Vision: A Primary Source Book* (New York: Paragon House, 1987), 130–131.

29. The *Howl* trial is discussed in Michael Schumacher, *Dharma Lion: A Critical Biography of Allen Ginsberg* (New York: St. Martin's Press, 1992), 254–255, 259–264. Gregory Corso to Lawrence Ferlinghetti, [Spring 1957], CLBR. For examples of the literature of outcasts, see Ray Bremser, "Poem of Holy Maddness, Part IV," in Donald M. Allen, ed., *The New American Poetry* (New York: Grove Press, 1960), 354, and the poem by New Jersey state prison inmate Edwin J. Becker "Who Cried against the Wall?" *Portfolio*, Spring 1947, leaf 7.

30. Jean Franklin, editorial, *New Iconograph*, Fall 1947, 2. Oscar Collier, "A Piece of Bombast," *Iconograph Quarterly Supplement of Prejudice and Opinion*, no. 2 [Fall 1946]: 2.

31. Mark Rothko quoted by Douglas McAgy, "Mark Rothko," *Magazine of Art*, January 1949, 21. Merce Cunningham, "Space, Time, Dance," *Trans/Formation* 1 (1952): 150. David Smith quoted in Seldon Rodman, *Conversations with Artists* (New York: Devin-Adair, 1957), 127–128.

32. Poggioli, *Theory of the Avant-Garde*, 107–108. William Baziotes, "A Speech for a Television Program Scheduled at Hunter College," MS, ca. 1957, 1, WBP. James Boyer May, "Towards Print," *Trace*, August 1958, 10. Philip Whalen, "Further Notice," *Yugen*, [no. 1], 1958, 2.

33. Poggioli, *Theory of the Avant-Garde*, 109. Clyfford Still to Betty Parsons, 26 September 1949, BPP. Harold Rosenberg, "Introduction to Six American Artists," *Possibilities*, Winter 1947–1948, 75.

34. Rosenberg, "Six American Artists," 75. Mark Rothko, "The Romantics Were Prompted," *Possibilities*, Winter 1947–1948, 84. John Ferren, "Epitaph for an Avant-Garde," *Arts*, November 1958, 26.

35. William Baziotes, "Speech for a Television Program," 1.

36. The expatriation of the writers of the 1920s is ably described in Malcolm Cowley, *Exile's Return: A Literary Odyssey of the 1920s* (Harmondsworth, U.K.: Penguin Books, 1976 [1951]). Robert Motherwell to William Baziotes, 6 September 1944, WBP.

NOTES TO CHAPTER 4

1. Cid Corman, "The Little Magazine," *Trace*, October 1952, 1–2. Richard Kostelanetz, ed., *John Cage* (New York: Praeger, 1970), 117.

2. John Clellon Holmes, "Crazy Days, Numinous Nights: 1948–1950," in Arthur Knight and Kit Knight, eds., *The Beat Vision: A Primary Source Book* (New York: Paragon House, 1987), 75.

3. Clement Greenberg, "Modernist Painting," in Gregory Battcock, ed., *The New Art*, 2d ed. (New York: E. P. Dutton, 1973), 66–77.

4. Irving Howe, "Mass Society and Post-Modern Fiction," *Partisan Review* 26 (1959): 435.

5. Renato Poggioli, *The Theory of the Avant-Garde*, trans. Gerald Fitzgerald (Cambridge: Harvard University Press, 1968), 97.

6. Robert Duncan, "Properties of our REAL Estate," *Journal for the Protection of All Beings* 1 (1961): 87. Leslie Woolf Hedley, *Galley*, Fall 1950, 9. Ralph Borsodi and Mildred Jensen Loomis, "Major Problems of Living," *Grundtvig Review*, Spring 1950, 39–44. James Boyer May, "Concerning a Maker," *Inferno Quarterly*, no. 10, [1954]: 21–28. John Bernard Myers, "Interactions: A View of *View*," *Art in America* 69 (1981): 91. John Arthur Maynard, *Venice West: The Beat Generation in Southern California* (New Brunswick, N.J.: Rutgers University Press, 1991), 63.

7. Herbert Read, *The Politics of the Unpolitical* (London: Routledge, 1943).

8. Robert Motherwell and Harold Rosenberg, editorial, *Possibilities*, Winter 1947–1948, 1.

9. Michael McClure, "From a Journal: Sept. '59," in Donald Allen, ed., *The New American Poetry* (New York: Grove Press, 1960), 423. William H. Ryan, editorial, *Contact*, February 1960, 20. "Morton Feldman" in Walter Zimmermann, ed., *Desert Plants: Conversations with Twenty-Three American Musicians* (Vancouver: Aesthetics Research Center, 1976), 12–13.

10. Editorial, *Miscellaneous Man*, Spring 1955, inside cover. *Yugen*, [no. 1], 1958, cover. Kenneth Rexroth, "Disengagement: The Art of the Beat Generation," reprinted in Thomas Parkinson, ed., *A Casebook on the Beat* (New York: Crowell, 1961), 180–181.

11. David Koven and James Harmon quoted in Anthony Linick, "A History of the American Literary 'Avant-Garde' since World War II" (Ph.D. diss., University of California, Los Angeles, 1965), 147. John Cage, *Silence: Lectures and Writings* (Middletown, Conn.: Wesleyan University Press, 1961), 37.

12. William Carlos Williams quoted in Peter Ackroyd, *T. S. Eliot: A Life* (New York: Simon and Schuster, 1984), 127. Williams's reaction to Eliot was well known to the Beat writers: see John Clellon Holmes, quoted in Neil A. Chassman, ed., *Poets of the Cities: New York and San Francisco, 1950–1965* (New York: E. P. Dutton, 1974), 64. Joel Oppenheimer quoted in Donald Allen and George F. Buttrick, eds., *The Postmoderns: The New American Poetry Revised* (New York: Grove Press, 1982), 421. James MacKenzie, "An Interview with Allen Ginsberg," in Arthur Knight and Kit Knight, eds., *The Beat Journey, The Unspeakable Visions of The Individual* 8 (1978): 3–4. William Carlos Williams, "Howl for Carl Solomon: Introduction," in Allen Ginsberg, *Howl and Other Poems* (San Francisco: City Lights Books, 1956), 7–8.

13. "Jackson Pollock," *Arts and Architecture*, February 1944, 14. John Ferren, "Epitaph for an Avant-Garde," *Arts*, November 1958, 26.

14. Thomas Hart Benton quoted Stephen Polcari, *Abstract Expressionism and the Modern Experience* (New York: Cambridge University Press, 1991), 16.

15. Harry Partch, *Genesis of a Music* (Madison: University of Wisconsin Press, 1949), xvi. Catherine M. Cameron, "Fighting with Words: American Composers' Commentary on Their Work," *Comparative Studies in Society and History* 27 (1985): 451–452.

16. Cage, *Silence*, 63, 71, 84.

17. Willem de Kooning quoted in Maurice Tuchman, ed., *The New York School: Abstract Expressionism in the Forties and Fifties* (London: Thames and Hudson, 1969), 49. Allen Ginsberg to Peter Orlovsky, 15 June 1958, POP.

18. Robert Motherwell, *The Dada Painters and Poets: An Anthology* (New York: Wittenborn, Schultz, 1951). Max Kozloff, "An Interview with Robert Motherwell," *Artforum*, September 1965, 37.

19. Partch, *Genesis of a Music*, xi. Ellen G. Landau, *Jackson Pollock* (New York: Harry N. Abrams, 1989), 241. F. T. Martinetti, "The Foundation and Manifesto of Futurism" (1908), reprinted in Hershel B. Chipp, *Theories of Modern Art: A Source Book by Artists and Critics* (Berkeley: University of California Press, 1968), 284–289, especially 286.

20. Francis Lee, "Interview with Miro," *Possibilities*, Winter 1947–1948, 67.

21. Cage, *Silence*, 17.

22. Ibid., 64; see also 44. Claes Oldenberg quoted in Sidra Stitch, *Made in the USA: An Americanization in Modern Art, the '50s and '60s* (Berkeley: University of California Press, 1987), 208.

23. Harry Russell Huebel, Jr., "The Beat Generation and the Bohemian Left Tradition in America" (Ph.D. diss., Washington State University, 1970), 124, 73–92. Mary Lynn Kotz, *Rauschenberg: Art and Life* (New York: Harry N. Abrams, 1990), 73–76.

24. Robert Motherwell quoted in Irving Sandler, *The Triumph of American Painting: A History of Abstract Expressionism* (New York: Harper and Row, 1970), 217. Robert Duncan, "Pages from a Notebook," in Allen, ed., *New American Poetry*, 404. Earl Brown quoted in H. Wiley Hitchcock, *Music in the United States*, 3d ed. (Englewood Cliffs, N.J.: Prentice-Hall, 1988), 269. Jack Kerouac, "Essentials of Spontaneous Prose," in Parkinson, *Casebook on the Beat*, 65–67.

25. Ferlinghetti quoted in Michael Davidson, *The San Francisco Renaissance: Poetics and Community at Mid-Century* (Cambridge: Cambridge University Press, 1989), 16.

26. "Gary Snyder," *Literary Times*, December 1964, 22, clipping in Gary Snyder File, CLBR.

27. James E. B. Breslin, *From Modern to Contemporary: American Poetry, 1945–1965* (Chicago: University of Chicago Press, 1984), 59–60. Davidson, *San Francisco Renaissance*, 16–23. Charles Altieri, "From Symbolist Thought to Immanence: The Ground of Postmodern American Poetics," *Boundary II* 1 (1973): 605.

28. Barnett Newman quoted in Rose, *Readings in American Art*, 135; Oscar Collier to Judson Crews, [June 1946], JCP.

29. Barnett Newman quoted from the *New York Herald-Tribune*, 6 May 1951, n.p., clipping in BPP. Ferren, "Epitaph for an Avant-Garde," 26.

30. Davidson, *San Francisco Renaissance*, 87; Earle Brown, "Some Notes on Composing," in Gilbert Chase, ed., *The American Composer Speaks* (Baton Rouge: Louisiana State University Press, 1966), 303.

31. Robert Rauschenberg quoted in Dorothy C. Miller, ed., *Sixteen Americans* (New York: Museum of Modern Art, 1959); reprinted in Rose, *Readings in Ameri-*

can Art, 149. Frank O'Hara quoted in Marjorie Perloff, *Frank O'Hara: Poet among Painters* (Austin: University of Texas Press, 1977), 24.

32. Frank O'Hara and LeRoi Jones, "Statements on Poetics," in Allen, ed., *New American Poetry*, 419–420 and 424–425.

33. Charles Olson's "Projective Verse" is reprinted in Allen, ed., *New American Poetry*, 386–397.

34. Cage, *Silence*, 3, 22. Christian Wolff quoted in ibid., 68. Richard Kostelanetz, *Conversing with Cage* (New York: Limelight Editions, 1988), 65.

35. Cage, *Silence*, 68–69. Kostelanetz, *Conversing with Cage*, 65.

36. Jack Kerouac, "Origins of the Beat Generation," *Playboy*, June 1959, 31–32; reprinted in Parkinson, *Casebook on the Beat*, 68–72.

37. John Clellon Holmes quoted in John Tytell, *Naked Angels: The Lives and Literature of the Beat Generation* (New York: Grove Press, 1976), 22. Norman Mailer, "The White Negro: Superficial Reflections on the Hipster," *Dissent* 4 (1957): 279.

38. Kenneth Rexroth, "The World Is Full of Strangers," *New Directions* 16 (1957): 194. Kenneth Rexroth, *Bird in the Bush* (New York: New Directions, 1959), 38–39. Rexroth, "Disengagement," 181.

39. Peter Willmott, "Jazz and Society," *Jazz Forum*, January 1947, 16.

40. "On the Society," *Climax*, no. 1 (1955): 3. Eithne Wilkins, "Jazz, Surrealism, and the Doctor," *Jazz Forum*, no. 1, [1946]: 10. Allen Ginsberg, "Footnote to Howl," in *Howl and Other Poems*, 21.

41. Allen Ginsberg to Donald Allen, [April 1958], AGP,SU. Jack Kerouac quoted in Tytell, *Naked Angels*, 143. Untitled poem by Michael McClure in *Semina* 4 (1959): n.p.

42. Kenneth Rexroth, "Jazz Poetry" (1958) reprinted in Bradford Morrow, ed., *World Outside the Window: The Selected Essays of Kenneth Rexroth* (New York: New Directions, 1987), 68–72. Carolyn See, "The Jazz Musician as Patchen's Hero," *Arizona Quarterly* 17 (1961): 141–146. Allen Brown, "A Poet Turned to Night Club Jazz," *San Francisco Chronicle*, 6 October 1957, 14, in Kenneth Patchen File, CLBR.

43. Tuli Kupferberg, "Death and Love," *Kulchur* 3 (1961): 32. Ronald Sukenick, *Down and In: Life in the Underground* (New York: Beechtree Books, 1987), 32–33. *Fuck You: A Magazine of the Arts*, no. 2 (April 1962).

44. Lawrence Barth, "Digging the Roots of Our Chaos," *Miscellaneous Man*, April 1956, 11–12. Paul Goodman, "The Fate of Dr. Reich's Books," *Kulchur* 2 (1960): 22–23.

45. Paul Goodman, "Sex and Revolution," *View*, October 1945, 15.

46. Sukenick, *Down and In*, 32. James Atlas, "Golden Boy," *New York Review of Books*, 29 June 1989, 45. Martin Duberman, *Black Mountain: An Exploration in Community* (Garden City, N.Y.: Doubleday, 1973), 433. Jay Landesman, *Rebel without Applause* (London: Bloomsbury, 1987), 31, 103. Dennis McNally, *Desolate Angel: Jack Kerouac, the Beat Generation, and America* (New York: Random House, 1979), 123, 139. Barry Miles, *Ginsberg: A Biography* (New York: Simon and Schuster, 1989), 95–97. William Carlos Williams to Kenneth Burke, St. Patrick's [Day, 1947], in John C. Thirwall, *The Selected Letters of William Carlos Williams*

(New York: McDowell, Obolensky, 1957), 257. Ted Morgan, *Literary Outlaw: The Life and Times of William S. Burroughs* (New York: Henry Holt, 1988), 140–143. Jack Kerouac recorded Burroughs's Reichian critique of American society in the rantings of the character Bull Lee in *On the Road* (New York: Viking, 1957), 119–127. Adam Margoshes, "Epitaph for a Scientist," in Daniel Wolf and Edwin Fander, eds., *The Village Voice Reader* (New York: Doubleday, 1962), 212–214.

47. G. Legman, "The Psychopathology of the Comics," *Neurotica*, Autumn 1948, 29. Editorial, *Semina*, December 1957, back cover. Documents printed in *Provincetown Review*, Winter 1961. Elliott Anderson and Mary Kinzie, eds., *The Little Magazine in America: A Modern Documentary History* (Yonkers, N.Y.: Pushcart Books, 1978), 682. John D'Emilio and Estelle B. Freedman, *Intimate Matters: A History of Sexuality in America* (New York: Harper and Row, 1988), 275–278.

48. Manfred Wise, "Sex, Ignorance, Desire, and the Orgasm," *Deer and Dachshund*, no. 5 [1953]: n.p. Lenore Kandel, "To Fuck with Love," *Fuck You: A Magazine of the Arts*, no. 5, vol. 1 [sic] [1962]: n.p. Partch, *Genesis of a Music*, 54–57. Kenneth Rexroth also referred to D. H. Lawrence: see "Poetry, Regeneration, and D. H. Lawrence," in *Bird in the Bush*, 202.

49. Polcari, *Abstract Expressionism*, 99, 191–192, 286–291.

50. Paul O'Neil, "The Only Rebellion Around," *Life*, 30 November 1959, 115–130, quote on 238. O'Neil's essay was also abridged in *Reader's Digest*, further publicizing the stereotype; see Paul O'Neil, "Life among the Beatniks," *Reader's Digest*, April 1960, 64–68. Allen Ginsberg quoted in Larry Sloman, *Reefer Madness: The History of Marijuana in America* (Indianapolis: Bobbs-Merrill, 1979), 178. Stuart Z. Perkoff Journal, [August 1956], SPP.

51. Allen Ginsberg to Marcel Duchamp, 1 August 1964, AGP,CU. Frances Joseph Rigney and L. Douglas Smith, *The Real Bohemia: A Sociological and Psychological Study of the "Beats"* (New York: Basic Books, 1961), 52–65, especially 57 and 58 for examples of drugs and aesthetic experiments. Lawrence Lipton, *The Holy Barbarians* (New York: Julien Messner, 1959), 171–189, especially 172–175 for Michael McClure's "Peyote Poem." Kerouac is discussed in McNally, *Desolate Angel*, 133–134.

52. Paul Bowles, "Kif—Prologue and Compendium of Terms," *Kulchur 3* (1961): 36. Allen Ginsberg, "Poetry, Violence, and the Trembling Lambs," reprinted in Parkinson, *Casebook on the Beat*, 25.

53. John Cage quoted in Richard Kostelanetz, *Masterminds: Portraits of Contemporary Artists and Intellectuals* (New York: Macmillan, 1969), 126. Gary Snyder, "Note on the Religious Tendencies," reprinted in Parkinson, *Casebook on the Beat*, 155. Stuart Z. Perkoff Journal, [August 1956], SPP. Miles, *Ginsberg*, 304.

54. Miles, *Ginsberg*, 398–399. Gary Snyder to Shig Murao, 29 March 1967, CLBR.

55. Sukenick, *Down and In*, 33. Gerald Nicosia, *Memory Babe: A Critical Biography of Jack Kerouac* (New York: Grove Press, 1983), 697. The destructive effects of alcohol on Willem and Elaine de Kooning are described in Lee Hall, *Elaine and Bill, Portrait of a Marriage: The Lives of Willem and Elaine de Kooning* (New York: HarperCollins, 1993), 176–182 and passim.

56. In Linick's 1965 survey of more than sixty members of the literary avant

garde, asking, among other things, about their religious background and practice, more than three-quarters of them responded that they were reared either Christian or Jewish, but most described themselves as lapsed. Only 14 percent of the respondents attended religious services. See Linick, "American Literary Avant-Garde," 373.

57. John Fles, "The Root," *Kulchur*, Spring 1960, 39–40. Robert Motherwell, "The Modern Painter's World," *Dyn*, no. 6 (1944): n.p.; reprinted in Rose, ed., *Readings in American Art*, 105.

58. Martha Graham quoted in Polcari, *Abstract Expressionism*, 53. John Cage, *Silence*, 45.

59. Clyfford Still quoted in Ann Eden Gibson, "Theory Undeclared: Avant-Garde Magazines as a Guide to Abstract Expressionist Images and Ideas" (Ph.D. diss., University of Delaware, 1984), 388. Richard Pousette-Dart quoted in Tuchman, *New York School*, 126–127; and *Richard Pousette-Dart* (New York: Art of This Century, 1947), n.p. For Mark Rothko's well-known comments on the religious experience of painting, see Seldon Rodman, *Conversations with Artists* (New York: Devin-Adair, 1957), 93–94.

60. Jack Kerouac quoted in Linick, "American Literary Avant-Garde," 396.

61. "Jackson Pollock," *Arts and Architecture*, p. 14. Kenneth Lawrence Beaudoin, "This Is the Spring of 1946," *Iconograph* 1 (Spring 1946): 3–4. B. B. Newman, introduction to *Northwest Coast Indian Painting* (New York: Betty Parson's Gallery, 1946), n.p., in BPP. Arthur L. Dahl, ed., *Mark Tobey: Art and Belief* (Oxford: George Ronald, 1984), 5.

62. Richard D. Lehan, "Cities of the Living/Cities of the Dead: Joyce, Eliot, and the Origins of Myth in Modernism," in Lawrence B. Gamache, and Ian S. MacNiven, eds., *The Modernists: Studies in a Literary Phenomenon* (Rutherford, N.J.: Fairleigh Dickinson University Press, 1987), 61–74.

63. James Boyer May, "What Stuff to Destine Dreams?" *Grundtvig Review*, no. 3 (1952): 1–2. Marjorie Farber, "The Live Dog: Art as Magic and as Entertainment," *City Lights*, Spring 1955, 63. Edward F. Edinger, "The Role of Myth," *The Realist*, June-July 1958, 10–11. Harry Slochomer, "The Import of Myth for Our Time," *Trans/Formation* 1 (1951): 97–99.

64. Barnett Newman quoted in Rose, *Readings in American Art*, 113. Stuart Z. Perkoff Journal, [ca. September 1956], SPP.

65. Mark Rothko, *Clyfford Still: Paintings* (New York: Art of This Century, [1946]).

66. Carl Jackson, "The Counterculture Looks East: Beat Writers and Asian Religion," *American Studies* 29 (1988): 53, 68. Lawrence W. Chisolm, *Fenollosa: The Far East and American Culture* (New Haven: Yale University Press, 1963), 222–223. Monica Furlong, *Zen Effects: The Life of Alan Watts* (Boston: Houghton Mifflin, 1986), 142–143, 159–160.

67. Nicholas O'Connell, interview with Gary Snyder in *At the Field's End: Interviews with Twenty Pacific Northwest Writers* (Seattle: Madrona Publishers, 1987), 313.

68. This and the following paragraph are based on Davidson, *San Francisco Renaissance*, 97–98.

69. Margaret Leng Tan, "'Taking a Nap, I Pound the Rice': Eastern Influences on John Cage," in Richard Fleming and William Duckworth, eds., *John Cage at Seventy-Five* (Lewisburg, Pa.: Bucknell University Press, 1989), 34–57. James Pritchett, *The Music of John Cage* (New York: Cambridge University Press, 1993), 36–38, 74–78.

70. Norman Podhoretz, "The Know-Nothing Bohemians," *Partisan Review* 25 (1958): 307–398. Holmes, "Crazy Days, Numinous Nights," 86. William Carlos Williams, "Symposium: The Beat Poets," *Wagner Literary Magazine*, Spring 1959, 24.

71. Snyder, "Note on the Religious Tendencies," 156.

NOTES TO CHAPTER 5

1. "Statement of Editorial Policy," *Coastline*, Spring 1956, 40.

2. Roderick Seidenberg, "The Sense of the Future: Man's About Face," *Nation* 181 (1955): 157.

3. Mark Rothko to Edward Alden Jewel, [June 1943], MRP. Louis Dudeck quoted in Wendell B. Anderson, "Love and Labor without Loss," *Deer and Dachshund*, no. 5 [1953]: n.p. Michel Seuphor, "Yesterday—Today—Tomorrow," in American Abstract Artists, eds., *The World of Abstract Art* (New York: Wittenborn, [1957]), 5.

4. Harry Holtzman and Martin James, "Measure of Man," *Trans/Formation* 1 (1950): 1.

5. John Cage, *Silence: Lectures and Writings* (Middletown, Conn.: Wesleyan University Press, 1961), 10. "Anne Waldman Talks with Diane di Prima," in Arthur Knight and Kit Knight, eds., *The Beat Vision: A Primary Source Book* (New York: Paragon House, 1987), 145. Jacqueline Johnson quoted in Thomas Albright, *Art in the San Francisco Bay Area, 1945–1980: An Illustrated History* (Berkeley: University of California Press, 1985), 41.

6. Elmer Bischoff, "A Talk Given at the Oakland Museum," 27 October 1973, MS, San Francisco Art Institute Archives.

7. Allen Ginsberg to Peter Orlovsky, 27 February 1958, POP.

8. Peter Clecak, *America's Quest for the Ideal Self: Dissent and Fulfillment in the 60s and 70s* (New York: Oxford University Press, 1983).

9. Laszlo Moholy-Nagy, quoted in Sibyl Moholy-Nagy, *Moholy-Nagy: Experiment in Totality* (Cambridge: Harvard University Press, 1950), xii. Clement Greenberg, "Master Léger," *Partisan Review* 21 (1954): 91. Renato Poggioli, *Theory of the Avant-Garde*, trans. Gerald Fitgerald (Cambridge: Harvard University Press, 1968), 135–139.

10. Meyer Schapiro, "The Liberating Qualities of Avant-Garde Art: The Vital Role That Painting and Sculpture Play in Modern Culture," *Art News*, Summer 1956, 39.

11. Herbert Benjamin, "Psychiatrist: God or Demitasse," *Neurotica*, Spring 1949, 31–38. Paul Mocsanyi, "Art in Review," unidentified clipping, ca. 1949, Rothko File, BPP. Michael Fraenkel, "Note on Death," *Death*, Summer 1946, 63–64. Gary Snyder quoted in Harry Russell Huebel, Jr., "The Beat Generation

and the Bohemian Left Tradition in America" (Ph.D. diss., Washington State University, 1970), 67.

12. Mark Tobey quoted in Katherine Kuh, *The Artist's Voice: Talks with Seventeen Artists* (New York: Harper and Row, 1962), 235. [James Boyer May], "Towards Print," *Trace*, August 1958, 9. James Russell Grant, "Poetry and Mind," *Trace*, August 1957, 4. Frederick Kiesler, *Hans Richter* (New York: Art of This Century, 1946), n.p.

13. Robert Anton Wilson, "The New Art of the Brave," *Realist*, December 1960, 12. T. J. Jackson Lears, *No Place of Grace: Antimodernism and the Transformation of American Culture, 1880–1920* (New York: Pantheon, 1981), 32–47.

14. B. B. Newman, *Northwest Coast Indian Painting* (New York: Betty Parsons Gallery, 1946), n.p., BPP. Harry Partch, *Genesis of a Music* (Madison: University of Wisconsin Press, 1949), 218. Jack Kerouac, *On the Road* (New York: Viking, 1957), 299.

15. Wolfgang Paalen, *Wolfgang Paalen* (New York: Art of This Century, 1945), n.p. "Edgard Varèse and Alexei Haieff Questioned by 8 Composers," *Possibilities*, Winter 1947–1948, 96. Edgard Varèse quoted in Elliott Schwartz and Barney Childs, eds., *Contemporary Composers on Contemporary Music* (New York: Holt, Rinehart and Winston, 1967), 202, 208.

16. Richard Kostelanetz, ed., *John Cage* (New York: Praeger, 1970), 170–171. On Marshall McLuhan, see Philip Marchand, *Marshall McLuhan: The Medium and the Messenger* (New York: Ticknor and Fields, 1989). On R. Buckminster Fuller, see Martin Pawley, *Buckminster Fuller* (London: Trefoil, 1990).

17. Irving Sandler, *The New York School: The Painters and Sculptors of the Fifties* (New York: Harper and Row, 1978), 304–305. Richard Kostelanetz, "A Conversation with Robert Rauschenberg," *Partisan Review* 35 (1968): 105.

18. Partch, *Genesis of a Music*, 217, 329–330.

19. Stephen Polcari, *Abstract Expressionism and the Modern Experience* (Cambridge: Cambridge University Press, 1991), 52, 192–193.

20. Jack Tworkov, "Four Excerpts from a Journal," *It Is*, Autumn 1959, 12 (entry dated 25 September 1953).

21. Barding Dahl, "Reform and the Myth of Perfection," *Coastlines*, Winter 1956, 32.

22. Adolph Gottlieb, "The Ides of Art," *Tiger's Eye*, December 1949, 43. Gene Fowler, "Gary Snyder," *Literary Times*, December 1964, 22, CLBR. Martha Graham quoted in Polcari, *Abstract Expressionism*, 208–209.

23. Willem de Kooning quoted in Irving Sandler, *The Triumph of American Painting: A History of Abstract Expressionism* (New York: Praeger, 1970), 98. Existentialism was discussed at the time in such avant-garde magazines as *View* and *Instead:* see Nicolas Calas's reveiw of *The Stranger* by Albert Camus in *View*, March-April 1946, 31; and Lionel Abel, "An Open Letter to Jean Paul Sartre," *Instead*, no. 2 [1948], n.p.

24. Annette Cox, *Art-As-Politics: The Abstract Expressionist Avant-Garde and Society* (Ann Arbor, Mich.: UMI Research Press, 1982), 129–140. Warren I. Susman, *Culture as History: The Transformation of American Society in the Twentieth Century* (New York: Pantheon, 1984), 180.

25. Alan W. Watts, *The Way of Zen* (New York: Pantheon, 1957), 199. Cage, *Silence*, 43, 46–47.

26. Christian Wolff quoted in Charles Hamm, *Music in the New World* (New York: W. W. Norton, 1983), 606–607.

27. John Arthur Maynard, *Venice West: The Beat Generation in Southern California* (New Brunswick, N.J.: Rutgers University Press, 1991), 192.

28. Allan Kaprow quoted in, "Jackson Pollock: An Artists' Symposium, Part 1," *Art News*, April 1967, 33.

29. Robert Rauschenberg quoted in Calvin Tomkins, *The Bride and the Bachelors* (Harmondsworth, U.K.: Penguin, 1965), 210. Cage, *Silence*, 12. La Monte Young quoted in H. Wiley Hitchcock, *Music in the United States*, 2d ed. (Englewood Cliffs, N.J.: Prentice-Hall, 1974), 273.

30. Maynard, *Venice West*, 12. Lawrence Lipton, *The Holy Barbarians* (New York: Julien Messner, 1959), 166–170.

31. Cage, *Silence*, 65.

32. Allan Kaprow quoted in Irving Sandler, "In the Art Galleries," *New York Post*, 16 June 1963, magazine section, 14.

33. Mary Emma Harris, *The Arts at Black Mountain College* (Cambridge: M.I.T. Press, 1987), 226–228. Richard Kostelanetz, *Conversing with Cage* (New York: Limelight Editions, 1988), 103–105.

34. Allan Kaprow quoted in "Jackson Pollock: An Artists' Symposium," 60. Allan Kaprow, "'Happenings' in the New York Art Scene," *Art News*, May 1961, 39.

35. George Brecht, "Motor Vehicle Sundown (Event)," and La Monte Young, "Composition 1960 # 3," both in La Monte Young, ed., *An Anthology: Chance Operations/ Concept Art/ Meaningless Work/ Natural Disasters/ Indeterminancy/ Anti-Art/ Plans of Action/ Improvisation/ Stories/ Compositions/ Mathematics/ Music* (New York: Heiner Friedrich, 1963), n.p.

36. Kaprow, "'Happenings,'" 60, 61.

37. Frank Stella quoted in Barbara Rose, ed., *Readings in American Art: 1900–1975* (New York: Praeger, 1975), 173. Marvin Cohen, "What Is the Real, Really? . . ." in Charles Russell, ed., *The Avant-Garde Today: An International Anthology* (Urbana: University of Illinois Press, 1981), 111; and see Russell's analysis, 101–104. Robert Indiana quoted in John Russell and Suzi Gablik, *Pop Art Redefined* (New York: Praeger, 1969), 81.

38. Jim Dine quoted in Russell and Gablik, *Pop Art Redefined*, 63.

NOTES TO CHAPTER 6

1. Horace Schwartz quoted in Anthony Linick, "A History of the American Literary 'Avant-Garde' Since World War II" (Ph.D. diss., University of California, Los Angeles, 1965), 293–294. Leslie Woolf Hedley quoted in ibid., 84.

2. Gary Snyder, "Buddhist Anarchism," *Journal for the Protection of All Beings* 1 (1961): 11. Jack Kerouac, *On the Road* (New York: Viking, 1957), 124.

3. Lawrence Barth, "Little Magazines and Tyranny," *Trace*, June 1953, 1.

4. Advertisement for *Inferno* in *Galley*, Spring 1950, 37. William S. Bur-

and the Bohemian Left Tradition in America" (Ph.D. diss., Washington State University, 1970), 67.

12. Mark Tobey quoted in Katherine Kuh, *The Artist's Voice: Talks with Seventeen Artists* (New York: Harper and Row, 1962), 235. [James Boyer May], "Towards Print," *Trace*, August 1958, 9. James Russell Grant, "Poetry and Mind," *Trace*, August 1957, 4. Frederick Kiesler, *Hans Richter* (New York: Art of This Century, 1946), n.p.

13. Robert Anton Wilson, "The New Art of the Brave," *Realist*, December 1960, 12. T. J. Jackson Lears, *No Place of Grace: Antimodernism and the Transformation of American Culture, 1880–1920* (New York: Pantheon, 1981), 32–47.

14. B. B. Newman, *Northwest Coast Indian Painting* (New York: Betty Parsons Gallery, 1946), n.p., BPP. Harry Partch, *Genesis of a Music* (Madison: University of Wisconsin Press, 1949), 218. Jack Kerouac, *On the Road* (New York: Viking, 1957), 299.

15. Wolfgang Paalen, *Wolfgang Paalen* (New York: Art of This Century, 1945), n.p. "Edgard Varèse and Alexei Haieff Questioned by 8 Composers," *Possibilities*, Winter 1947–1948, 96. Edgard Varèse quoted in Elliott Schwartz and Barney Childs, eds., *Contemporary Composers on Contemporary Music* (New York: Holt, Rinehart and Winston, 1967), 202, 208.

16. Richard Kostelanetz, ed., *John Cage* (New York: Praeger, 1970), 170–171. On Marshall McLuhan, see Philip Marchand, *Marshall McLuhan: The Medium and the Messenger* (New York: Ticknor and Fields, 1989). On R. Buckminster Fuller, see Martin Pawley, *Buckminster Fuller* (London: Trefoil, 1990).

17. Irving Sandler, *The New York School: The Painters and Sculptors of the Fifties* (New York: Harper and Row, 1978), 304–305. Richard Kostelanetz, "A Conversation with Robert Rauschenberg," *Partisan Review* 35 (1968): 105.

18. Partch, *Genesis of a Music*, 217, 329–330.

19. Stephen Polcari, *Abstract Expressionism and the Modern Experience* (Cambridge: Cambridge University Press, 1991), 52, 192–193.

20. Jack Tworkov, "Four Excerpts from a Journal," *It Is*, Autumn 1959, 12 (entry dated 25 September 1953).

21. Barding Dahl, "Reform and the Myth of Perfection," *Coastlines*, Winter 1956, 32.

22. Adolph Gottlieb, "The Ides of Art," *Tiger's Eye*, December 1949, 43. Gene Fowler, "Gary Snyder," *Literary Times*, December 1964, 22, CLBR. Martha Graham quoted in Polcari, *Abstract Expressionism*, 208–209.

23. Willem de Kooning quoted in Irving Sandler, *The Triumph of American Painting: A History of Abstract Expressionism* (New York: Praeger, 1970), 98. Existentialism was discussed at the time in such avant-garde magazines as *View* and *Instead*: see Nicolas Calas's reveiw of *The Stranger* by Albert Camus in *View*, March-April 1946, 31; and Lionel Abel, "An Open Letter to Jean Paul Sartre," *Instead*, no. 2 [1948], n.p.

24. Annette Cox, *Art-As-Politics: The Abstract Expressionist Avant-Garde and Society* (Ann Arbor, Mich.: UMI Research Press, 1982), 129–140. Warren I. Susman, *Culture as History: The Transformation of American Society in the Twentieth Century* (New York: Pantheon, 1984), 180.

25. Alan W. Watts, *The Way of Zen* (New York: Pantheon, 1957), 199. Cage, *Silence*, 43, 46–47.

26. Christian Wolff quoted in Charles Hamm, *Music in the New World* (New York: W. W. Norton, 1983), 606–607.

27. John Arthur Maynard, *Venice West: The Beat Generation in Southern California* (New Brunswick, N.J.: Rutgers University Press, 1991), 192.

28. Allan Kaprow quoted in, "Jackson Pollock: An Artists' Symposium, Part 1," *Art News*, April 1967, 33.

29. Robert Rauschenberg quoted in Calvin Tomkins, *The Bride and the Bachelors* (Harmondsworth, U.K.: Penguin, 1965), 210. Cage, *Silence*, 12. La Monte Young quoted in H. Wiley Hitchcock, *Music in the United States*, 2d ed. (Englewood Cliffs, N.J.: Prentice-Hall, 1974), 273.

30. Maynard, *Venice West*, 12. Lawrence Lipton, *The Holy Barbarians* (New York: Julien Messner, 1959), 166–170.

31. Cage, *Silence*, 65.

32. Allan Kaprow quoted in Irving Sandler, "In the Art Galleries," *New York Post*, 16 June 1963, magazine section, 14.

33. Mary Emma Harris, *The Arts at Black Mountain College* (Cambridge: M.I.T. Press, 1987), 226–228. Richard Kostelanetz, *Conversing with Cage* (New York: Limelight Editions, 1988), 103–105.

34. Allan Kaprow quoted in "Jackson Pollock: An Artists' Symposium," 60. Allan Kaprow, "'Happenings' in the New York Art Scene," *Art News*, May 1961, 39.

35. George Brecht, "Motor Vehicle Sundown (Event)," and La Monte Young, "Composition 1960 # 3," both in La Monte Young, ed., *An Anthology: Chance Operations/ Concept Art/ Meaningless Work/ Natural Disasters/ Indeterminancy/ Anti-Art/ Plans of Action/ Improvisation/ Stories/ Compositions/ Mathematics/ Music* (New York: Heiner Friedrich, 1963), n.p.

36. Kaprow, "'Happenings,'" 60, 61.

37. Frank Stella quoted in Barbara Rose, ed., *Readings in American Art: 1900–1975* (New York: Praeger, 1975), 173. Marvin Cohen, "What Is the Real, Really? . . ." in Charles Russell, ed., *The Avant-Garde Today: An International Anthology* (Urbana: University of Illinois Press, 1981), 111; and see Russell's analysis, 101–104. Robert Indiana quoted in John Russell and Suzi Gablik, *Pop Art Redefined* (New York: Praeger, 1969), 81.

38. Jim Dine quoted in Russell and Gablik, *Pop Art Redefined*, 63.

NOTES TO CHAPTER 6

1. Horace Schwartz quoted in Anthony Linick, "A History of the American Literary 'Avant-Garde' Since World War II" (Ph.D. diss., University of California, Los Angeles, 1965), 293–294. Leslie Woolf Hedley quoted in ibid., 84.

2. Gary Snyder, "Buddhist Anarchism," *Journal for the Protection of All Beings* 1 (1961): 11. Jack Kerouac, *On the Road* (New York: Viking, 1957), 124.

3. Lawrence Barth, "Little Magazines and Tyranny," *Trace*, June 1953, 1.

4. Advertisement for *Inferno* in *Galley*, Spring 1950, 37. William S. Bur-

roughs, *Naked Lunch* (New York: Grove Press, 1959); see, for example, "The Examination" section, 187–197. John Clellon Holmes quoted in John Tytell, *Naked Angels: The Lives and Literature of the Beat Generation* (New York: Grove Press, 1976), 133. Gary Snyder to Allen Ginsberg, 3 June 1956, AGP,SU.

5. Oscar Collier to Judson Crews, [ca. June 1946], JCP.

6. "LeRoi Jones in the East Village," an interview with Amiri Baraka by Debra L. Edwards, in Arthur Knight and Kit Knight, eds., *The Beat Vision: A Primary Source Book* (New York: Paragon House, 1987), 131. Lawrence Barth, "Digging the Roots of Our Chaos," *Miscellaneous Man*, April 1956, 10–13. William S. Burroughs to Jack Kerouac, 1 January 1950, JKP.

7. Joseph Wood Krutch, "Have You Caught On Yet?" *House Beautiful*, November 1951, 221, 270.

8. Irwin Edman, "Art and Freedom," *Art Digest*, 15 April 1951, 22. Rene d'Harnoncourt, "Challenge and Promise: Modern Art and Modern Society," *Magazine of Art* 41 (1948): 252. Aline B. Louchheim, "Cultural Diplomacy: An Art We Neglect," *New York Times Magazine*, 3 January 1954, 16–17.

9. Alfred H. Barr, "Is Modern Art Communistic?" *New York Times Magazine*, 14 December 1952, 22–23. Gilbert Highet, "The Beat Generation," transcript of a radio talk published by the Book-of-the-Month Club, ca. 1958, n.p., in clipping file, AGP,CU.

10. "The U.S. Government Vetoes Living Art," *Art News*, September 1956, 34–35, 54–56.

11. Alfred H. Barr quoted in Eva Cockcroft, "Abstract Expressionism: Weapon of the Cold War," *Artforum*, June 1974, 41.

12. Harold Rosenberg, "The American Action Painters," reprinted in *The Tradition of the New* (New York: McGraw-Hill, 1965.), 23–39. Clement Greenberg, "Introduction," in *Ten Years* (New York: Betty Parsons Gallery, [1955]), n.p., BPP.

13. Leslie A. Fiedler, "The State of American Writing," *Partisan Review* 15 (1948): 875. S. E. M., "Opinion," *Trace*, June 1953, 15. See also Walter Gropius, "The Necessity of the Artist in a Democratic Society," *Arts and Architecture*, December 1955, 16–17. These concerns pre-date the Cold War, of course; see Robert Motherwell, "The Modern Painter's World," originally published in *Dyn* in 1944 and reprinted in Barbara Rose, ed., *Readings in American Art: 1900–1975* (New York: Praeger, 1975), 105; and Samuel M. Kootz, *New Frontiers in American Painting* (New York: Architectural Books Publishing, 1943), 3–9, especially 7.

NOTES TO CHAPTER 7

1. Throughout this work I have used the term "culture" in the broad, anthropological sense. In this chapter I must use the term in the narrower sense of artistic and intellectual activity.

2. Kenneth Rexroth, *Bird in the Bush* (New York: New Directions, 1959), 95. S. M. K. [Samuel M. Kootz], *Recent Paintings by Baziotes* (New York: Samuel M. Kootz Gallery, 1948), n.p., WBP.

3. Harry Partch, *Genesis of a Music* (Madison: University of Wisconsin, 1949), xi, 52.

4. Gerald Reitlinger, *The Economics of Taste: The Rise and Fall of Picture Prices, 1760–1960*, vol. 1 (London: Barrie and Rockliff, 1961), 410–411.

5. Alfred H. Barr, introduction to Peggy Guggenheim, *Confessions of an Art Addict* (New York: Macmillan, 1960), 12. *The New American Painting and Sculpture: The First Generation* (New York: Museum of Modern Art, 1969), n.p., exhibition checklist in WBP.

6. Marcia Bystryn, "Art Galleries as Gatekeepers: The Case of the Abstract Expressionists," *Social Research* 45 (1978): 402–407.

7. Bradford R. Collins, "Clement Greenberg and the Search for Abstract Expressionism's Successor: A Study in the Manipulation of Avant-Garde Consciousness," *Arts Magazine*, May 1987, 36–43. Greenberg's catalog essay for *Post-Painterly Abstraction* is abridged in Barbara Rose, ed., *Readings in American Art: 1900–1975* (New York: Praeger, 1975), 158–161.

8. Sophy Burnham, *The Art Crowd* (New York: David McKay, 1973), 361. Reitlinger, *Economics of Taste*, 236–237. The increase in value of Willem de Kooning's paintings from the 1950s through the 1980s (in part through the promotional efforts of his wife, Elaine) is discussed in Lee Hall, *Elaine and Bill, Portrait of a Marriage: The Lives of Willem and Elaine de Kooning* (New York: HarperCollins, 1993), 264–278.

9. *The Reminiscences of Robert Motherwell* (1977), 38, in the Oral History Collection of Columbia University. Guggenheim, *Confessions of an Art Addict*, 171–172. Kenneth Sawyer, "The Importance of a Wall: Galleries," *Evergreen Review*, Spring 1959, 122–135.

10. Tom Wolfe, *The Pump House Gang* (New York: Farrar, Straus, and Giroux, 1968), 173–203. Frank O'Hara, "How to Proceed in the Arts," *Art Chronicles: 1954–1966* (New York: George Braziller, 1975), 94.

11. Partch, *Genesis of a Music*, xi, xiv.

12. The statistics for academic growth come from Lewis Perry, *Intellectual Life in America: A History* (Chicago: University of Chicago Press, 1984), 435; see also 433–443. Irving Howe, "This Age of Conformity," *Partisan Review* 21 (1954): 26. R. P. Blackmur, "State of American Writing," *Partisan Review* 15 (1948): 864.

13. Michael Fraenkel, "Note on Death," *Death*, Summer 1946, 61. Robert Creeley quoted in Thomas Hill Schaup, *American Fiction in the Cold War* (Madison: University of Wisconsin Press, 1991), 51.

14. Leslie Woolf Hedley, "Interview," *Coastlines*, Summer 1956, 31–32. "Announcement of Hafaz Fellowships," *Yugen*, no. 5 (1959): 13. "Award," *The Sixties*, Fall 1960, 62.

15. Lawrence Ferlinghetti, "Young Poets Read at West Coast Poetry Center," *Intro Bulletin*, March–April 1956, n.p. Jack Kerouac, *Dharma Bums* (New York: New American Library, 1958), 32–33. Rexroth, *Bird in the Bush*, 99.

16. Harold Taylor, "Symposium Statement," *Arts in Society* 3 (1966): 456–458 and 510–523.

17. Catherine Mary Cameron, "Dialectics in the Arts: Composer Ideologies

and Culture Change" (Ph.D. diss., University of Illinois at Urbana-Champaign, 1982), 106–135. For a description of *HPSCHD*, see Virgil Thomson, *Twentieth Century Composers: American Music Since 1910* (New York: Holt, Rinehart and Winston, 1971), 67–68. Barbara C. Phillips Farley, "A History of the Center for New Music at the University of Iowa, 1966–1991" (Ph.D. diss., University of Iowa, 1991).

18. Alvin Toffler, *The Culture Consumers: A Study of Art and Affluence in America* (New York: St. Martin's, 1964), 71–91. Artist in residency programs are discussed in "The University as Cultural Leader," *Arts in Society* 3 (1966): 478–490.

19. Robert O. Bowen, "The Writer at the University," *Inland,* Winter 1960, 21–27. Richard Kostelanetz, *Master Minds: Portraits of Contemporary Artists and Intellectuals* (New York: Macmillan, 1969), 11. Kenneth Rexroth, *American Poetry in the Twentieth Century* (New York: Herder and Herder, 1971), 140–141.

20. Milton Babbitt, "Who Cares If You Listen," reprinted in Gilbert Chase, ed., *The American Composer Speaks* (Baton Rouge: Louisiana State University Press, 1966), 235–244, quotation on 242. Richard Maxfield, "Composers, Performance and Publication," in Elliott Schwartz and Barney Childs, eds., *Contemporary Composers on Contemporary Music* (New York: Holt, Rinehart and Winston, 1967), 353. Martin Brody, " 'Music for the Masses': Milton Babbitt's Cold War Music Theory," *Musical Quarterly* 7 (1993): 161–192.

21. Oliver Andrews interviewed by George M. Goodwin, "Los Angeles Art Community: Group Portrait" (Los Angeles: Oral History Program, University of California, Los Angeles, 1977), 137–138.

22. The statistics for the 1920s are from Lewis Coser, *Men of Ideas* (New York: Free Press, 1965), 269. Coser also notes that 40 percent of contributors to little magazines in the 1950s were from universities. However, these figures do not accurately represent the avant garde because of changes in the nature of little magazines during this time. The growth of academic quarterlies and other establishment reviews in the decades since the 1920s, and especially in the 1940s and 1950s, has made the designation "little magazine" less precise than it was in the first decades of the century. Journals such as *The Antioch Review* (1941–) and the *Hudson Review* (1948–) are typically described as little magazines but are hardly comparable to avant-garde publications such as *Suck-Egg Mule* (1951–1952) and *Fuck You* (1962–1965). The Allen anthology, *The New American Poetry,* is more representative of the avant-garde movement, and the poets included were primarily contributors to independent and ephemeral little magazines who rarely published in academic quarterlies at this time. The occupations of contributors can be found in the biographical statements in Donald M. Allen, ed., *New American Poetry* (New York: Grove Press, 1960), 427–445; and Donald Allen and George F. Buttrick, eds., *The Postmoderns: The New American Poetry Revised* (New York: Grove Press, 1982), 381–436. I have computed statistics for the 1960s through the 1980s using the biographical information in the following anthologies: Richard Kostelanetz, ed., *A Critical (Ninth) Assembling* (New York: Assembling Press, 1979); Morty Sklar and Jim Mulac, eds., *Editor's Choice: Literature and Graphics from the U.S. Small Presses, 1865–1977* (Iowa City, Iowa: The Spirit That Moves

Us Press, 1980); Bill Henderson, *The Pushcart Prize: The Best of the Small Presses* (Yonkers, N.Y.: Pushcart Press), vols. 1 (1976); 9 (1984–1985); and 16 (1991–1992).

23. Andrews, "Los Angeles Art Community," 36–37.

24. Morton Feldman quoted in Kostelanetz, *Master Minds*, 233. "Morton Feldman," H. Wiley Hitchcock and Stanley Sadie, eds., *New Grove Dictionary of American Music* (London: Macmillan, 1986), 108. Irving Howe, *A Margin of Hope: An Intellectual Autobiography* (New York: Harcourt, Brace, Jovanovich, 1982), 288–289, 321. Linda Hamalian, *A Life of Kenneth Rexroth* (New York: W. W. Norton, 1991), 330–334.

25. The phrase "knowledge-industrial complex" comes from Edmund Fawcett and Tony Thomas, *The American Condition* (New York: Harper and Row, 1982), 308.

26. The unnamed poet is quoted in Dore Ashton, "What Is 'Avant Garde'?" *Art Digest*, 15 September 1955, 8. John Ferren, "Epitaph for an Avant Garde," *Arts*, November 1958, 26. Thomas Albright, *Art in the San Francisco Bay Area, 1945–1980: An Illustrated History* (Berkeley: University of California Press, 1985), 126.

27. Judith Adler, "Innovative Art and Obsolescent Artists," *Social Research*, 42 (1975): passim; quotation on 375.

NOTES TO CHAPTER 8

1. John Keats quoted in Colin Campbell, *The Romantic Ethic and the Spirit of Modern Consumerism* (Oxford: Basil Blackwell, 1987), 58.

2. John Patrick Diggins, *The Proud Decades: America in War and Peace, 1941–1960 (New York: W. W. Norton, 1988)*. Walter Lippmann quoted in William H. Chafe, *The Unfinished Journey: America since World War II* (New York: Oxford University Press, 1986), 111–112.

3. David Riesman, Nathan Glazer, and Reuel Denney, *The Lonely Crowd: A Study of the Changing American Character* (New Haven: Yale University Press, 1950). William Whyte, Jr., *The Organization Man* (New York: Simon and Schuster, 1956).

4. The phrase "problems of prosperity" is from Richard H. Pells, *The Liberal Mind in a Conservative Age: American Intellectuals in the 1940s and 1950s* (New York: Harper and Row, 1985), 188. Joseph A. Barry, "Free Taste: The American Style of the Future," *House Beautiful*, October 1952, 176–180, 228, 230, 232.

5. The citations in this paragraph are from *House Beautiful*, October 1952: Elizabeth Gordon, "The New Taste Trend," 174–175; Joseph Wood Krutch, "How to Develop Taste Discrimination," 226; editorial, "What Is Happening to American Taste?" 173; Elizabeth Gordon, "The Editor's Forecast of the New Taste Cycle," 183.

6. Horace Schwartz, "Reflections on the Contemporary American Situation," *Goad*, Summer, 1951, 7–8. Parker Tyler, *Ted Bradley: Paintings* (New York: Art of This Century, 1945), n.p. Gary Snyder, "Buddhist Anarchism," *Journal for the Protection of All Beings* 1 (1961): 11.

7. James Boyer May, *Twigs as Varied Bent* (Corona, N.Y.: Sparrow Magazine, 1954), 8.

8. Clyfford Still to Betty Parsons, 10 March 1948, BPP. Harry Partch, *Genesis of a Music* (Madison: University of Wisconsin Press, 1949), 48. Gregory Corso quoted in Anthony Linick, "A History of the American Literary 'Avant Garde' since World War II," (Ph.D. diss., University of California, Los Angeles, 1965), 422.

9. Wendell Anderson to Judson C. Crews, 28 August 1945, JCP. Allen Ginsberg to Louis Ginsberg, 30 November 1957, in Ann Charters, ed., *Scenes Along the Road: Photographs of the Desolation Angels, 1944–1960* (New York: Portents/ Gotham Bookmart, 1970), 40.

10. David Koven quoted in Linick, "American Literary Avant-Garde," 148. Jay Waite quoted in ibid., 65.

11. Interview with Gary Snyder, "Moving the World a Millionth of an Inch: Gary Snyder," in Arthur Knight and Kit Knight, eds., *The Beat Vision: A Primary Source Book* (New York: Paragon House, 1987), 10. Jay Waite quoted in Linick, "American Literary Avant-Garde," 65. Christopher Maclaine quoted in ibid., 287.

12. Earnest Calkins quoted in Roland Marchand, *Advertising the American Dream: Making Way for Modernity, 1920–1940* (Berkeley: University of California Press, 1985), 146.

13. Walter Paepcke quoted in James Sloan Allen, *The Romance of Commerce and Culture: Capitalism, Modernism, and the Chicago-Aspen Crusade for Cultural Reform* (Chicago: University of Chicago Press, 1983), 29; writer in *Harper's* quoted on 31. Walter Abell, "Industry and Painting," *Magazine of Art* 39 (1946): 82–93.

14. John Cage quoted in Alvin H. Reiss, *Culture and Company* (New York: Twayne, 1972), 95–96.

15. Stephanie French, *Philip Morris and the Arts: 25 Year Report* (New York: Philip Morris, Inc., [1983]), 8–9.

16. Reeves Lewenthal quoted in Erika Doss, "Catering to Consumerism: Associated American Artists and the Marketing of Modern Art, 1934–1958," *Winterthur Portfolio* 26 (1991): 143–144.

17. Ad Reinhardt quoted in Barbara Rose, ed., *Readings in American Art: 1900–1975* (New York: Praeger, 1975), 139.

18. Neil Postman, *Amusing Ourselves to Death: Public Discourse in the Age of Show Business* (Harmondsworth, U.K.: Penguin Books, 1986), 64–80.

19. Daniel J. Boorstin, *The Image: A Guide to Pseudo-Events in America* (New York: Atheneum, 1972), 45–76.

20. "A *Life* Round Table on Modern Art," *Life*, 11 October 1948, 62. "Jackson Pollock: Is He the Greatest Living Painter in the United States?" *Life*, 8 August 1949, 92–94.

21. "The Wild Ones," *Time*, 20 February 1956, 70–75. George Segal quoted in Ellen G. Landau, *Jackson Pollock* (New York: Harry N. Abrams, 1989), 17.

22. Philip Fisher, *Making and Effacing Art: Modern American Art in a Culture of Museums* (New York: Oxford University Press, 1989), 48.

23. Dick Hebdige, *Hiding in the Light: On Images and Things* (London: Routledge, 1988), 118–119. Helen A. Harrison, *Larry Rivers* (New York: Harper

and Row, 1984), 73, 97, 107. Norman Podhoretz, "Norman Mailer: The Embattled Vision," *Partisan Review* 26 (1959): 377. Advertisement for the Five Spot Cafe, *Yugen*, no. 3, (1958): inside cover.

24. Andy Warhol quoted in Robert Hughes, "The Rise of Andy Warhol," *New York Review of Books*, 18 February 1982, 7. Andy Warhol, *The Philosophy of Andy Warhol (From A to B and Back Again)* (San Diego: Harcourt Brace Jovanovich, 1975), 182–183.

25. Kynaston McShine, "Introduction," in McShine, ed., *Andy Warhol: A Retrospective* (New York: Museum of Modern Art, 1989), 14.

26. Robert Rosenblum, "Warhol as Art History," in McShine, ed., *Warhol*, 34–35; and McShine, "Introduction," in ibid., 14.

27. Advertisement quoted in Patrick S. Smith, *Andy Warhol's Art and Films* (Ann Arbor, Mich.: UMI Research Press, 1986), 167. R. Bolton, "Enlightened Self-Interest: The Avant Garde in the 80s," *Afterimage*, February 1989, 16. Gregory Battcock, "The Warhol Generation," in *The New Art: A Critical Anthology*, 2d ed. (New York: E.P. Dutton, 1973), 25. The promotion continues after Warhol's death through the Andy Warhol Musuem in Pittsburgh; see Donald Garfield, "Warhol's Starship Enterprise," *Museum News*, May-June 1994, 44–47.

28. Harry Russell Huebel Jr., "The Beat Generation and the Bohemian Left Tradition in America" (Ph.D. diss., Washington State University, 1970), 29–37, Gene Bara quoted on 35–36. Leslie Cross, "California 'Beat' Renaissance," *Milwaukee Journal*, 16 June 1957, n.p., KRP.

29. Norman Podhoretz, "The Know-Nothing Bohemians," *Partisan Review* 25 (1958): 305–318. "Fried Shoes," *Time*, 9 February 1959, 16. Corso's hair is mentioned in the *Time* article and in Paul O'Neil, "The Only Rebellion Around," *Life*, 30 November 1959, 123, from which the quote is taken.

30. O'Neil, "The Only Rebellion Around," 114. For a similar stereotypical recreation, this time featuring Gloria Vanderbilt and Truman Capote posing as jaded beatniks, see "Fads of the Fifties," *Look*, 2 February 1960, 85. Francis Joseph Rigney and L. Douglas Smith, *The Real Bohemia: A Sociological and Psychological Study of the "Beats"* (New York: Basic Books, 1961), 156. "There Are Also 'Zen Beatniks' Western-Style in Japan," *Look*, 10 September 1963, 28. Gary Snyder to Lawrence Ferlinghetti, 29 August [1960], CLBR. John Arthur Maynard, *Venice West: The Beat Generation in Southern California* (New Brunswick, N.J.: Rutgers University Press, 1991), 5, 127–130.

31. Gene Frumkin, "The Great Promoter: A Hangnail Sketch of Lawrence Lipton," *Coastlines*, Autumn 1959, 7. O'Neil, "The Only Rebellion Around," 235. Ronald Sukenick, *Down and In: Life in the Underground* (New York: Beechtree Books, 1987), 118–119. Roy Carr, Brian Cass, and Fred Dellor, *The Hip: Hipsters, Jazz and the Beat Generation* (London: Faber and Faber, 1986), 39–41, 56, 106. John Ashberry quoted in Marjorie Perloff, *Frank O'Hara: Poet among Painters* (Austin: University of Texas Press, 1977), 12.

32. Lawrence Lipton, *The Holy Barbarians* (New York: Julien Messner, 1959).

33. Lipton quoted in Maynard, *Venice West*, 23.

34. Lipton's poem quoted in ibid., 41.

35. Lipton, *Holy Barbarians*, 263–264. Sukenick, *Down and In*, 170.

36. John Cage, *Silence: Lectures and Writings* (Middletown, Conn.: Wesleyan University Press, 1961), 269. Joyce Glassman to Allen Ginsberg and Peter Orlovsky, 28 October 1957, POP.

37. Wes Whittlesey, "Notes from the Village," *White Dove Review* 1, no. 2 (1959): n.p. Stuart Z. Perkoff Journal, [October 1959], SPP.

38. Maynard, *Venice West*, 20.

39. "Jackson Pollock's Abstractions," *Vogue*, 1 March 1951, 156–159. Lee Hall, *Betty Parsons: Artist, Dealer, Collector* (New York: Harry N. Abrams, 1991), 100.

40. Eric Hodgins and Parker Lesley, "The Great International Art Market," *Fortune*, December 1955, 118–120, 150, 152, 157–158, 162, 169. "A Boom in U.S. Art Abroad," *Life*, 19 May 1958, 76.

41. Donal Henahan, "Experiments in Movement: Merce Cunningham," *Saturday Evening Post*, 19 October 1968, 40–45.

42. "A Boom in U.S. Art Abroad," 76. Cage's spread in *Life*, 15 March 1943, is reprinted in Richard Kostelanetz, ed., *John Cage* (New York: Praeger, 1970), illustrations 7–16. "Sonata for Bolt and Screw," *Time*, 24 January 1949, 36; "A Way to Kill Space," *Newsweek*, 12 August 1946, 106. "Speaking of Pictures: All of This Nonsense Is Known as 'Collage,' " *Life*, 6 September 1943, 10–12. Edward Alden Jewell, "Abstraction Now Rampant," *New York Times*, 19 March 1944, sec. 2, p. 7.

43. Alfredo Valente, "Adolph Gottlieb," *Promenade*, February 1949, 40. "The Wild Ones," 75. "A Spirited Survey of U.S. Painting," *Life*, 11 November 1957, 72–73. The article is a promotion for a *Time* publication, *Three Hundred Years of American Painting* by *Time* art editor Alexander Eliot. John Kobler, "Experiments in Music: John Cage," *Saturday Evening Post*, 19 October 1968, 46–47.

44. [Whipple McCoy], "Little Magazine Advertising," *Galley*, Summer 1949, 3. See also Roy A. Squires, "Effective Advertising," *Galley*, Summer 1950, 7–8. Walter De Maria, "Art Yard," in La Monte Young, ed., *An Anthology of Chance Operations* (New York: Heiner Friedrich, 1963), n.p.

45. Advertisement, *Show*, August 1964, 101. Thomas Hess quoted in Irving Sandler, *The New York School: The Painters and Sculptors of the Fifties* (New York: Harper and Row, 1978), 293.

46. Laszlo Moholy-Nagy, *Vision in Motion* (Chicago: Paul Theobald, 1947), 5–6, 33–34. Robert Jay Wolff, "We Can Try," *Trans/formation* 1 (1951): 83.

47. Sara Little, "Free Taste and Your Dining Table," *House Beautiful*, October 1952, 321–323. Advertisement for John Stuart Inc. *Art in America* 51 (1963): 15.

48. Moholy-Nagy, *Vision in Motion*, 62. C. Wright Mills, "Man in the Middle: The Designer," in *Power, Politics and People: The Collected Essays of C. Wright Mills*, ed. Irving Louis Horowitz (New York: Oxford University Press, 1963), 374–386. Oliver Andrews interviewed by George M. Goodwin, "Los Angeles Art Community: Group Portrait" (Los Angeles: Oral History Program, University of California, Los Angeles, 1977), 69. Alvin Toffler, *Culture Consumers: A Study of Art and Affluence in America* (New York: St. Martin's Press, 1964), 37–38, 51–52.

49. Richard Kostelanetz, ed., *Conversations with Cage* (New York: Limelight Editions, 1988), 199. William Flanagan quoted in Gilbert Chase, ed., *The American Composer Speaks* (Baton Rouge: Louisiana State University Press, 1966), 266.

50. Paul Brach quoted in Rose, *Readings in American Art,* 191. Donald M. Allen, ed., *The New American Poetry* (New York: Grove Press, 1960), 12–14. An indication of the aesthetic debate among writers can be found in Ellen Edelman, "Prognosis for Little Magazines," *Trace,* June 1954, 3–6; and [James Boyer May], "Replies to Prognosis," *Trace,* October 1954, 3–8. Sonya Rudikoff, "Tangible Abstract Art," *Partisan Review* 24 (1957): 276.

51. Gregory Corso to Lawrence Ferlinghetti, [ca. 20 September 1962], CLBR. Irving Howe to Dwight Macdonald, 15 August [1946], DMacdP. Compare Harold Rosenberg's critique of Herbert Read's *The Philosophy of Modern Art* in Rosenberg, *The Tradition of the New* (New York: McGraw-Hill, 1965), 81–82.

52. David Park quoted in Thomas Carr Howe, foreword to *David Park: Recent Paintings* (New York: Staempfli Gallery, 1959), n.p. Kostelanetz, *John Cage,* 24–25. Harold Rosenberg, "The Avant-Garde," in *Discovering the Present: Three Decades in Art, Culture, and Politics* (Chicago: University of Chicago Press, 1973), 86.

53. Peter N. Stearns, *American Cool: Constructing a Twentieth Century Emotional Style* (New York: New York University Press, 1994), 264–284.

54. Robert Duncan to Robin Blaser, 30 April 1957, REDP. [Daniel Banko and William V. Ward], "To Believe," *Provincetown Quarterly* 1 (Summer 1958): 1. Donald Judd quoted in Rose, *Readings in American Art,* 178–179. Robert Morris quoted in ibid., 212–214. Robert Indiana quoted in John Russell and Suzi Gablik, eds., *Pop Art Redefined* (New York: Praeger, 1969), 80.

55. Barbara Ehrenreich, *Fear of Falling: The Inner Life of the Middle Class* (New York: Pantheon, 1989), 173–182. The quote is from John D'Emilio and Estelle B. Freedman, *Intimate Matters: A History of Sexuality in America* (New York: Harper and Row, 1988), 305. Casey Nelson Blake points out, in the context of the early twentieth-century van, that the consumer culture was not the only alternative to Victorian gentility; see Blake, *Beloved Community: The Cultural Criticism of Randolph Bourne, Van Wyck Brooks, Waldo Frank, and Lewis Mumford* (Chapel Hill: University of North Carolina Press, 1990), 7–8.

56. David Boroff, "The College Intellectual, 1965 Model," *New York Times Magazine,* 6 December 1964, 37.

NOTES TO CHAPTER 9

1. Jürgen Habermas's 1980 lecture on winning the Adorno Prize can be found, under the title "Modernism—An Incomplete Project," in Hal Foster, ed., *The Anti-Aesthetic: Essays on Postmodern Culture* (Port Townshend, Wa.: Bay Press, 1983), 6.

2. Daniel Moore quoted in Mohammed Khan, "Floating Lotus," *Berkeley Barb,* 26 September–2 October 1969, 4.

3. The underground journalist is quoted in Godfrey Hodgson, *America in Our Time* (New York: Vintage Books, 1978), 340.

4. Don Carpenter to Philip Whalen, 10 November 1966, PWP. Sally Banes, *Greenwich Village 1963: Avant-Garde Performance and Effervescent Body* (Durham, N.C.: Duke University Press, 1993), 7–10; quote on 7.

5. The political art of the 1960s is discussed in Jeanne Siegel, *Artwords:*

Discourse on the 60s and 70s (Ann Arbor, Mich.: UMI Research Press, 1985), 86–119; the New York Art Strike is discussed on 139. Robert Hughes, "The Arcadian as Utopian," *Time*, 24 January 1983, 77. The ROCI project is discussed in Mary Lynn Kotz, *Rauschenberg: Art and Life* (New York: Harry N. Abrams, 1990), 19–43.

6. The discussion on business and the arts in this and the following paragraphs is based on R. Bolton, "Enlightened Self-Interest: The Avant Garde in the 80s," *Afterimage*, February 1989, 12–18; Gideon Chagy, ed., *The State of the Arts and Corporate Support* (New York: P. S. Eriksson, 1971); Gideon Chagy, *The New Patrons of the Arts* (New York: Harry N. Abrams, [1973]); Alvin H. Reiss, *Culture and Company* (New York: Twayne, 1972), 99–105; and Herbert I. Shiller, *Culture, Inc.: The Corporate Takeover of Public Expression* (New York: Oxford University Press, 1989), 91–98, the oil executive is quoted on 92.

7. Quote from BCA survey in Chagy, *State of the Arts*, 36, chart 7. William Blount quoted in Bolton, "Enlightened Self-Interest," 13.

8. The Cunningham ad is reproduced in Chagy, *State of the Arts*, 64. Lynn Sounder quoted in Bolton, "Enlightened Self-Interest," 15.

9. The development of arts councils is discussed in Alvin Toffler, *The Culture Consumers: A Study in Art and Affluence in America* (New York: St. Martin's Press, 1964), 109–126. The NEA and NEH are discussed in Kevin V. Mulcahy, "Government and the Arts in the United States," in Milton C. Cummings, Jr., and Richard S. Katz, eds., *The Patron State: Government and the Arts in Europe, North America, and Japan* (New York: Oxford University Press, 1987), 311–322. The CCLM and controversies surrounding it are discussed in Elliott Anderson and Mary Kinzie, eds., *The Little Magazine in America: A Modern Documentary History* (Yonkers, N.Y.: Pushcart Book Press, 1978), 9–10, 15–21, 652–654.

10. Anderson and Kinzie, *The Little Magazine in America*, 346–350. Ted Morgan, *Literary Outlaw: The Life and Times of William S. Burroughs* (New York: Henry Holt, 1988), 1–13.

11. Nicholas E. Tawa, *A Most Wondrous Babble: American Art Composers, Their Music, and the American Scene, 1950–1985* (New York: Greenwood Press, 1987). Richard Kostelanetz, "Innovative Literature in America," in Kostelanetz, ed., *The Avant-Garde Tradition in Literature* (Buffalo: Prometheus Books, 1982), 393.

12. Judy Chicago, *Through the Flower: My Struggle as a Woman Artist* (New York: Anchor Books, 1977), 62–63, 128–129.

13. Yvonne Rainer, "Looking Myself in the Mouth," *October* 17 (1981): 67–68. See also Yvonne Rainer, *Work: 1961–1973* (Halifax: Press of the Nova Scotia College of Art and Design, 1974).

14. Henry M. Sayre, *The Object of Performance: The American Avant-Garde since 1970* (Chicago: University of Chicago Press, 1989), 87 and figure 33 on 89. Carolee Schneemann, *More Than Meat Joy: Complete Performance Works and Selected Writings*, ed. Bruce McPherson (New Paltz, N.Y.: Documentext, 1979), 234–239. Judy Chicago, *The Dinner Party* (Garden City, N.Y.: Anchor Books, 1979). Judy Chicago, *The Dinner Party Needlework* (Garden City, N.Y.: Anchor Books, 1980). Pauline Oliveros's work is discussed in Walter Zimmermann, ed., *Desert Plants: Conversations with Twenty-Three American Musicians* (Vancouver: Aes-

thetics Research Center, 1976), 165–182. See also the interviews with Laurie Anderson, Jenny Holzer, Barbara Kruger, and Cindy Sherman in Jeanne Siegel, *Artwords 2: Discourse on the Early 80's* (Ann Arbor, Mich.: UMI Research Press, 1988).

15. Richard Kostelanetz, a stalwart advocate of avant gardism, makes just this argument against the feminist art movement; see his *Dictionary of the Avant-Gardes* (Pennington, N.J.: A Cappella Books, 1993), xiii-xvi, 135. David A. Hollinger, "How Wide the Circle of 'We'? American Intellectuals and the Problem of the Ethnos since World War II," *American Historical Review* 98 (1993): 317–337.

16. Howard N. Fox, *Avant-Garde in the Eighties* (Los Angeles: Los Angeles County Museum of Art, 1987), 238.

17. Schneemann, *More Than Meat Joy*, 6. Zimmermann, *Desert Plants*, 174. Kathy Halbreich, ed., *Culture and Commentary: An Eighties Perspective* (Washington, D.C.: Hirshhorn Museum and Sculpture Garden, 1990). Feminist art could also be profitable: Walter B. Kalaidjian describes Jenny Holzer's economic success in *American Culture between the Wars: Revisionary Modernism and Postmodern Critique* (New York: Columbia University Press, 1993), 236–237.

18. These events are chronicled in the *New York Times*; see 30 June 1990, sec. I, 1; 1 July 1990, sec. I, 14; 12 July 1990, sec. C, 12; 24 July 1990, sec. C, 12. John E. Frohnmayer defended his agency in "Ultimate Expression: Government and the Arts," *Christian Century* 109 (1992): 518, 521.

19. Martha Wilson is quoted from Richard Bernstein, "Why the Cutting Edge Has Lost Its Bite," *New York Times*, 30 September 1990, sec. 2, 30. James Davison Hunter, *Culture Wars: The Struggle to Define America* (New York: Basic Books, 1991), 225–249; and Daniel Bell, "The Culture Wars: American Intellectual Life, 1965–1992," *Wilson Quarterly*, Summer 1992, 74–107.

20. Olga Garay quoted in "Budget Cuts Leave NEA Unable to Provide Steady Support to Colleges," *Chronicle of Higher Education*, 27 July 1994, A23. Timothy Ferris, "When Science Is the Star," *New York Times*, 16 August 1992, 11.

21. Charles R. Simpson, *SoHo: The Artist in the City* (Chicago: University of Chicago Press, 1981), 226–229. Bolton, "Enlightened Self-Interest," 18 n. 26. Jo-Anne Berelowitz, "L. A. Stories: Of Art, MOCA, Myths, and City Building" (Ph.D. diss., University of California, Los Angeles, 1991). Ian Burn, "The Art Market: Affluence and Degradation," in Amy Baker Sandback, ed., *Looking Critically: 21 Years of Artforum Magazine* (Ann Arbor, Mich.: UMI Research Press, 1984), 173–176 (originally published in 1975).

22. The statement of purpose and description of John Cage are from the brochure *An Intersection in Space, Time and the Arts* (Columbus, Ohio: Wexner Center for the Arts, 1989), n.p. The first series of exhibitions at the Wexner Center are described in *Breakthroughs: Avant-Garde Artists in Europe and America, 1950–1990* (New York: Rizzoli, 1991); and in calendars for November 1989 through November 1990, in the author's collection. "Dedication of Wexner Center Gala Event," *Ohio State University Lantern*, 17 November 1989, 6.

23. Hilton Kramer, "The Wexner Center in Columbus," *New Criterion*, December 1989, 5–9.

24. Writer in *Public Relations Journal* quoted in Bolton, "Enlightened-Self Interest," 13.

25. Jasper Johns quoted in John Russell and Suzi Gablik, eds., *Pop Art Redefined* (New York: Praeger, 1969), 82. Raymond Federman, "Surfiction—Four Propositions in the Form of a Manifesto," in Kostelanetz, ed., *Avant Garde Tradition in Literature*, 384. See also Ron Silliman, "If By 'Writing' We Mean Literature (If By 'Literature' We Mean Poetry (If . . .))," $L=A=N=G=U=A=G=E$, October 1979, n.p.

26. Sidra Stich, *Made in the U.S.A.: An Americanization in Modern Art, the '50s and '60s* (Berkeley: University of California Press, 1987), 207.

Bibliographical Essay

·

·

·

The most important sources for this work were the primary ones, especially the more than one hundred avant-garde little magazines and exhibition catalogs and the paper collections that I examined. Those that are quoted directly are cited in the notes.

The secondary sources on the avant garde constitute a vast and growing literature. I cannot claim to have seen all of it, but I have sampled a large portion. This essay is to acknowledge the works, in addition to those cited in the notes, that I found particularly useful in writing this work. (A more fully annotated version of this work is in the collections of the Ohio State University library.)

Of general works on the avant garde, two were particularly helpful to me in formulating my understanding of the movement: Renato Poggioli, *The Theory of the Avant-Garde*, translated by Gerald Fitzgerald (Cambridge: Harvard University Press, 1968); and Peter Bürger, *Theory of the Avant-Garde*, translated by Michael Shaw (Minneapolis: University of Minnesota Press, 1984). Other volumes that I found insightful were Charles Russell, *Poets, Prophets, and Revolutionaries: The Literary Avant Garde from Rimbaud through Postmodernism* (New York: Oxford University Press, 1985); Christopher Butler, *After the Wake: An Essay on the Contemporary Avant-Garde* (Oxford: Oxford University Press, 1980); Matie Calinescu, *Five Faces of Modernity: Modernism, Avant-Garde, Decadence, Kitsch, Postmodernism* (Durham, N.C.: Duke University Press, 1987); Arnold Hauser, *The Sociology of Art*, translated by Kenneth J. Northcott (Chicago: University of Chicago Press, 1982); Frederick J. Hoffman, Charles Allen, and Carolyn F. Ulrich, *The Little Magazine: A History and Bibliography* (Princeton: Princeton University Press, 1946); Albert Parry, *Garrets and*

Pretenders: A History of Bohemianism in America (New York: Covici, Friede, 1933); Emily Hahn, *Romantic Rebels: An Informal History of Bohemia in America* (Boston: Houghton, Mifflin, 1967); and Richard Miller, *Bohemia: The Protoculture Then and Now* (Chicago: Nelson-Hall, 1977).

Memoirs can provide a vivid picture of avant-garde communities. Three different perspectives on the last American vanguard can be found in Dan Wakefield, *New York in the Fifties* (Boston: Houghton Mifflin/ Seymour Lawrence, 1992); Joyce Johnson, *Minor Characters* (Boston: Houghton Mifflin, 1983); and my favorite, the luminous Hettie Jones, *How I Became Hettie Jones* (New York: E. P. Dutton, 1990).

For an excellent discussion of the culture of modernism and the avant garde in an American context, see David Joseph Singal, "Towards a Definition of American Modernism," *American Quarterly* 39 (1987): 7–26, and also the other essays in this issue, which is devoted to American modernism. Other works I found helpful were Hugh Kenner, *A Home-made World: The American Modernist Writers* (New York: William Morrow, 1975); and the essays in Malcolm Bradbury and James McFarlane, eds., *Modernism: 1890–1930* (Harmondsworth, U.K.: Penguin, 1976).

On the postwar American literary avant garde, I found the work of Anthony Linick, Harry Russell Huebel, Jr., James E. B. Breslin, John Tytell, and Michael Davidson, all cited in the notes, to be very informative. A useful bibliography is Morgen Hickey, *The Bohemian Register: An Annotated Bibliography of the Beat Literary Movement* (Metuchen, N.J.: Scarecrow Press, 1990). For individual biographical and literary studies, see the entries in Ann Charters, ed., *The Beats: Literary Bohemians in Postwar America* (Detroit: Gale Research Co., 1983).

On avant-garde painting and sculpture of the postwar years, the works of Irving Sandler, Stephen Polcari, Thomas Albright, and Sidrah Stich cited in the notes are good starting points. Also insightful is Alwynne Mackie, *Art/Talk: Theory and Practice in Abstract Expressionism* (New York: Columbia University Press, 1989). Among works on individual artists, Ellen G. Landau, *Jackson Pollock* (New York: Harry N. Abrams, 1989), is especially good on the construction of Pollock's celebrity, as is Mary Lee Corlett, "Jackson Pollock: American Culture, the Media and the Myth," *Rutgers Art Review* 8 (1987), 71–108. In *Jackson Pollock: An American Saga* (New York: C. N. Potter, 1989), Steven Naifeh and Gregory White Smith perpetuate the media image by reducing Pollock's art to his publicity: the tortured art of a tortured soul. On Robert Rauschenberg, two works stand out: Andrew Forge, *Rauschenberg* (New York: Harry N. Abrams, 1969)

and Judith Bernstock, "A New Interpretation of Rauschenberg's Imagery," *Pantheon* 46 (1988): 149–164. James E. B. Breslin's *Mark Rothko: A Biography* (Chicago: University of Chicago Press, 1993) is a fine study. Biographies are still needed for Robert Motherwell, Clyfford Still, Willem de Kooning, and Barnett Newman. One can only hope they will find as sensitive and engaging a chronicler as Rothko's.

The literature on the innovations of the American musical avant garde is somewhat thinner than on the other topics, but excellent introductions can be found in Michael Nyman, *Experimental Music: Cage and Beyond* (New York: Schirmer, 1975); and Paul Griffiths, *Modern Music: The Avant Garde since 1945* (London: J. M. Dent and Sons, 1981). James Pritchett, *The Music of John Cage* (Cambridge: Cambridge University Press, 1993) is an authoritative study on Cage.

For the debate among historians about history and the linguistic turn, see the essays in the *American Historical Review* 94 (1989), especially David Harlan and David A. Hollinger, pp. 581–621; and Joyce Appleby's response, pp. 1326–1332. See also Dominick LaCapra, "Of Lumpers and Readers," *Intellectual History Newsletter* 10 (1988): 3–10. As the present work reveals, I side with Hollinger in this discussion.

The literatures on American Marxism and Marxism and the arts, the subject of chapter 2, are large and growing. Good starting points are two books by Donald Drew Egbert, *Social Radicalism and the Arts* (New York: Alfred A. Knopf, 1970), cited in the notes, and *Socialism and American Art* (Princeton: Princeton University Press, 1971). For a bibliography of Communism in America, see John Earl Haynes, *Communism and Anti-Communism in the United States: An Annotated Guide to Historical Writings* (New York: Garland, 1987), especially the section on Communist Party organizing activity among American intellectuals, pp. 143–176. Harvey Klehr chronicles the Communist Party during the Red Decade in *The Heyday of American Communism: The Depression Decade* (New York: Basic Books, 1984). Richard H. Pells, *Radical Visions and American Dreams: Culture and Social Thought in the Depression Years* (New York: Harper and Row, 1973), covers the decade well. I found the following overviews of the American left to be useful: Guenter Lewy, *The Cause That Failed: Communism in American Political Life* (New York: Oxford University Press, 1990); David Caute, *The Fellow Travellers: Intellectual Friends of Communism*, 2d ed. (New Haven: Yale University Press, 1988); and Paul Buhle, *Marxism in the United States: Remapping the History of the American Left* (London: Verso, 1987).

The *Partisan Review* and the New York Intellectuals have also gener-
ated a large body of literature. The best recent works on the subject are
Terry A. Cooney, *The Rise of the New York Intellectuals: "Partisan Review"
and Its Circle, 1934–1945* (Madison: University of Wisconsin Press, 1986),
for the period up to 1945; and for the period after World War II, Neil
Jumonville, *Critical Crossings: The New York Intellectuals in Postwar America*
(Berkeley: University of California Press, 1990).

On America in the years after World War II, in addition to insightful
works by William Chafe and Godfrey Hodgson cited in the notes, the
following works influenced my thinking: John Diggins, *The Proud Decades:
America in War and Peace, 1941–1960* (New York: W. W. Norton, 1988)
(Diggins perceptively questions the conformist character of the 1950s);
Barbara Ehrenreich, *Fear of Falling: The Inner Life of the Middle Class* (New
York: Pantheon, 1989); Eric F. Goldman, *The Crucial Decade and After:
America, 1945–1960* (New York: Vintage Books, 1960); W. T. Lhamon,
Jr., *Deliberate Speed: The Origins of a Cultural Style in the American 1950s*
(Washington, D.C.: Smithsonian Institution Press, 1990); several of the
essays in Larry May, ed., *Recasting America: Culture and Politics in the Age
of the Cold War* (Chicago: University of Chicago Press, 1989); and Richard
Polenberg, *One Nation Divisible: Class, Race, and Ethnicity in the United
States since 1938* (Harmondsworth, U.K.: Penguin Books, 1980).

On the bomb and American culture, I found the following works most
helpful: Paul Boyer, *By the Bomb's Early Light: American Thought and
Culture at the Dawn of the Atomic Age* (New York: Pantheon, 1985);
Spencer R. Weart, cited in the notes; and Stephen J. Whitfield, *The
Culture of the Cold War* (Baltimore: Johns Hopkins University Press,
1991).

On avant-garde innovation in the years since 1945, see the works on
the various vanguard movements cited above. In addition, Sally Banes,
Terpsichore in Sneakers: Post-Modern Dance (Boston: Houghton Mifflin,
1980), was informative on dance and music, while Charles Olson's poetics
is discussed extensively in the Charles Olson issue of *Boundary II*, 2
(Fall 1973–Winter 1974). For biographical accounts see Paul Christensen,
Charles Olson: Call Him Ishmael (Austin: University of Texas Press, 1979);
and Robert von Hallberg, *Charles Olson: The Scholar's Art* (Cambridge:
Harvard University Press, 1978).

On the controversy surrounding the politics and political use of the
abstract expressionists, see Serge Guilbaut, *How New York Stole the Idea of
Modern Art: Abstract Expressionism, Freedom, and the Cold War*, translated

by Arthur Goldhammer (Chicago: University of Chicago Press, 1983); Francis Frascina and Serge Guilbaut, eds., *Pollock and After* (New York: Harper and Row, 1985); Peter Fuller, "American Painting since the Last War," in Fuller, *Beyond the Crisis in Art* (London: Writers and Readers Publishing Cooperative Ltd., 1980), 70–97; Max Kozloff, "American Painting during the Cold War," *Artforum*, May 1973, 43–54. For a critical evaluation of these interpretations, see Casey Blake's review of Guilbaut in *Telos* 62 (1984–1985): 211–17; Stephen Polcari, "Abstract Expressionism: 'New and Improved,'" *Art Journal* 47 (1988): 176–178, and the Polcari volume cited above. For a response by Guilbaut, see his review of Polcari's book in *The American Historical Review* 97 (1992): 1491.

On specific issues discussed in chapter 3, see the notes. The following works were also helpful. On jazz, see Lawrence W. Levine, "Jazz and American Culture," *Journal of American Folklore* 102 (1989): 6–22; Richard Palmer, "Jazz: The Betrayed Art," *Journal of American Studies* 23 (1989): 287–294; Lloyd Miller and James Skipper, Jr., "Sounds of Black Protest in Avant-Garde Jazz," in R. Serge Denisoff and Richard A. Peterson, eds., *The Sounds of Social Change* (Chicago: Rand McNally, 1972), 26–37; James Lincoln Collier, *The Making of Jazz: A Comprehensive History* (Boston: Houghton Mifflin, 1978); and Russell Ross, *Bird Lives: The High Life and Hard Times of Charlie (Yardbird) Parker* (New York: Charterhouse, 1973).

The attitudes toward sex held by the first avant garde are discussed in Gilman M. Ostrander, *American Civilization in the First Machine Age, 1890–1940* (New York: Harper and Row, 1970). For the last American vanguard, see Donald Morton, "The Cultural Politics of (Sexual) Knowledge: On the Margins with Goodman," *Social Text* 25–26 (1990): 227–241; and Richard King, *Party of Eros: Radical Social Theory and the Realm of Freedom* (Chapel Hill: University of North Carolina Press, 1972). Wilhelm Reich's ideas and career are discussed in Myron R. Sharaf, *Fury on Earth: A Biography of Wilhelm Reich* (New York: St. Martin's Press, 1983); and George Nemeth, "Freud and Reason or Fraud and Treason: Ezra Pound and Wilhelm Reich: The Trials and Tribulations of Two Famous Mavericks in Postwar America," *Discourse Social/Social Discourse: The International Research Papers in Comparative Literature* 1 (1988): 229–238. On changing attitudes toward sex and drugs, see John C. Burnham, *Bad Habits: Drinking, Smoking, Taking Drugs, Gambling, Sexual Misbehavior, and Swearing in American History* (New York: New York University Press, 1992).

On the influence of primitivism, see W. Jackson Rushing, "The Impact

of Nietzsche and Northwest Coast Indian Art on Barnett Newman's Idea of Redemption in the Abstract Sublime," *Art Journal* 47 (1988): 187–195; Jeffrey Weiss, "Science and Primitivism: A Fearful Symmetry in the Early New York School," *Arts Magazine*, March 1983, 81–87.

The chief sources for Orientalism and the avant garde are the works by Carl Jackson, Margaret Leng Tan, and Michael Davidson cited in the notes. In addition to these and other cited works, see Helen Tworkov, *Zen in America: Profiles of Five Teachers* (San Francisco: North Point Press, 1989); and Sidney Ahlstrom, *A Religious History of the American People* (New Haven: Yale University Press, 1972), 1047–1054.

For intellectual histories of the idea of the future, see Robert L. Heilbroner, *The Future as History* (New York: Grove Press, 1961); and Clarke A. Chambers, "The Belief in Progress in Twentieth-Century America," *Journal of the History of Ideas* 19 (1958): 197–224. On changing attitudes toward the future, see the essays in Gabriel A. Almond, Marvin Chodorow, and Roy Harvey Pearce, eds., *Progress and Its Discontents* (Berkeley: University of California Press, 1982); and Frank Füredi, *Mythical Past, Elusive Future: History and Society in an Anxious Age* (London: Pluto Press, 1992).

On existentialism in America, see Walter Kaufmann, "The Reception of Existentialism in the United States," *Salmagundi* 10–11 (Fall 1969/ Winter 1970): 69–96; and Jason Peter Lowther, "The Reception of Existentialism in the United States, 1930–1950: The Modern American Intellectual, Change, and the School of Thought" (master's thesis, Ohio State University, 1991).

Happenings have generated an extensive literature. See, for example, Adrian Henri, *Total Art: Environments, Happenings, and Performance* (New York: Praeger, 1974); and Pamela A. Lehnert, "An American Happening: Allan Kaprow and a Theory of Process Art" (Ph.D. diss., University of North Carolina at Chapel Hill, 1989).

On the End of the Avant Garde, Paul Mann offers a helpful summary of "obituaries" in *The Theory-Death of the Avant-Garde* (Bloomington: Indiana University Press, 1991). Various facets of the phenomenon are described in James S. Ackerman, "The Demise of the Avant-Garde: Notes on the Sociology of Recent American Art," *Comparative Studies in Society and History* 11 (1969): 371–384; George T. Noszlopy, "The Embourgeoisement of Avant-Garde Art," *Diogenes*, 67 (1969): 83–109; and Suzi Gablik, *Has Modernism Failed?* (New York: Thames and Hudson, 1984). Pluralism without direction is analyzed in Leonard B. Meyer, *Music, the*

Arts, and Ideas: Patterns and Predictions in Twentieth Century Culture (Chicago: University of Chicago Press, 1967). The role of the avant garde in the Cold War is discussed in Jane De Hart Mathews, "Art and Politics in Cold War America," *American Historical Review* 81 (1976): 762–787; Eva Cockcroft, "Abstract Expressionism: Weapon of the Cold War," *Artforum*, June 1974, 39–41; Kathleen McCarthy, "From Cold War to Cultural Development: The International Cultural Activities of the Ford Foundation, 1950–1980," *Daedalus* 116 (1987): 93–117; Christopher Lasch, "The Cultural Cold War: A Short History of the Congress for Cultural Freedom," in Barton Bernstein, ed., *Towards a New Past: Dissenting Essays in American History* (New York: Pantheon, 1968), 322–359; William Hauptman, "The Suppression of Art in the McCarthy Decade," *Artforum*, October 1973, 48–52; Margaret Lynne Ausfield and Virginia M. Mecklenburg, *Advancing American Art: Politics and Aesthetics in the State Department Exhibition, 1946–1948: Essays* (Montgomery, Ala.: Montgomery Museum of Fine Arts, 1984); and James D. Herbert, "The Political Origins of Abstract-Expressionist Art Criticism," *Telos*, Winter 1984–1985, 178–187. Frank Kofsky, *Black Nationalism and the Revolution in Music* (New York: Pathfinder Press, 1970), discusses the use of jazz.

For a summary of the growth of the New York art world, see Diana Crane, *The Transformation of the Avant-Garde: The New York Art World, 1940–1985* (Chicago: University of Chicago Press, 1987). The role of galleries and museums as gatekeepers and promoters is discussed in a diverse literature, including Russell Lynes, *The Tastemakers* (New York: Harper and Row, 1954); Neil Harris, "Museums, Merchandising, and Popular Taste: The Struggle for Influence," in Ian M. G. Quimby, ed., *Material Culture and the Study of American Life* (New York: W. W. Norton, 1978), 140–174; Deirdre Robson, "The Avant-Garde and the On-Guard: Some Influences on the Potential Market for the First Generation Abstract Expressionists in the 1940s and Early 1950s," *Art Journal* 47 (1988): 215–221; and Bernard Rosenberg and Norris Fliegel, *The Vanguard Artist: Portrait and Self Portrait* (Chicago: Quadrangle Books, 1965). Robert Jenson, "The Avant-Garde and the Trade in Art," *Art Journal* 47 (1988): 360–367, describes a similar process of cultural assimilation through institutional acceptance for the turn-of-the-century French vanguard.

On the preeminent avant-garde assimilator, the Museum of Modern Art, see Alice Goldfarb Marguis, *Alfred H. Barr, Jr.: Missionary for the Modern* (Chicago: Contemporary Books, 1989); and Annette Cox, "Mak-

ing American Modern: Alfred H. Barr, Jr., and the Popularization of Modern Art," *Journal of American Culture* 7 (1984): 19–25.

On universities and professionalism, see Burton J. Bledstein, *The Culture of Professionalism: The Middle Class and the Development of Higher Education in America* (New York: W. W. Norton, 1976). Steven Biel describes American intellectuals' opposition to the academy in *Independent Intellectuals in the United States, 1910–1945* (New York: New York University Press, 1992). Biel argues that such opposition ended after World War II; this study makes clear that it did not. Russell Jacoby, *The Last Intellectuals: American Culture in the Age of Academe* (New York: Basic Books, 1987), discusses the impact of intellectual academization. On the transformation of art into ideas, see Arthur Danto, *The Transfiguration of the Commonplace* (Cambridge: Harvard University Press, 1981).

The categories in which I analyze the integration of the last American avant garde into consumer culture were suggested by Adrian Marino, "Le Cycle social de l'avant-garde," *Review de l'institute de Sociologie* 3–4 (1980): 631–642. For a survey of the growing historiography on consumer culture, see Jean-Christophe Agnew, "Coming Up for Air: Consumer Culture in Historical Perspective," *Intellectual History Newsletter* 12 (1990): 6–10. The origins of consumer culture in seventeenth-century Europe are discussed in Grant McCracken, *Culture and Consumption: New Approaches to the Symbolic Character of Consumer Goods and Activities* (Bloomington: Indiana University Press, 1988). On the role of advertising, see Jackson Lears, *Fables of Abundance: A Cultural History of Advertising in America* (New York: Basic Books, 1994). For classic statements on the history of consumer culture, see Daniel J. Boorstin, *The Americans: The Democratic Experience* (New York: Vintage Books, 1973); and Richard Wightman Fox and T. J. Jackson Lears, eds., *The Culture of Consumption: Critical Essays in American History, 1880–1980* (New York: Pantheon, 1983).

On the integration of art into corporate culture, in addition to the notes to chapter 8, see Neil Harris, "Design on Demand: Art and the Modern Corporation," in Harris, *Cultural Excursions: Marketing Appetites and Cultural Tastes in Modern America* (Chicago: University of Chicago Press, 1990), 349–378; Terry Smith, *The Making of the Modern: Industry, Art, and Design in America* (Chicago: University of Chicago Press, 1993); and Daryl Chin, "The Avant-Garde Industry," *Performing Arts Journal*, 9 (1975): 59–75.

My framework for understanding the media was suggested by John C. Burnham, *How Superstition Won and Science Lost: Popularizing Science and*

Health in the United States (New Brunswick, N.J.: Rutgers University Press, 1987).

On celebrity, see Leo Braudy, *The Frenzy of Renown: Fame and Its History* (New York: Oxford University Press, 1986). For the example of Arturo Toscanini, see Joseph Horowitz, *Understanding Toscanini* (Minneapolis: University of Minnesota Press, 1987). Andy Warhol is discussed in Patrick S. Smith, *Andy Warhol's Art and Films* (Ann Arbor, Mich.: UMI Research Press, 1986); and Stephen Koch, *Stargazer: The Life, World, and Films of Andy Warhol*, 2d ed. (New York: Marion Boyars, 1991). Donald Kuspit has a good discussion of Warhol the celebrity in *The Cult of the Avant-Garde Artist* (Cambridge: Cambridge University Press, 1993), 64–82.

Pluralism and novelty are discussed in Christopher Booker, *The Neophiliacs* (Boston: Gambit, 1970); and Hal Foster, "The Problem of Pluralism," *Art in America*, January 1982, 9–15.

The connections between the 1950s avant garde and the 1960s counterculture are explored in Morris Dickstein, *Gates of Eden: American Culture in the Sixties* (New York: Basic Books, 1977); and James Arthur Winders, "The Revolt and the Style of Dada, Beat, and Rock" (Ph.D. diss., Duke University, 1976). The rise and fall of the counterculture is described in William L. O'Neill, *Coming Apart: An Informal History of America in the 1960s* (New York: Quadrangle Books, 1971); and Todd Gitlin, *The Whole World Is Watching: Mass Media in the Making and Unmaking of the New Left* (Berkeley: University of California Press, 1980). The alternative press of the 1960s is discussed in Abe Peck, *Uncovering the 60s: The Life and Times of the Underground Press* (New York: Pantheon, 1985); and James L. Spates, "Counterculture and Dominant Culture Values: A Cross-National Analysis of the Underground Press and Dominant Culture Magazines," *American Sociological Review* 41 (1976): 868–883.

For an example of political art of the 1990s, see the exhibition catalog *Artists of Conscience II* (New York: Alternative Museum, [ca. 1992]. Examples of the diverse innovations of artists, writers, and performers since the 1960s can be found in the following: Robert Pincus-Witten, *Postminimalism into Maximalism: American Art, 1966–1986* (Ann Arbor, Mich.: UMI Research Press, 1987); Peter Frank and Michael McKenzie, *New, Used, and Improved: Art for the 80's* (New York: Abbeville, 1984); RoseLee Goldberg, *Performance Art: From Futurism to the Present*, 2d ed. (New York: Harry N. Abrams, 1988); Eugene Goodheart, "Four Decades of

American Fiction," in *American Literature*, vol. 9 of Boris Ford, ed., *The New Pelican Guide to English Literature* (Harmondsworth, U.K.: Penguin, 1988), 628–637; and Douglas Davis, "The Avant-Garde Is Dead! Long Live the Avant-Garde!" *Art in America*, April 1982, 11–19.

The feminist art of this period is discussed in Giesela Ecker, ed., *Feminist Aesthetics* (Boston: Beacon Press, 1986); Lucy R. Lippard, *From the Center: Feminist Essays on Women's Art* (New York: E. P. Dutton, 1976); Roberta Smith, "Women Artists Engage the 'Enemy,' " *New York Times*, 16 August 1992, sec. 2, pp. 1, 23. E. Ann Kaplan has argued that some feminist art constituted a "utopian" postmodernism; see E. Ann Kaplan, ed., *Postmodernism and Its Discontents* (London: Verso, 1988).

The literature on postmodernism is vast. A helpful summary of definitions and interpretations is Todd Gitlin, "The Postmodern Predicament," *Wilson Quarterly*, Summer 1989, 67–76. Michael Bérubé is one who argues for the similarities between modernism and postmodernism, describing them as "more like overlapping 'structures of feeling'" rather than distinct periods; see his *Marginal Forces/Cultural Centers: Tolson, Pynchon, and the Politics of the Canon* (Ithaca, N.Y.: Cornell University Press, 1992). Also insightful is Jean-François Lyotard, *The Postmodern Condition: A Report on Knowledge*, translated by Geoff Bennington and Brian Massumi (Manchester: Manchester University Press, 1984). On postmodern literature, I found especially helpful Jerome Klinkowitz, *Literary Disruptions: The Making of a Post-Contemporary American Fiction*, 2d ed. (Urbana: University of Illinois Press, 1980). Classic statements are Fredric Jameson, "Postmodernism, or the Cultural Logic of Late Capitalism," *New Left Review*, July-August 1984, 53–92; Charles Jencks, *What Is Post-Modernism?* (London: Academy Editions; New York: St. Martin's Press, 1987); Andreas Huyssen, *After the Great Divide: Modernism, Mass Culture, Postmodernism* (Bloomington: Indiana University Press, 1986). The connections between postmodernism and consumer capitalism are discussed in David Harvey, *The Condition of Postmodernity: An Enquiry into the Origins of Cultural Change* (Oxford: Basil Blackwell, 1989).

Index

Abstract expressionism, 6, 12–13; in mass media, 160; paintings as investments, 161. *See also names of individual artists*

African Americans and the avant garde, 75–76

Albright, Thomas, 138

Alienation, 9–10, 41–43; Cold War, 116–18; conformity in the U.S., 50–53; consumer culture, 143–46; cultural institutions, 126–25, 131–33; and the future, 104–16; and integration, 172–76; and Marxism, 22, 26–28; politics and anarchism, 61–62; as positive force, 54–56; from technology, 98–100; from tradition, 53–54. *See also* Bomb

Allen, Donald, 43, 136, 164–65

American Abstract Artists (AAA), 30

American Communist Party. *See* Marxism

"American cool," 167

Anarchism, 5, 61–62

Anderson, Laurie, 178–79, 182

Anderson, Wendell, 145

Andrews, Oliver, 136–37, 165

Art of This Century Gallery, 99

Assemblages, 13

Associated American Artists, 148–49

Atomic bomb. *See* Bomb

Auden, W. H., 44

Avant garde: in American intellectual history, 5–6, 8; anthropology, 62, 85; artist as shaman, 108; culture and, 185–86; and the counterculture, 172; defined, 3–5, 8–12; earlier American vanguards, 13, 20,
25, 30, 56, 62, 67, 97, 158; end of, summarized, 3, 15–17, 185–86; European and American, 4, 11, 14, 29–31, 41–42, 65–68, 70–71, 81, 98, 164; expatriation, 56; individualism and society, 97; last American, defined, 12–15; and the middle class, 9, 10, 51–53, 138, 144, 148–49, 159–68; and new critics, 132; and New York intellectuals, 34–37, 90; politics, 4–5, 60–65; postmodern discourse, 7–8, 183–86; and totalitarianism, 116–18, 122–23. *See also* Alienation; Cold War; Consumer culture; Cultural institutions; Fascism; Future; Innovation; Marxism; Mass media and the avant garde; Modernism; Spirituality and the avant garde; *specific individuals, movements, and little magazines*

Babbitt, Milton, 135

Banes, Sally, 6, 173

Baraka, Amiri. *See* Jones, LeRoi

Barr, Alfred H. 35, 128

Barrett, William, 32

Barth, Lawrence, 33–34, 78, 117–18

Baziotes, William, 34, 56, 126–27; alienation as positive force, 54–55

Beats, 6, 12–13, 45; as consumer culture lifestyle, 155–59; critical reception, 155–56; drugs, 80–82; jazz, 75–77; oriental spirituality, 88–90; stereotyped, 156–57, 159, 168. *See also names of individual writers*

Bebop jazz, 74–77

Benton, Thomas Hart, 66

225